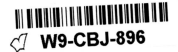
W9-CBJ-896

THE FIGURE

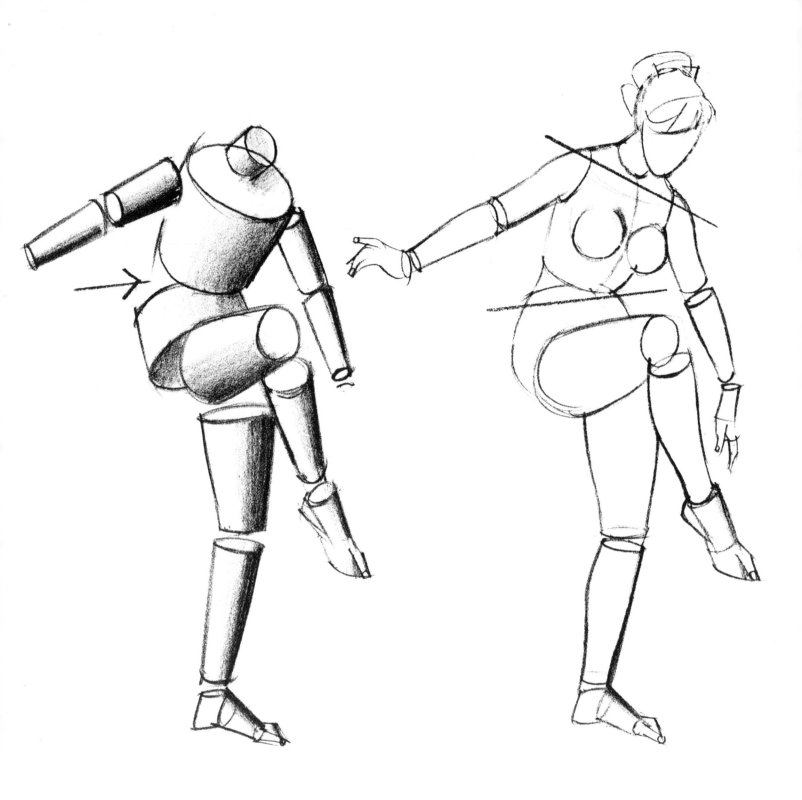

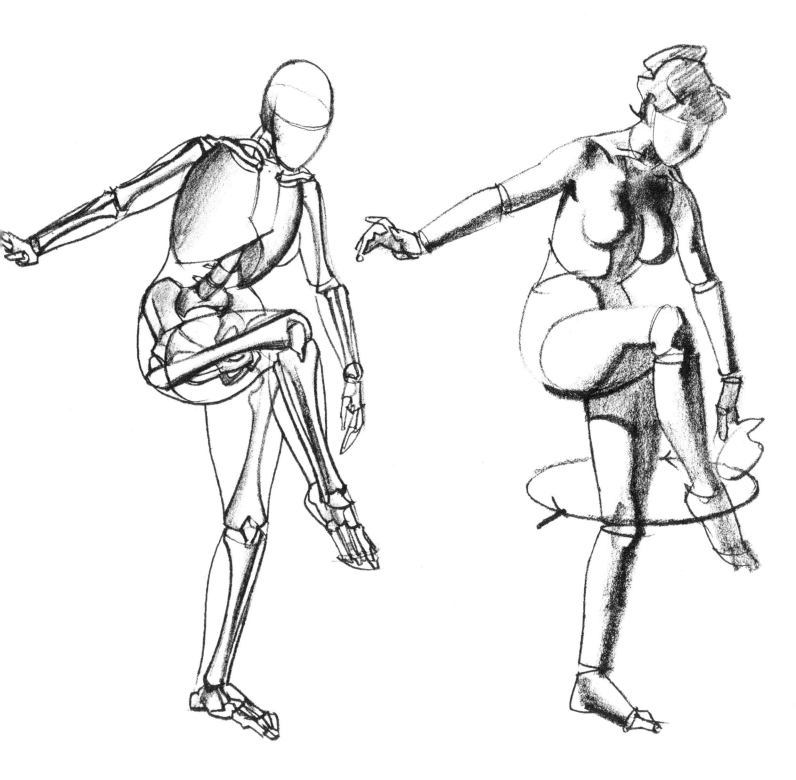

An approach to drawing and constructing
The Figure

Compiled and edited by Walt Reed North Light Books

The Figure. Copyright © 1976, 1984 by Fletcher Art Services, Inc.
Printed and bound in the United States of America. All rights reserved.
No part of this book may be reproduced in any form or by any
electronic or mechanical means including information storage and
retrieval systems without permission in writing from the publisher,
except by a reviewer, who may quote brief passages in a review.
Published by North Light Books, an imprint of F&W Publications, Inc.,
1507 Dana Avenue, Cincinnati, Ohio 45207. (800) 289-0963.
Revised softcover edition 1984.

Other fine North Light Books are available at your local bookstore, art
supply store or direct from the publisher.

03 02 01 00 15 14 13 12

Library of Congress Cataloging-in-Publication Data

Main entry under title:

The Figure.

1. Human figure in art. 2. Drawing—Instruction.
I. Reed, Walt.
NC765.F53 743'.4 76-4545
ISBN 0-89134-097-1

Dedicated to the long roster of friends and colleagues from the Guiding Faculty and instruction staff of the Famous Artists School, whose teaching methods, evolved and tested over more than twenty years, developed much of the information presented in this book.

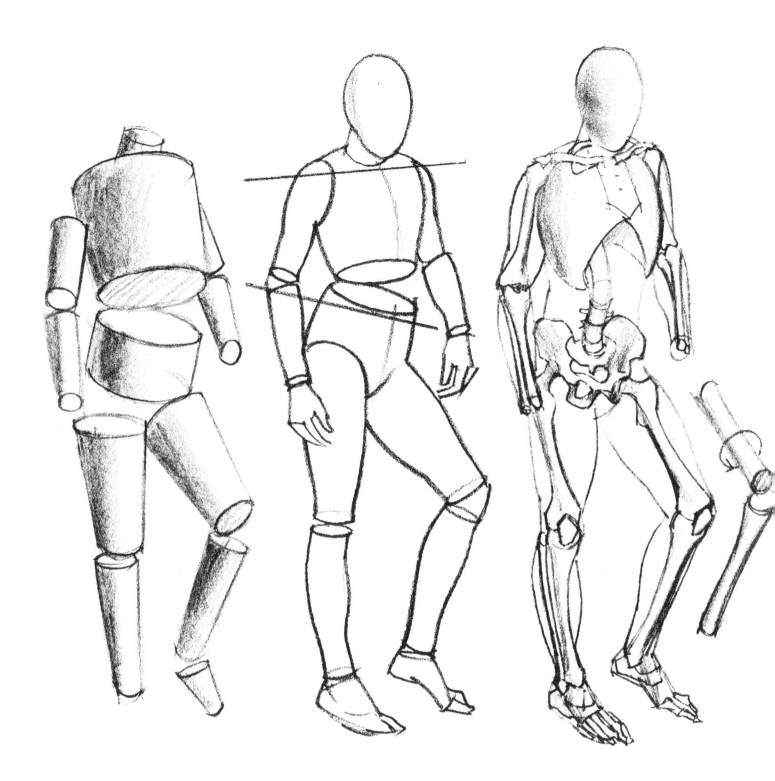

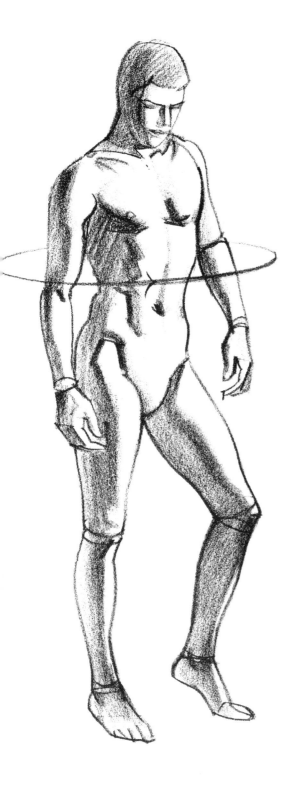

CONTENTS

Dancing Faun, antique bronze,
National Museum, Naples. (Alinari)

INTRODUCTION

The Human Figure

There is no other vehicle so subtle or so effective for the expression of human thoughts and emotions as the human figure.

The artist who has mastered drawing of the human figure can call human personalities to life at will, and depict the specific attitudes, actions, mood, and emotions which will best express the situation he wants to portray. He transports the viewer to a world that may be far removed from immediate experience, and enables him to live, momentarily, an imaginary existence with imaginary people. The great artists are dramatists in paint, who can help their fellow men bridge the gap between imagination and reality.

From previous attempts, you may have concluded that drawing the figure is extremely difficult. This book will show you that it can be much easier than you think. But you must be willing to progress one step at a time, mastering each step as you go along.

The chief reason most students have trouble mastering the human figure is very simple: They want to start right off by drawing a fully clothed model in a complicated pose. They spend a great deal of time worrying about details of features, anatomy, and drapery. They try to capture the expression on the model's face, get a good likeness, and render textures convincingly. But in their concern about these details they lose all sense of proportion, construction — and, most of all, the solid form of the figure.

The soundest way to approach the problem of drawing the human figure is to begin with a very clear concept of the basic form. The human body is not a two-dimensional symbol on a flat surface; nor is it a paper doll with such decorative details as hair, eyes, teeth, clothes, shoes, etc., drawn on top of it. The human figure is first and primarily a three-dimensional object, a solid object with bulk and weight. It is as three-dimensional as a piece of sculpture in wood, marble, or bronze.

This solid form of the human body looks complex. It is obviously not a single sphere or cube or cylinder.

But when we examine it we discover that this complex form is actually a combination of very simple forms which anyone can draw. Once you can draw those forms well, you will have no difficulty putting them together to make the total human form.

This chapter will show you how to analyze the human figure in terms of these simple, basic forms. It will show you what the proportions of these individual forms are, in relation to the total form. It will illustrate the methods by which these individual forms are connected, and demonstrate how the parts move. In other words, we will explore the basic construction of the figure. Then you will be shown how to draw this basic human form in any position, engaged in any kind of activity. Concentrate on this basic form figure until you can do anything you want with it. Draw it in as many positions as possible. Look for it in photographs of people, paintings, and above all in the people you see around you.

In the following chapters detailed studies of anatomy will be presented, examining the bone and muscle structures which hold the basic form together and make it move. This book will also consider special problems involved in drawing individual parts of the body, such as the head, the hands, and the feet.

The information presented in this chapter is so important that it is not enough for you merely to read it. You should actually memorize every detail thoroughly. You can do this most effectively simply by making dozens of drawings. Most of these practice drawings can be done in just a few minutes. Practice of this kind will help train your hand and your mind in the proportions, construction, and relationships of the individual forms so that you will never forget them.

These essential facts about the human form are as basic and invaluable to you, as an artist, as the simple multiplication table is to the mathematician. You may be drawing the human figure the rest of your life, so build your knowledge and control of it as solidly as you can.

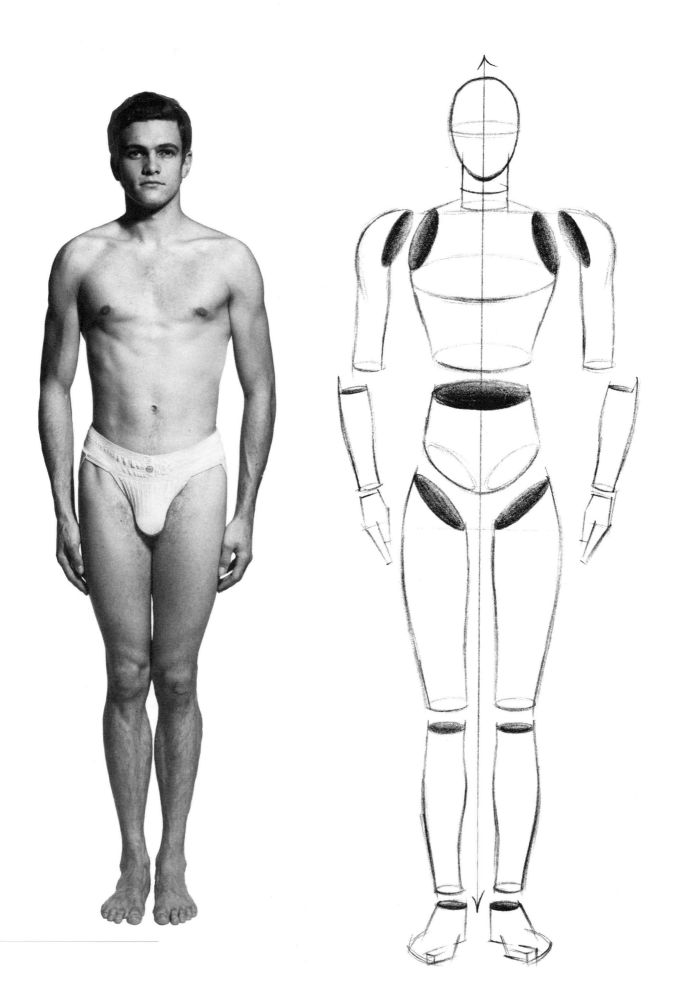

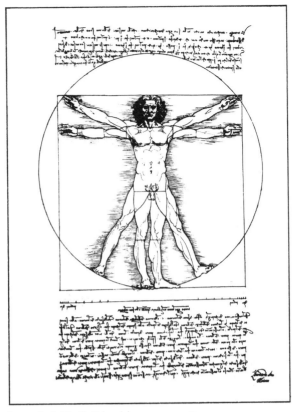

Leonardo DaVinci's 8 head human proportions.

The basic form figure

The basic form figure on the left demonstrates the all-important principle emphasized throughout this book — the fact that the human body is made up of simple, solid forms. The basic form figure presents the body in its essential masses. Every distracting element has been eliminated. Think of the form figure as if it were carved out of heavy wood; it is solid, three-dimensional. In this drawing the form figure has been pulled apart, or "exploded," to emphasize the various separate elements. They consist of head and neck; upper torso and lower torso; upper arms, lower arms, and hands; upper legs, lower legs, and feet.

Compare the form figure with the photograph of the living model to its left. Note that the model and the basic form figure are similar in basic mass and construction, with the same association of parts. In both model and form figure the neck, the arms, the legs, and the torso are essentially modified cylinders. The head is basically a simple sphere. The hands can be reduced to cubic forms, while the feet are combined cone and cube forms.

It is extremely important in the beginning to view the body in terms of these simple, basic forms, understanding the essential masses of the separate parts, and placing these in their proper proportions and relationships. For the present you can ignore hair and features, as well as the more subtle curves resulting from underlying bone and muscular structure. Once you can control and draw the basic forms properly, you will have little trouble drawing the details of these forms.

The artist uses the human head as his basic unit of measurement for the entire human figure. The head can be viewed in two ways, however — in terms of its height,

and its width. The height of the head from chin to top of skull is the ruler by which all vertical measurements are made. For example, the artist speaks of an "eight-head figure," by which he means that the figure is eight vertical heads high. It is more convenient to use the width of the head in making horizontal measurements. The shoulders, for instance, are three head width across.

If you look at the people around you in real life, you will see that they differ considerably in proportions. One man has a head which we think is large for his body, another has a head which seems smaller than normal. The great majority of people, however, are reasonably similar in proportions and shape at any given age. It is because of this fact, of course, that it is possible for clothing manufacturers to design "ready-made" suits and dresses. Most people can be fitted into standard patterns successfully with only minor adjustments.

On this basis we could easily arrive at average proportions for the adult figure. There is a distinct difference, however, between the "average" and the "ideal." Artists have always sought to discover the perfect figure. The Greek sculptors, for example, established a set of proportions for their idealized figures of gods and goddesses. In the same way later artists, such as Leonardo and Durer, set up their own canons of proportions for the ideal figure. In many respects the concept of the ideal changes from nation to nation, and from period to period. The hefty, voluptuous beauties of the Rubens murals were much admired in their day, when women were considered beautiful only if they had achieved monumental proportions. It is obvious that today popular taste has swung in the opposite direction.

7-head division

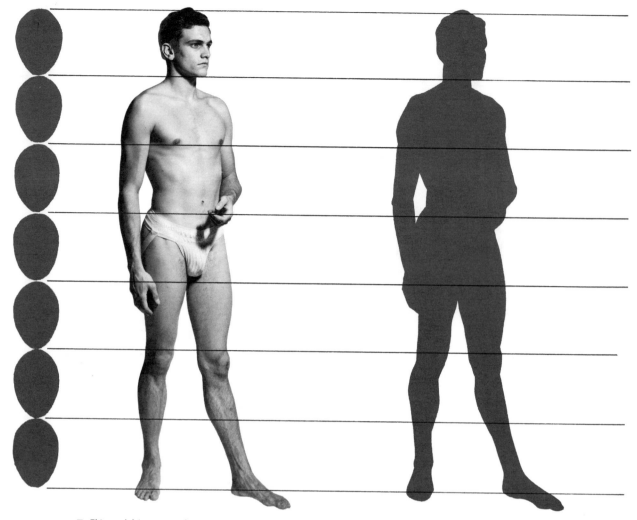

1 This model is a man of average height and good physical development. His total height is seven times the height of his head. If you ran into him accidentally in real life you would consider him well-proportioned. Yet when we draw him on paper, as the silhouette demonstrates, he seems to be much broader and stockier than most Americans think the "ideal" man should be.

2 The head is the basic unit by which the figure is measured. In the head-unit "ruler" above, the vertical height of the head is used to make vertical measurements of the body. Thus we say that the model is a "seven-head" figure.

Proportions

In attempting to draw people who will seem ideal to the average person of today, we must set up a canon of proportions based on present-day taste. This canon need not necessarily be the same as the measurements of the present-day average man or woman. In the photograph silhouetted above, the model is a well-developed male of average height. He is a "seven-head figure." Most people today, however, do not consider a seven-head figure tall enough to satisfy their concept of the ideal. They prefer the eight-head figure, which they feel handsomer or more elegant.

On the right-hand side of these two pages, you will see how the eight-head figure looks. To make this figure the same height as the seven-head figure we divide the height into eight parts. One of these parts serves as the basic head measurement unit. After drawing in the head,

8-head division

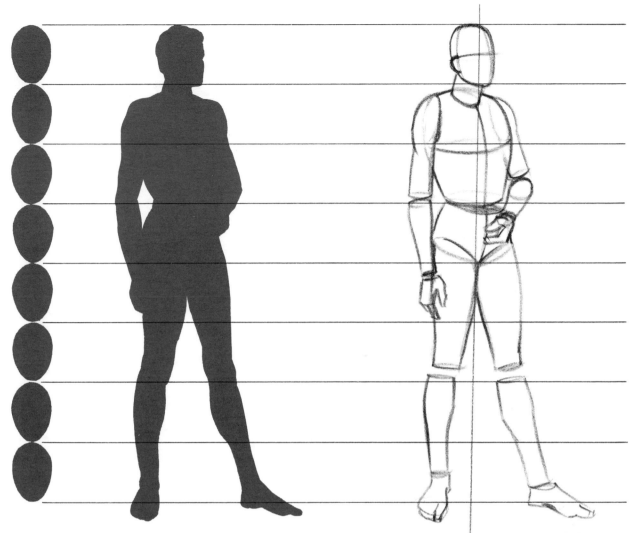

3 In the ideal figure the body is eight times the height of the head, as we have diagramed above. Notice that although the _total_ height of this eight-head figure is the same as that of the seven-head figure at the left, the size of the head has been reduced in the eight-head figure. All the other parts of the figure have been elongated proportionately, so that the figure now seems slim and graceful.

4 Here the eight - head figure is presented in basic form. Study the relationship of the different parts of the figure, noticing how they are balanced on a vertical axis.

we position the other parts of the body along the vertical axis. The body alone, from neck to feet, now measures seven head units, instead of six. The parts are all slightly elongated because of this, and as a result the figure seems much better proportioned.

The eight-head figure is the set of proportions upon which we will base most of the instruction in this book. Occasionally you will want to draw people who are obviously not average. If you want to caricature a person, or show that he is shorter than average or taller than average, you can do this very easily by retaining the same width measurements used to draw the eight-head figure, but reducing the height to five or six heads, or increasing the height to nine or ten heads. However, any departure from the eight-head formula should be deliberate.

Rely on your eyes for correct proportion. The head as

a unit of measure is convenient and helpful while you are first learning figure proportions. You must realize, though, that you do not make figure drawings with a pair of dividers or a ruler. You make them with your pencil and your eyes. Actually, the only time you can literally measure the body and see how many heads long it is, is when the figure is standing bolt upright, in a position of attention. Any other time — which means most of the time — the figure or parts of it are foreshortened to some extent. Therefore, the only way to gauge proportions is with your eyes. If it looks right it is right. By all means study the chart and fix in your mind the size of one part of the body compared with another, but put your ruler away when you start to draw. Never forget for a moment that skillful drawing is simply skillful seeing, transferred to the surface of your paper.

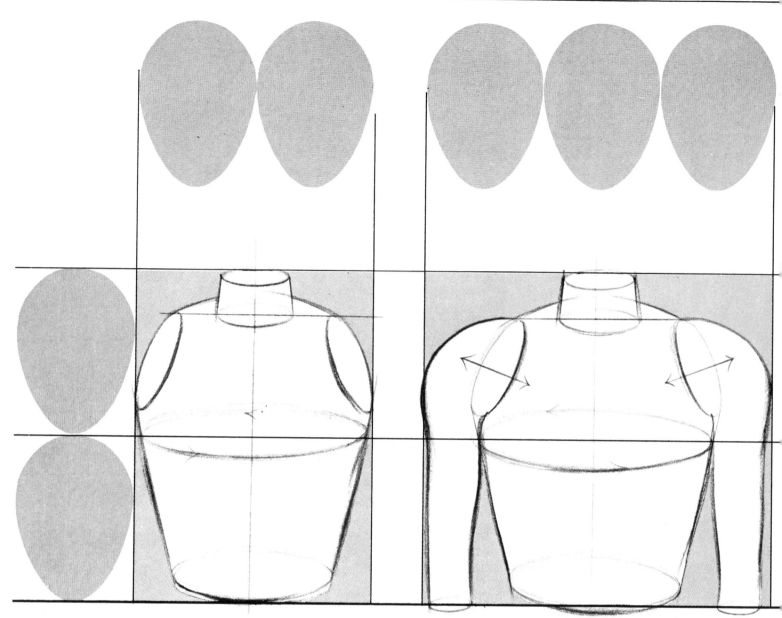

None of the individual parts of the figure are more than two heads high.

The upper torso is the largest part of the body.

The eight-head *male* shoulders fill out a space three heads wide.

The individual parts

The foot is about one vertical head measurement long; the hand is a little over two-thirds as long.

The chart on these two pages presents the individual parts of the idealized eight-head figure side by side, so that you can compare the parts directly and see how large they are in relation to each other.

The upper torso, the upper leg, and the lower leg including the foot are all approximately two heads high. The upper arm, and the lower arm including the hand are slightly less than two heads high. The lower torso is one head high, or half as long as the upper torso, the upper leg, and the lower leg.

Use the heads at the top of the page to measure the width of the parts. It is important that you have a good visual idea of how wide each part is in relation to its length, and in comparison with the width of the other parts.

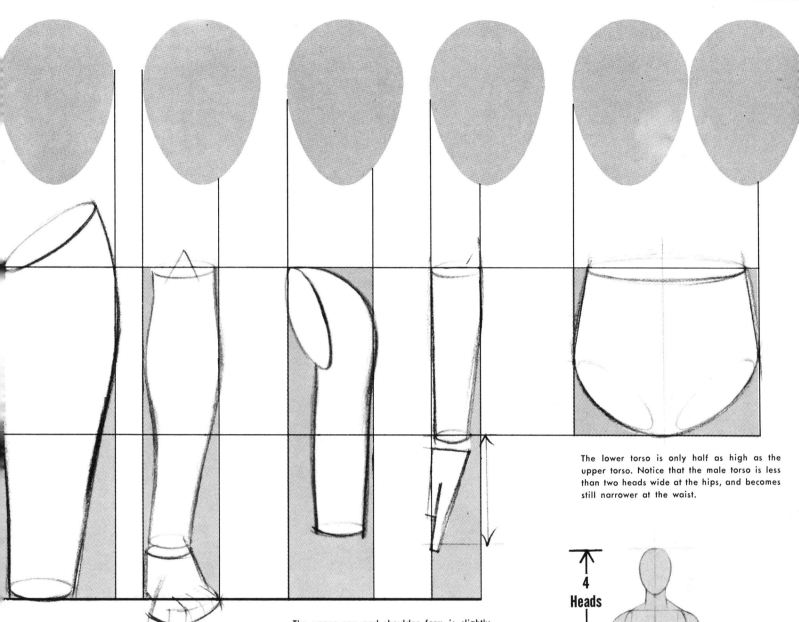

The upper leg of the male figure is two heads high and one head wide. The lower leg is the same length as the upper leg (foot included), but the lower leg is little more than half a head wide.

The upper arm and shoulder form is slightly shorter than the lower arm (hand included); the shoulder itself about three-quarters of a head wide while the rest of the arm and elbow are about half a head wide.

The lower torso is only half as high as the upper torso. Notice that the male torso is less than two heads wide at the hips, and becomes still narrower at the waist.

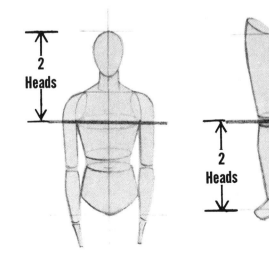

2 Heads

A line drawn across the nipples and just below the armpits divides the upper part of the figure in half.

2 Heads

A line drawn through the knees divides the lower part of the fig-ure in half.

4 Heads

A line drawn across the crotch divides the whole figure in half.

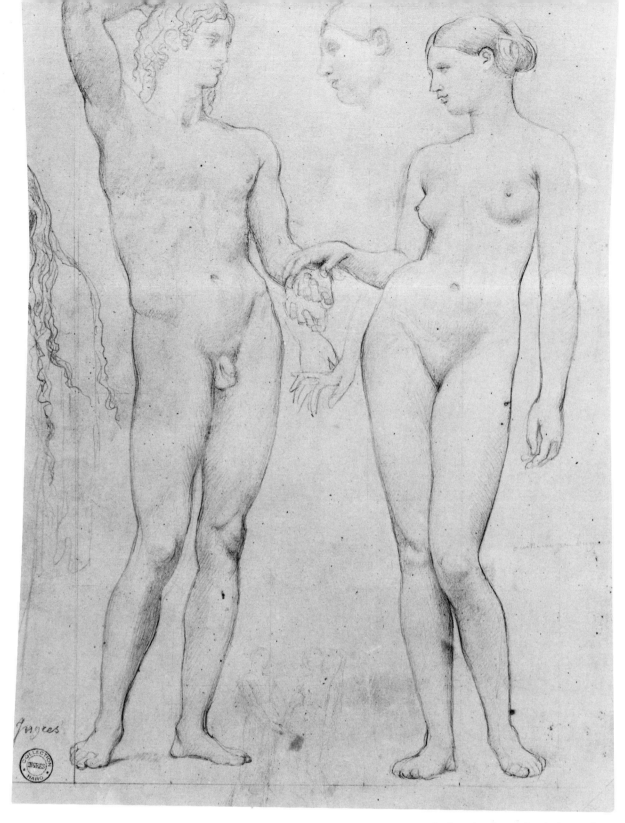

Studies of male and female figures for
L'age d'or by Ingres; collection Fogg Art Museum

Structural differences—male and female

Up to this point we have presented the male figure
proportions exclusively. The female figure is constructed
in the same manner, following the eight-head formula.
Important differences between the male and female form
are considered on these pages.

 Both figures are shown the same height on the right-
hand page in order to make direct comparisons.
Normally the woman is drawn slightly shorter than
the man beside her. To do this, using the eight-head
formula, you should construct her with a smaller basic
head measurement than that of the man.

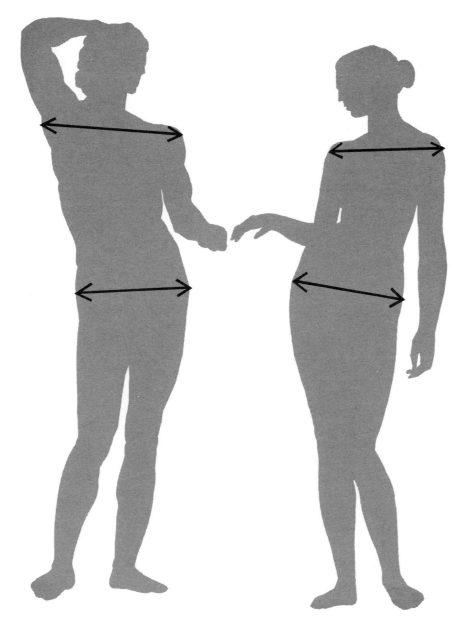

Study the diagrams above, comparing the male and female forms point by point. Notice that the man's shoulders are fully three heads wide; the woman's are much narrower. On the other hand, the man's hips are much narrower than his shoulders, while the woman's are about the same width as her own shoulders. The woman's shoulders also taper much more than the man's. Her arms, wrists, and fingers are smaller and thinner than the man's, and her lower legs taper to thinner ankles and smaller feet. The female breasts are two simple half-spheres, the bottom line of which is about one-third of the way down from the top of the shoulder to the crotch. The male's nipples are placed about two head-lengths from the top of his head. The female nipples are slightly lower.

Female

Male

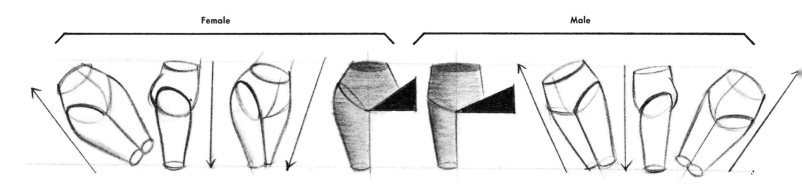

Comparing the hip structure in man and woman: The female hips are broader than the male, and where her legs join her body there is a much sharper angle.

The woman has a narrower waist than the man, and the angle from the waist to the widest point of the hips is much sharper in the woman's figure.

The upper thigh is clearly much thicker in the woman. Notice that the outer curve from waist to knee is much more prominent than it is in the male.

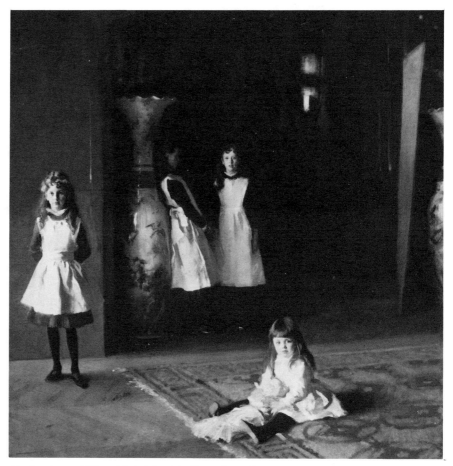

The Daughters of Edward D. Boit by John Singer Sargent,
collection, Museum of Fine Arts, Boston, Mass.

Relative proportions at various ages

When a child is born, some parts of its body are much
further developed than others. Its head, for example, is
quite large as compared with the length of its arms
and legs. By the time the baby is a year old, his body
from neck to feet is about three and one-half times the
length of his own head. In other words, he is about four
and one-half heads high. His legs are still quite short
compared to the length of his head and torso; therefore
the center of his body is at a line through the stomach,
rather than at the crotch.

As the child grows older his legs and arms become
much longer. By the time he is eight, the center of his
body has moved down to a line above the hips. At
the age of twelve, he is about seven heads high, and the
center of his body falls at the crotch. From this time on,
until he becomes a full grown adult, he broadens out in
addition to becoming taller.

The proportions given here are for the "ideal" children.
Actually, of course, it is very difficult to be specific
about the proportions of a child at a particular age.
Some children grow much more rapidly than others, and
girls tend to develop faster than boys. In practice the
infant is often made chubbier than he might be in real
life, and the child of ten or twelve is sometimes given a
mature grace. Despite individual variations, the
proportions shown here are satisfactory for most
purposes.

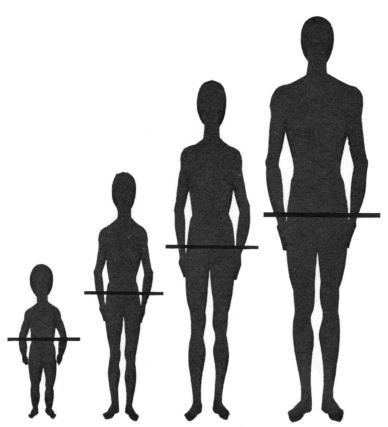

This diagram is intended to show you the relative height of children at various ages, as compared with the adult figure. The horizontal line is drawn to indicate the *center* of the figure. Notice how the center line moves down from a position on the lower chest of the one-year-old, until it reaches the crotch when the figure is fully developed. Notice also that the legs and arms grow much more than any other part of the body, while the head size changes quite slowly.

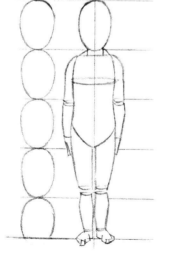

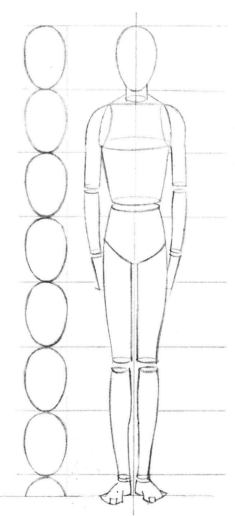

The one-year-old must be measured in terms of his own head, of course. Using this head size as a measuring unit, he is about four and one-half heads high. Study the points at which the head measurements fall on the various parts of the body so you can give them the right proportions.

By the time the child is eight years old, the head has grown somewhat larger. The eight-year-old can then be considered six and one-quarter heads high. Always remember that there is no absolute head measurement; each figure must be measured in terms of its own head size.

The head of a child twelve years old has again grown, and we measure the new figure in terms of the new head size. The usual twelve-year-old is about seven heads high. The center of the figure is now at the crotch. From this time on, all body parts develop at about the same rate.

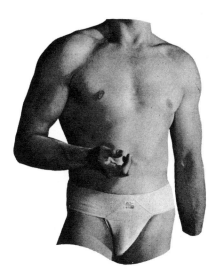

1 The human torso is essentially two forms joined together on a flexible spine which permits movement in all directions. The upper form is approximately twice as high as the lower.

2 In order to visualize the relationship of these two forms, get two ordinary tumblers, one twice as high as the other. Like these two glasses, the two forms of the human torso are essentially simple cylinders.

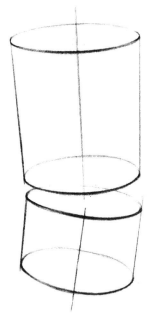

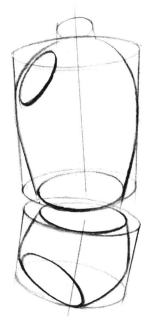

3 This is the way we would draw these two simple glass cylinders. If you think of the glasses as the upper and lower portions of the torso, and draw the glasses through, you will have no trouble visualizing the torso itself.

4 In this drawing you see how the two parts of the torso fit inside the two glasses. The torso forms look convincingly three-dimensional because they occupy the volume of space you have created by drawing the glass cylinders through to the other side.

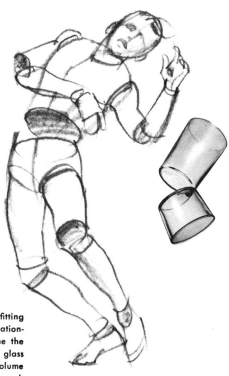

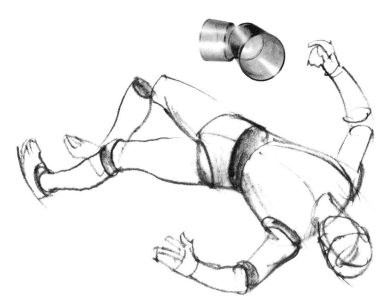

Think of the two parts of the torso as fitting inside the glasses. By changing the relationship of the glasses, you can then imagine the torso in any position. Draw through the glass ellipses to create a three-dimensional volume of space, and then draw the solid torso through inside this space. If you follow this procedure you will find it easy to visualize and draw the torso even in twisting or foreshortened poses.

Construction

It is helpful to reduce all objects to their simple basic forms of cube, cone, sphere, or cylinder. This can be done very easily even when the object seems quite complicated. On these pages we will demonstrate how to think of the torso, arms, and legs as modified cylinders, the hands and feet as cubic shapes, and the head as a simple sphere. If you can draw the basic forms you can draw the human body.

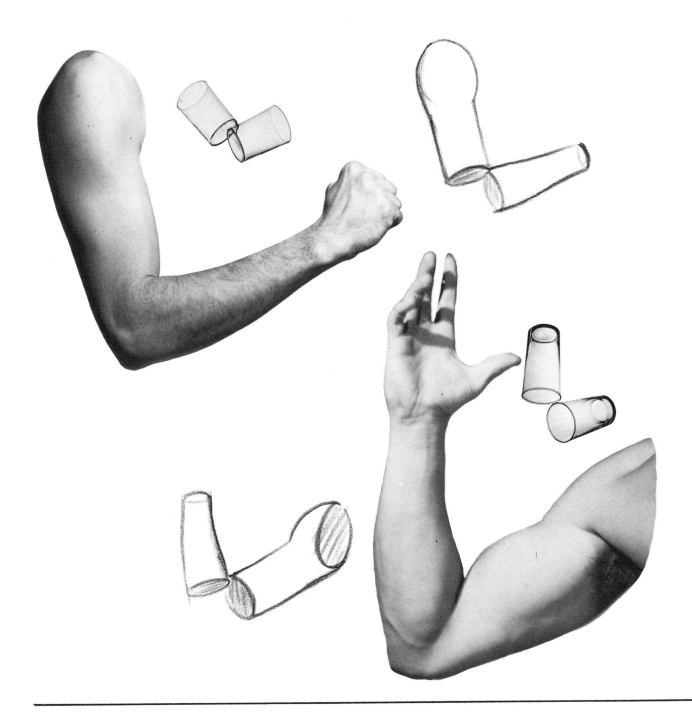

The arm

You can easily visualize the upper and lower parts of the
arm as modified cylinders, represented by the shapes
of two drinking glasses. The shapes are longer and
slimmer than those representing the torso, but the
principle is the same. As illustrated here, the cylinders
can be placed in any position that might be assumed by
the arm. It is the shape of the cylinder's ellipse which
determines the degree of foreshortening involved in the
pose. This is the reason why it is so important to
"draw through."

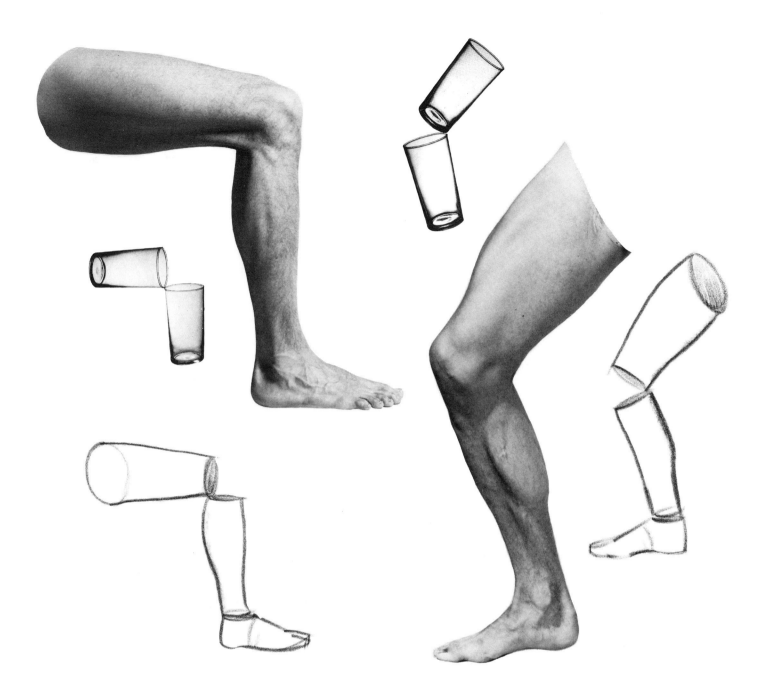

The leg

Like the arm, the two sections of the leg are modified
cylindrical shapes, but are even longer and heavier than
the arms. The major difference is that the joints of the
arms and legs are hinged in opposite directions. Other-
wise, the same approach can be followed in drawing
arms and legs, visualizing them first as glass tumblers.
Once you have determined the degree of foreshortening
involved in the position of each section, you can easily
modify the cylindrical shapes to resemble the contours of
the limbs.

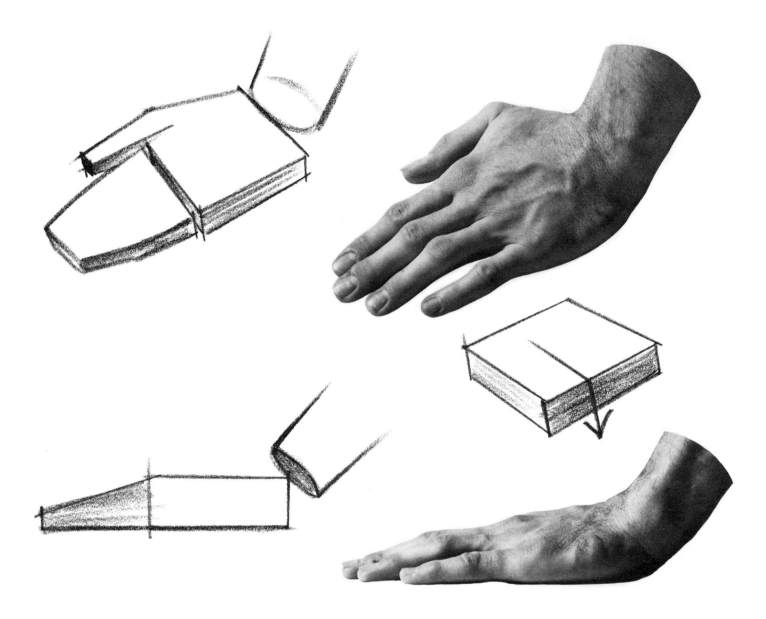

The hand

The hand, at first, looks complex. It too, however, can be
reduced to very simple basic shapes. Later on, the form
and structure of the hand will be treated in more
detail. However, it may be interpreted for the present
as a combination of simple forms which represents the
real hand with reasonable accuracy. At the left it is treated .
as a wedge-shaped cube divided into two sections. The
upper, broad section of the cube symbolizes the palm;
the lower, tapering wedge suggests the mass of the
fingers. The wedge of the palm, viewed alone, is a nearly
perfect square. The finger wedge is about as long as the
palm wedge. The visible part of the thumb is about
the length of the little finger. This simplified presentation
of the hand will serve for our basic form drawings.

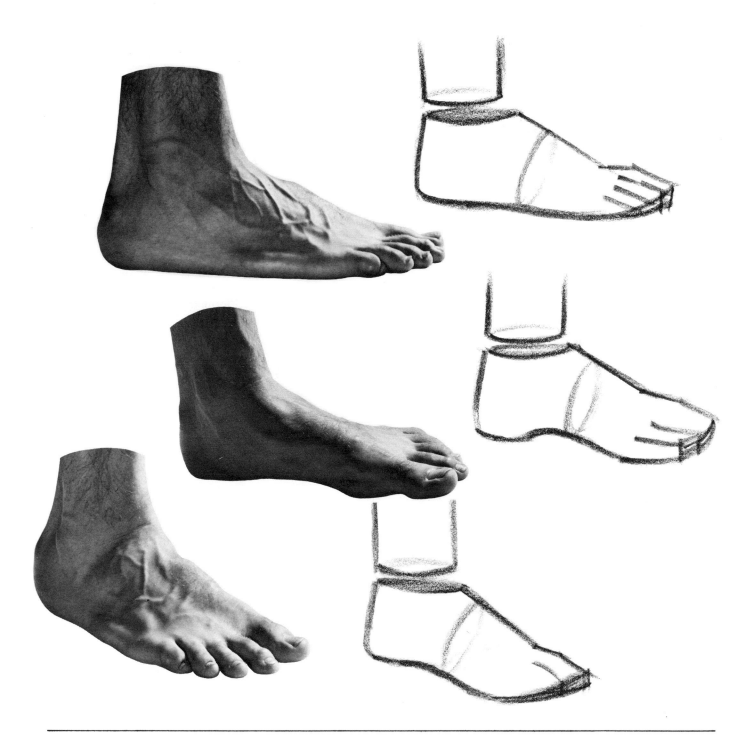

The foot

While the underlying structures of hands and feet are very similar, their outward shapes differ in shape and proportion. The foot is approximately as long as the head is high. The upper portion of the foot can be reduced quite logically to a cone that has been cut off at the point where the top of the foot meets the ankle. This cone is not symmetrical; it has a much sharper angle at the back, where it meets the heel, than it does at the front, where it slants down to meet the toe form. The toe form and the entire sole of the foot is best considered a thin cubic form. This approach to the foot will serve for your present drawings. The important thing now is to realize that it is a solid, three-dimensional object.

The head

Of all the individual parts of the human body, the head is undoubtedly the most important from the viewpoint of the artist. Later we will make an exhaustive study of the placement and formation of the features, the handling of the hair, and so on. For the present, however, it is extremely important for you to ignore these details and think of the head only in terms of its essential solidity and mass.

The basic head is a spherical form, like an egg, set on the cylindrical column of the neck. The nose and ears are not part of the basic egg form; they are wedges which project from the surface. If you sliced down through the egg-head on the vertical axis, the knife would pass through the center of the nose wedge, and the egg would fall apart into two equal halves. If you were to slice the egg on the horizontal axis, with the knife passing through where the top of the nose wedge meets the egg, you would again find that you had sliced the egg in half.

This demonstration is intended to remind you that the human head is a solid form. In your basic form drawings, think of the head as a solid sphere, and draw it as such, without attempting to work out details of the features.

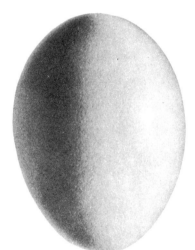

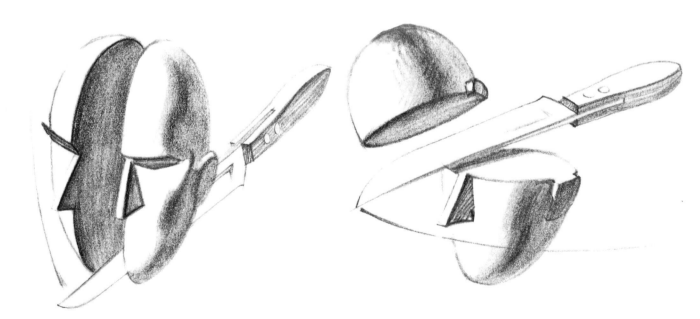

Front view

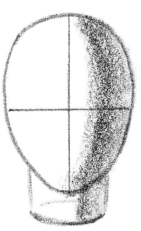

1 The head is an egg-shaped sphere with the narrow end at the bottom. It rests securely on the neck, which is a short cylinder. The horizontal and vertical center lines are guide lines for placing the features.

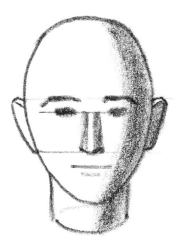

2 The eyes are located on the horizontal center line, the eyebrows on another line a little higher. The nose extends from this line halfway to the chin. Top of ears lines up with brows, bottom with base of nose.

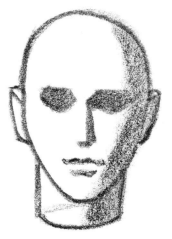

3 The eyes are recessed under the brows. The nose is a wedge shape with planes. The egg shape is modified so it has side planes too.

Side view

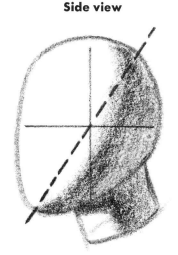

1 The form is wider at the top and narrower at the bottom than in the front view. Note that the egg shape is tilted, as shown by the diagonal line. The neck is toward the back of the head and slants forward.

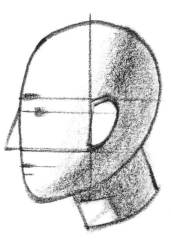

2 Nose and eyebrows are located as described at the left. The ear is placed just <u>back</u> of the center of the head. The top is level with the brow, the bottom with the base of the nose. Two lines indicate the mouth — one suggests the mouth opening, the other the bottom of the lower lip.

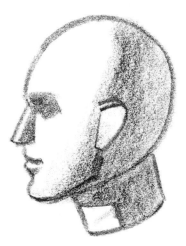

3 The jaw line angles down from the ear. The nose and ears are solid forms.

Movable parts

Important points at which motion occurs in the body are indicated by white dots on the figure at the left. The individual parts are connected by three distinctly different types of joints: 1) the ball-and-socket joint, which appears at the shoulders, hips, wrists, and ankles; 2) the hinge joint, found at the knees and elbows; and 3) the flexible column, a term used to describe the spine and the neck.

Each of these joints varies considerably in the type of motion it allows. The ball-and-socket joint is extremely flexible and permits rotary motion in all directions, although the amount of motion depends on the construction of the individual joint. The hinge joint at the elbows and knees may be visualized as a flat disk. This disk provides the flexibility-plus-rigidity which these members need to act as adaptable levers. The upper and lower arms and legs can be fixed in any relationship on a straight line, but all sideward motion is prohibited. The action of these two joints is illustrated on the following page.

The third type of joint is the flexible column of the spine. This connects the upper and lower halves of the body. The spine is involved in any motion which requires shifts in weight, such as walking, running, and jumping. Since it is highly flexible, it permits not only rotary motion in all directions, but also twisting motion throughout its entire length. The upper part of the spine is the neck, which controls all motion of the head.

The diagrams on this page are intended to remind you of the various possibilities which these three different joints provide. However, you can study the possibilities and limitations of motion in the human body best by experimenting to see how the various portions of your own body move. Test out these diagrams for yourself.

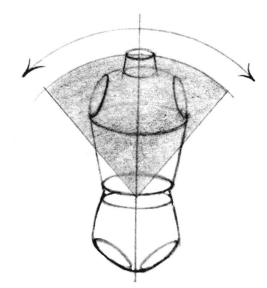

The motion of the upper and lower torso is extremely important in almost every action pose. Although the upper portion of the body has the greater range of motion, its side-to-side movement is limited as shown here.

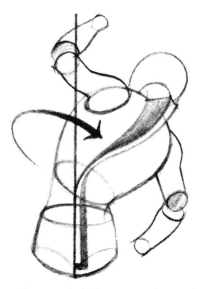

In many action poses the body twists in such a way that the upper and lower torso move in opposite directions. The spine is so constructed that it can bend and twist at the same time, as the illustration demonstrates.

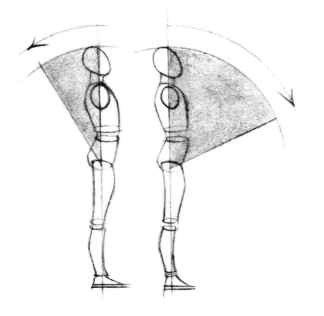

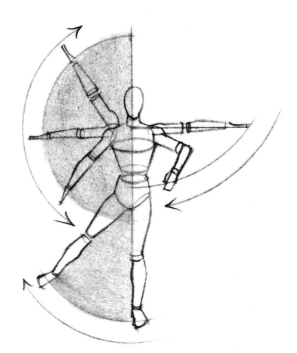

The spine and hip joints allow the upper part of the body to bend forward until it is practically at right angles to the lower. The backward motion is more limited. The spine permits somewhat the same movement as if the upper torso were mounted on a ball-and-socket joint.

The shoulder and the hip joints are both ball-and-socket rotary joints, but because of construction the shoulder joint is much more flexible than the hip joint. Motion of the shoulder joint covers a complete arc, as you can see, but motion of the hip joint is much more limited.

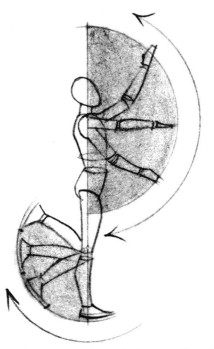

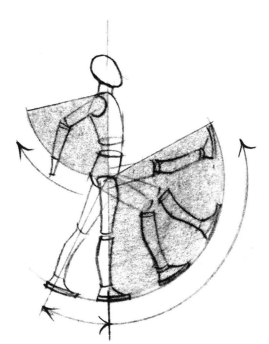

The sense of balance in the human body is so well developed that when one part reaches out from the central axis, another part instinctively tends to extend itself to create a new state of equilibrium. If the arm reaches up, the lower leg will probably be lifted back to balance it.

This diagram shows the possible backward movement of the arm and the forward movement of the leg. These two motions are naturally associated, as are the two motions shown in the previous example. Always take this matter of reciprocal balance into consideration.

The ball-and-socket joint

The ball-and-socket joint at the shoulders and hips permits the arms and legs to be revolved or swung back and forth in any direction. These two kinds of motion are indicated by the two balls in the diagrams. Swing your arms and legs and compare the action of the ball-and-socket joint and the hinge joint (right).

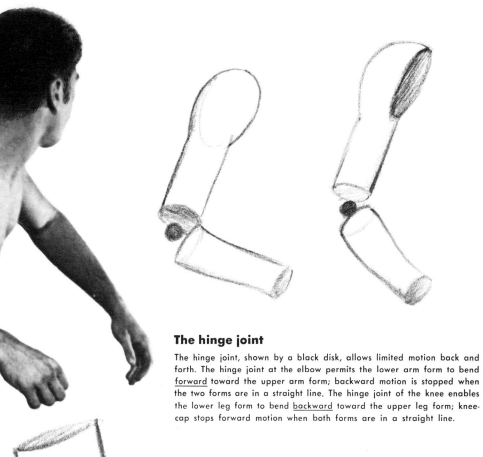

The hinge joint

The hinge joint, shown by a black disk, allows limited motion back and forth. The hinge joint at the elbow permits the lower arm form to bend <u>forward</u> toward the upper arm form; backward motion is stopped when the two forms are in a straight line. The hinge joint of the knee enables the lower leg form to bend <u>backward</u> toward the upper leg form; knee-cap stops forward motion when both forms are in a straight line.

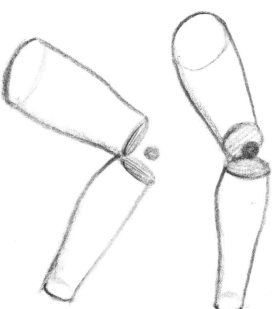

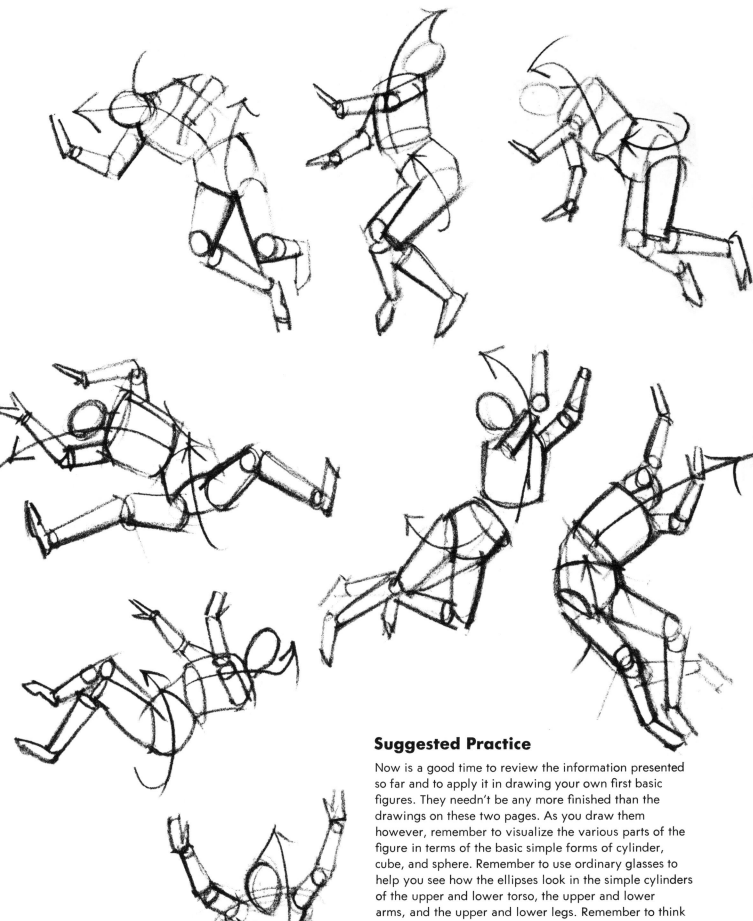

Suggested Practice

Now is a good time to review the information presented so far and to apply it in drawing your own first basic figures. They needn't be any more finished than the drawings on these two pages. As you draw them however, remember to visualize the various parts of the figure in terms of the basic simple forms of cylinder, cube, and sphere. Remember to use ordinary glasses to help you see how the ellipses look in the simple cylinders of the upper and lower torso, the upper and lower arms, and the upper and lower legs. Remember to think of the head as a simple sphere. Remember the law of balance and equilibrium. Remember to draw all these forms through to the other side. If you follow these principles, you will find it very easy to develop convincing drawings of the human figure in action.

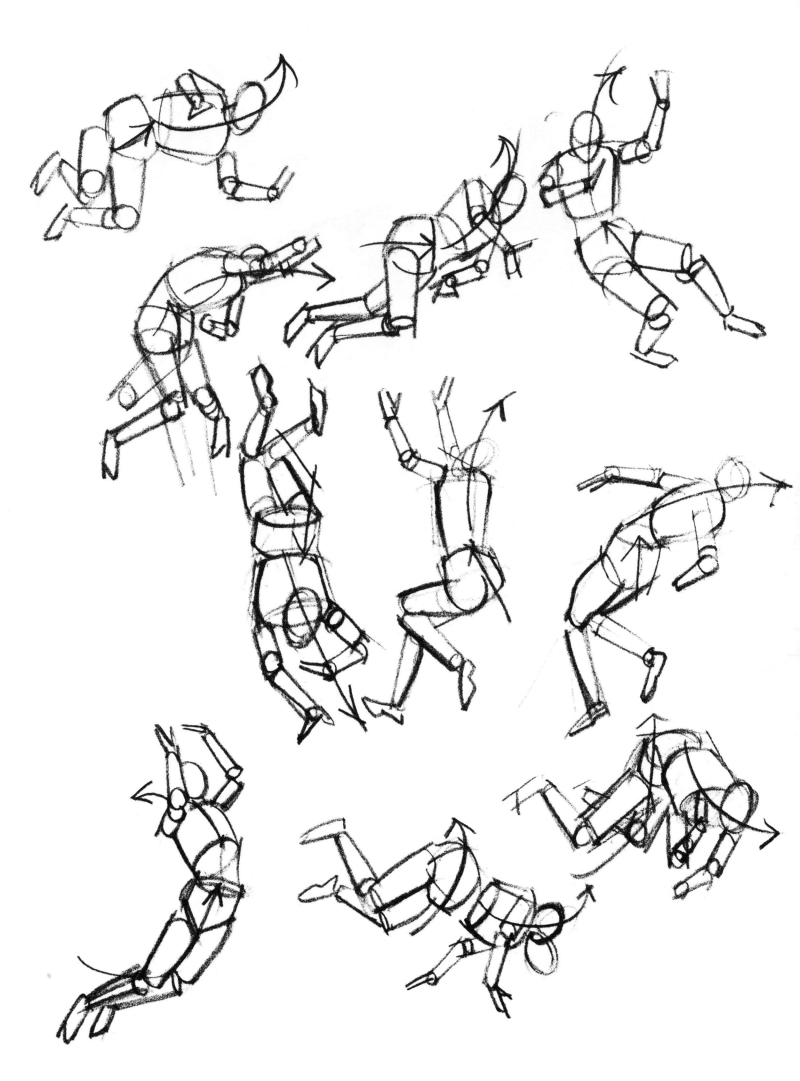

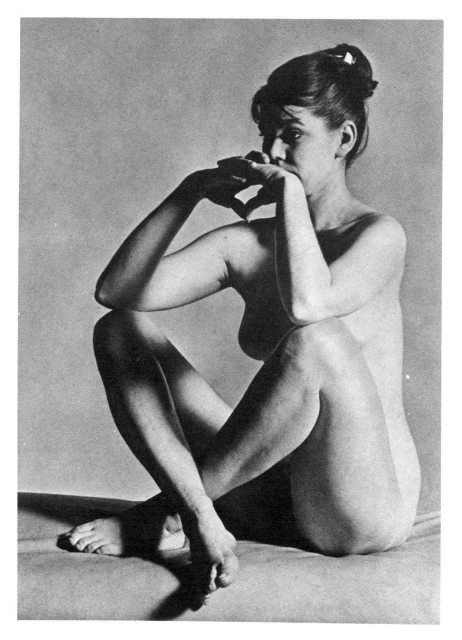

Even the most complicated poses can be reduced to the simple solid forms that make them up.

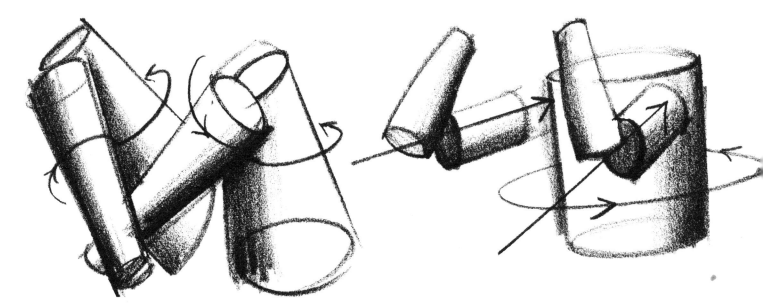

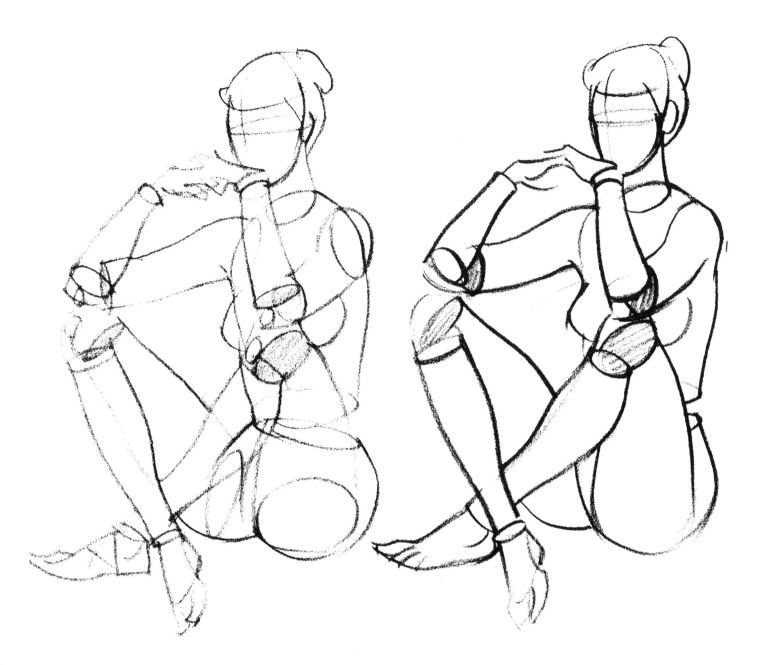

Foreshortening

When drawing from a model or a photograph, beginning with basic figure construction provides an excellent means of understanding and locating foreshortened forms or those parts of the body that are partly obscured from view.

Keeping in mind the simple three-dimensional component parts, draw the basic forms through completely, as though the figure itself were transparent like the drinking glass forms illustrated earlier.

When you are satisfied that the construction is right, it is then a simple matter to erase those "invisible" parts and strengthen those that are visible as indicated in the stages above.

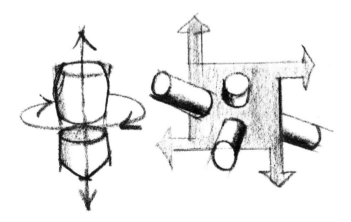

Practical uses

Although the material on the foregoing pages has been presented in a factual, impersonal way, as though we were analyzing the construction of a dressmaker's dummy, our ultimate object is to create real, breathing, living people. If you have learned to think of the basic form in simple three-dimensional cylinders, cubes, and spheres, you are now ready to take the much more exciting step of composing this form figure in action patterns. The drawings shown on these two pages are done in exactly the manner you have been studying, and very little attempt has been made even to suggest anatomical detail. But any one of these figures could be developed directly into a finished figure. The proportions and construction are correct, and the various elements are properly balanced. These figures have convincing mass and weight because each part has been drawn through in three dimensions.

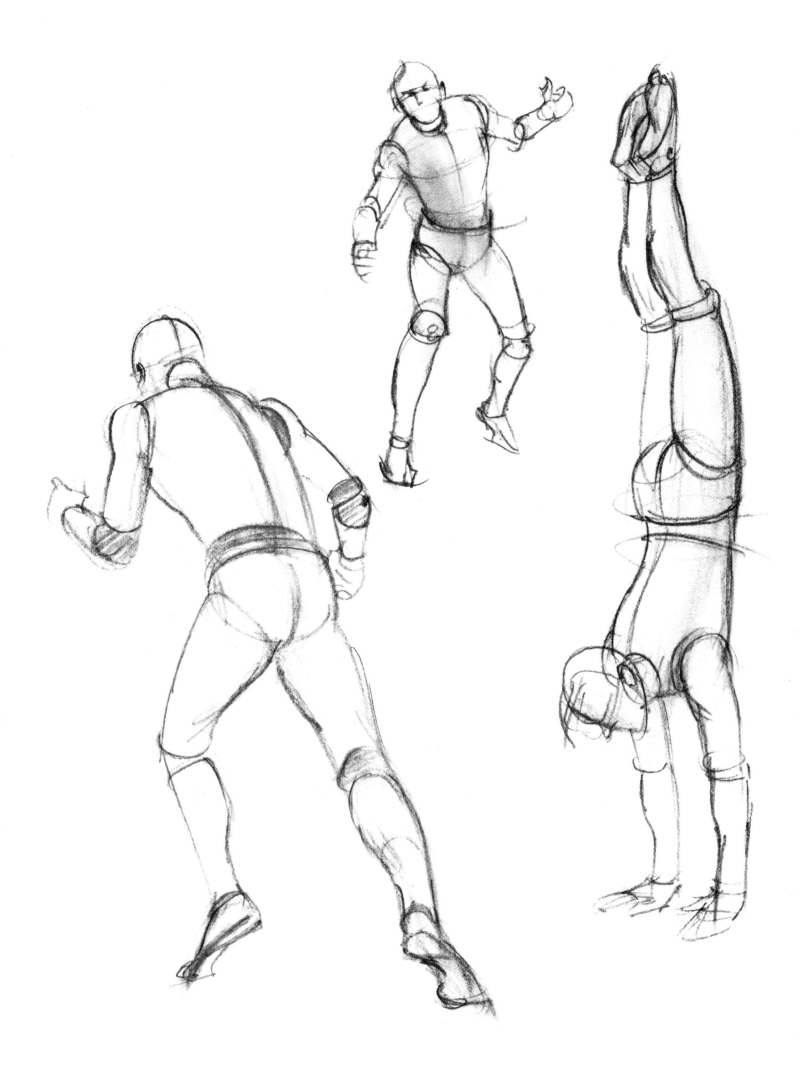

Drawing the basic form figure

The drawings on these two pages show you how to get started drawing the basic figure. The first step is to study the model or photograph from which you are about to draw. Then begin to lay in the preliminary sketch lines that indicate the size, proportions, and gesture or action of the figure. The lines don't have to be exact as you begin to draw. They are simply "starters," many of which will either be covered up or erased as the drawing develops.

Now, continuing to work freely in a relaxed, informal way, sketch in the basic forms over your first lines. Draw in pencil and don't hesitate to erase and change if necessary. It's a mistake to "freeze" or tighten up your sketch too quickly. Try to feel the action. Above all, keep the solidity of the forms in mind as you draw. This is the best way we know to create the illusion of three-dimensional figures. Do not begin to draw in clothing and other details until you're satisfied your basic figure is correct.

Whether you're drawing the male or female figure, use the same basic approach. First, sketch in the free-flowing lines that indicate the gesture. Then look for the proportions, which way the shoulders and hips tilt, and which way the head is turned. Note here the characteristic differences between the male and female figures. The female's shoulders are narrow and sloping, the hips wide. The male is broad shouldered and relatively narrower in the hips.

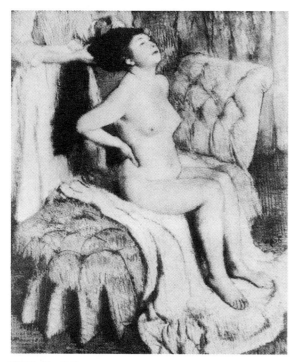

DEGAS. The Toilet

The form of the body is presented with complete naturalism. The pose seems casual yet the figure is very carefully observed and the forms, while feminine, are solidly three-dimensional.

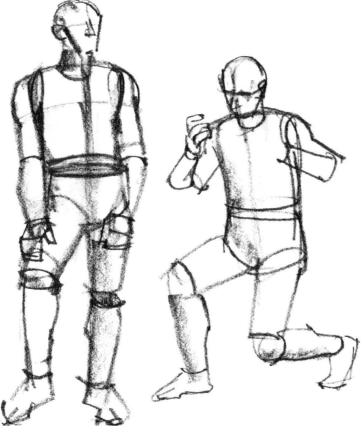

The Museum of Modern Art (Lent by the artist)

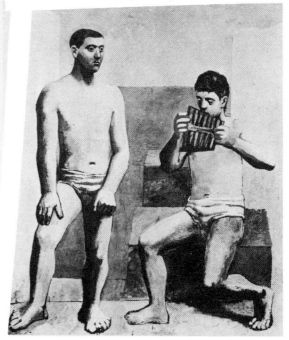

PICASSO. The Pipes of Pan

This painting might have been entitled "Composition of Masculine Forms," so thoroughly virile is the design in every way. The figures are generalized and modeled strongly to give the form maximum conviction. While the proportions are not idealized, they convey a sense of classic sculptured forms.

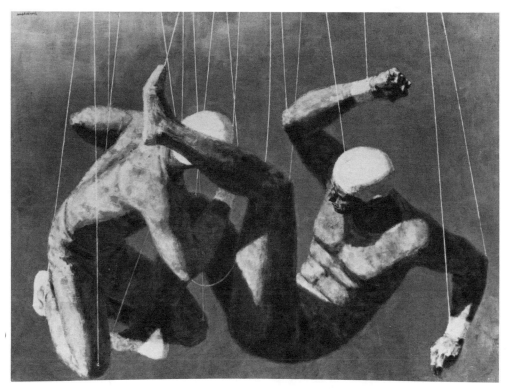

JOSEPH HIRSCH . Marionettes

Here's an exciting painting that exploits the very concept of this section on the basic form figure. These simplified figure forms have a dramatic starkness that helps to emphasize the active diagonals of straining torsos, flailing arms, anad kicking legs.

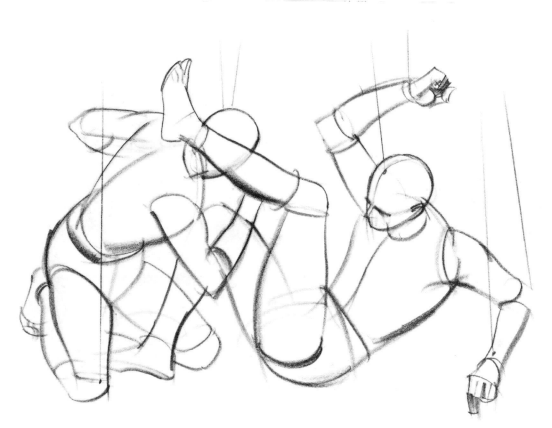

Good basic forms help make convincing pictures

The drawings on these pages represent the basic forms of the figures in these three pictures. When you make a picture with people in it, begin by drawing the underlying basic forms in this way. No matter what positions your figures are in, or whether they are clothed or unclothed, this simple procedure will be of real value. As an exercise to train yourself in working this way you may also find it helpful to study the figure illustrations of other artists and make your own diagrammatic basic figure drawings from them.

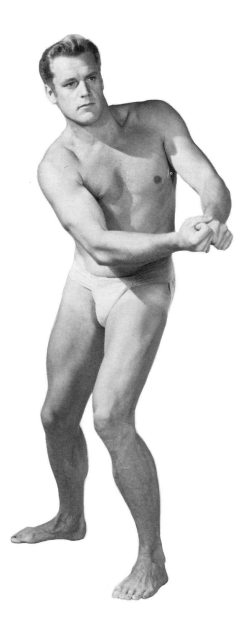

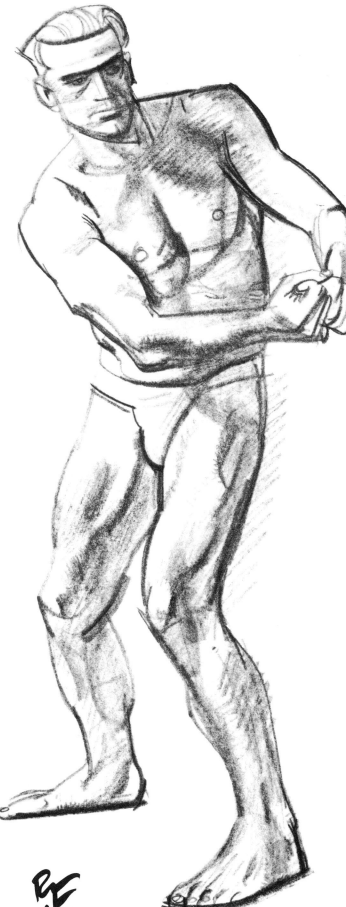

by Robert Fawcett.

Three artists draw the same figure

Each of the drawings on these pages was made by a different artist working from the figure shown above. Here are two important points which you should gain from your study of these drawings and apply to your own work:

1. Each artist has drawn the figure in his own personal way. He has used a style that is easy and natural for him.

2. Most important of all — each drawing clearly shows that the artist has thought of the figure and drawn it as though it were made up of solid three-dimensional forms.

Because the feeling for form has now become a habit with these artists, they no longer find it necessary to draw the arms, legs, torso, etc., as separate cylinders. Nevertheless, their pictures clearly show they still think of them in these terms as they draw.

To make solid, convincing figure drawings, you must concentrate on learning the basic forms of the figure which have been carefully described on the pages so far. As you gain more and more experience drawing these simple solid forms, you will naturally and unconsciously develop your own style.

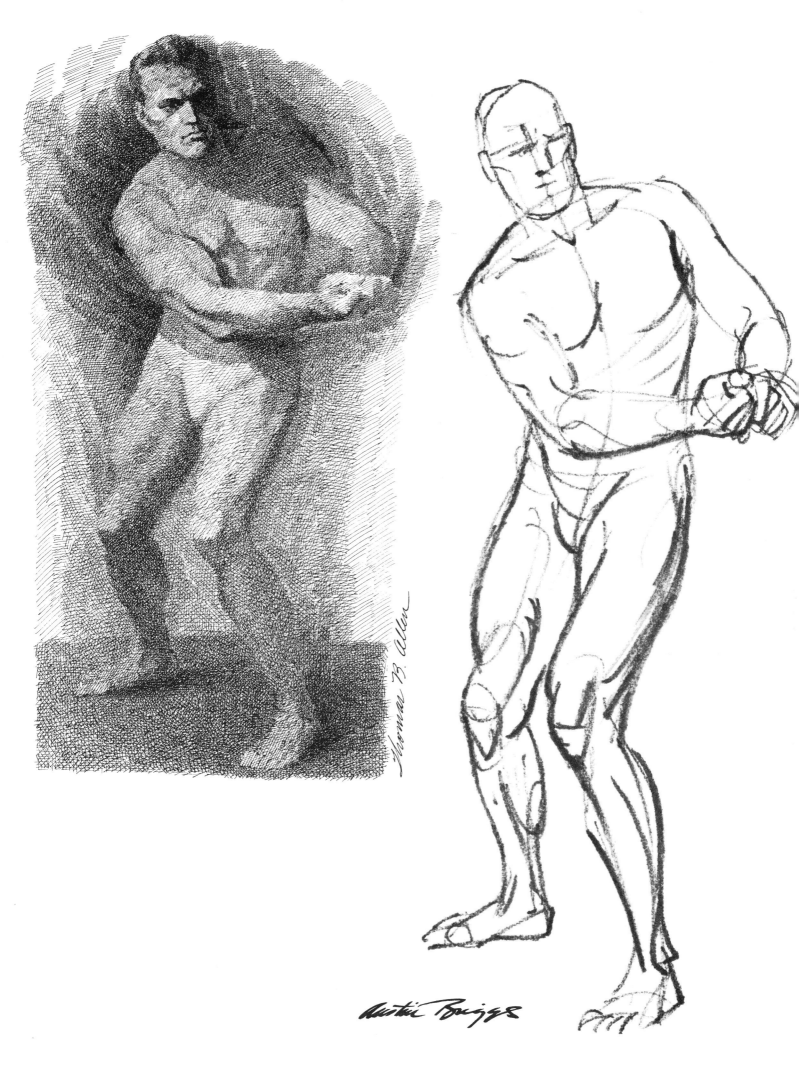

Review of terms used

You will find that the terms explained below are used frequently in this and the following chapters. Read the definitions carefully, and refer back to them from time to time if necessary.

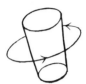

Drawing through: The glass at the left has been "drawn through to the other side"; all the structural lines can be seen. In the same way, you must sketch in all the structural lines when you are drawing a solid, opaque object, whether you can <u>actually</u> see them or not.

Three-dimensional: The square at the immediate left has only two dimensions — height and width. To make objects seem three-dimensional, you must also draw in <u>depth</u>, as shown in the three-dimensional cube at the far left.

Construction vs. outlining: An object that is "well constructed" has depth, as well as height and width. If we say that the construction of your drawing is bad, we will mean either that you have merely <u>out-lined</u> your forms, forgetting about depth, or you have made mistakes in the basic structural lines.

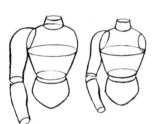

Proportions: Each separate form in the drawing at the extreme left is properly proportioned, but the different forms are not properly "related" to each other. The upper arm and the lower arm are drawn in a scale quite different from the one used in drawing the torso. Make sure that the individual forms have the right proportions; also make sure that when those forms are put together they have the proper relationship to each other, as in the drawing at the immediate left.

Modified cylinders: The cylinder at the far left is a geometric object, perfectly regular in shape and proportions. The tapered cylinder next to it is essentially the same basic cylindrical <u>form,</u> but the <u>shape</u> has been modified slightly. This is what we call a "modified cylinder."

Foreshortening: When an object is tipped toward you or away from you, it is said to be "foreshortened." It seems to diminish in size and change in shape as it goes back. In the case of the cylinder, notice that the sides become shorter and the ellipses more open as the foreshortening is increased.

Do's and don'ts

No matter how careful you are in drawing the form figure, you will sometimes find that you have made mistakes in construction or proportions without realizing it. The drawings in this section show you the most common errors. Keep these pitfalls in mind while making your drawings, and check your finished work against these pages; you may discover mistakes you had overlooked.

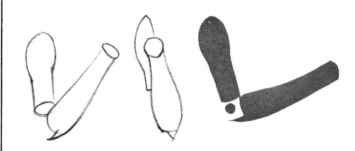

Remember to draw the figure through. Think of the individual forms as though they were transparent forms drawn within transparent glass cylinders. Then you will be able to avoid making "outline" drawings without three-dimensional solidity.

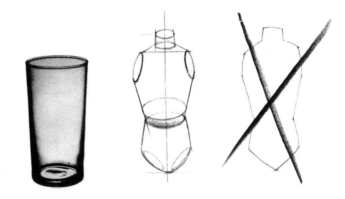

In these three drawings the lower part of the arm is much too long as compared with the upper part. This mistake is particularly easy to make when the arm is foreshortened; be careful to avoid this.

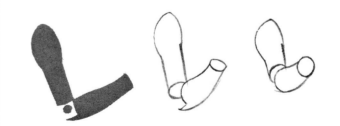

The three drawings above show you the right relationship between the upper and lower portions of the arm.

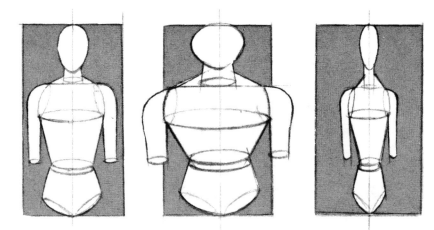

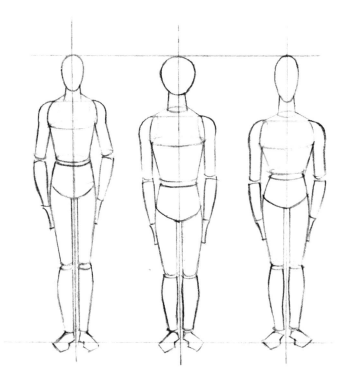

Don't get in the habit of making your figures too <u>broad</u> or too <u>narrow</u>. Remember that the head form you are using as a measuring unit must be correct in its proportions of height and width. If you use too broad or too narrow a head, as in the two drawings at the right, above, the resulting figure will probably be too broad or too narrow also. Remember particularly that the three-head measurement for the upper body includes the shoulders.

The two sides of your figure should be alike in <u>width</u> as well as in height. Make sure that you avoid the lopsided effect seen above. It is easy to check this in straight front or rear views; it is more difficult if the figure is drawn in a three-quarter view where foreshortening may be involved. Be careful to avoid this kind of distortion.

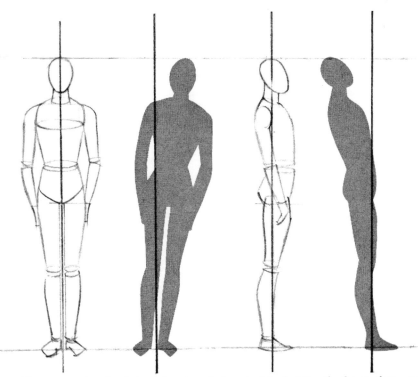

Always remember that <u>balance</u> is extremely important in depicting the figure. If you are drawing a vertical figure, like those above, establish a vertical axis and balance the figure on that axis. If the figure is drawn <u>off balance</u>, it must be supported against some other object, like a wall or a table, or it will topple over.

The two drawings at the right demonstrate what happens when the proportions of the individual parts of the body are incorrect. Notice the wrong head shapes, the long necks, the proportions of torso as compared with arms and legs. It is quite true that people in real life do not always follow the ideal proportions of the eight-head figure at the left; but remember that you are drawing <u>ideal</u> form figures now, and not attempting to make realistic copies of real-life models.

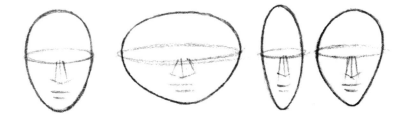

At the left you see the correct shape of the head. The width is right in relation to the height. The other three shapes are obviously incorrect. You should be careful to avoid distortions of this kind.

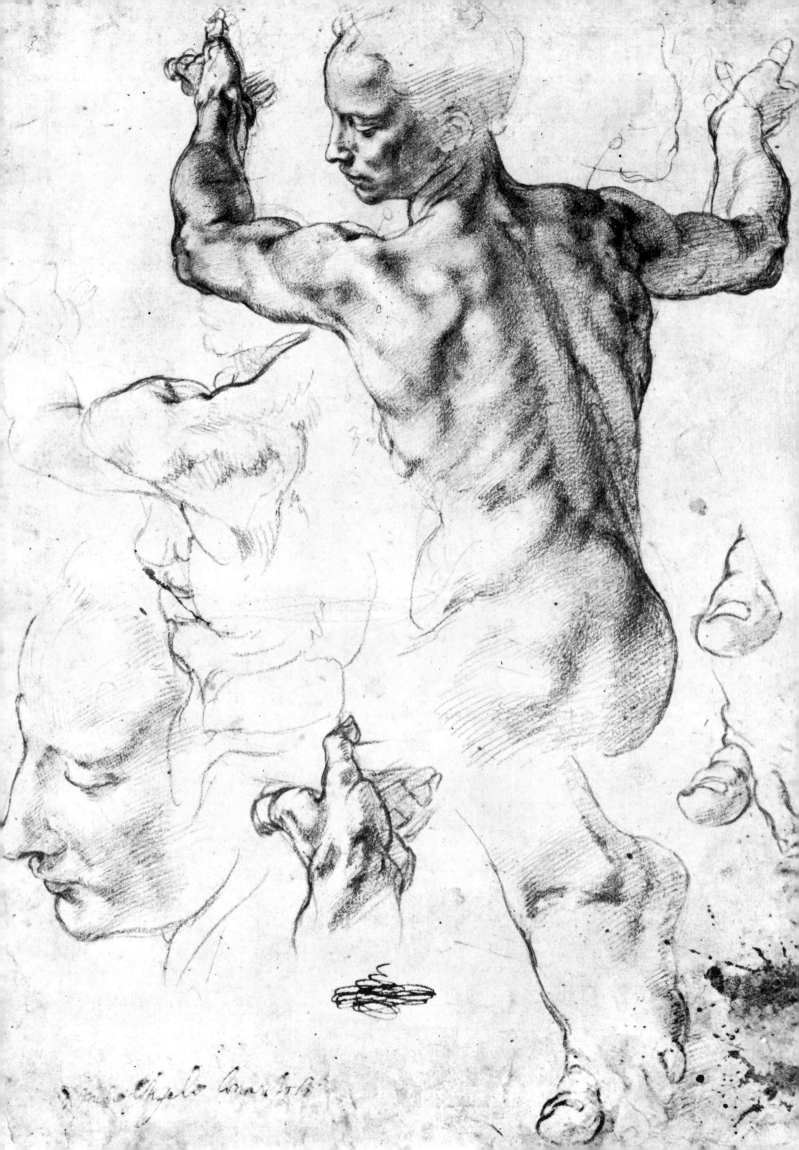

CHAPTER 2

Anatomy and Figure Drawing

The human figure is nature's most marvelous accomplishment. It has a simplicity that can be appreciated by everyone, yet its mechanism is so mysterious that without a knowledge of anatomy it is hard to understand and harder still to draw.

This is the reason that we, as artists, should learn the artistic anatomy of the figure — the knowledge we gain will help us to make convincing drawings or paintings of the human form in every position, in every action or attitude.

In this chapter we will present only the essentials of figure construction and anatomy. The art student is not the student of medicine — it is neither necessary nor desirable to learn the complete details of the functions and actions of every individual muscle, tendon and bone in the body. However, we will cover all the fundamental requirements in figure construction which are important to your training.

Bones and muscles have a distinct bearing on the outward appearance of the body and on the actions the body can perform. So, in this section, we are going to show you how the bone and muscle structure works and what it looks like in action as well as repose. As you study and draw, remember to start with the basic figure. Use the bone and muscle structure to refine and modify the simple basic figure forms — to make them more life-like. Never lose sight of the fact that your study of anatomy is a study of three-dimensional forms. These bones and muscles are not flat bands or lines beneath the skin — they are solid forms that protrude from the basic figure (like the bony kneecap or the biceps when you flex your muscle) or cut back into it (like the socket in which your eye is set).

Do not make the mistake of thinking that the more bones and muscles you put in, the more realistic your drawing will appear. Instead, spend your time in a careful study of each stage of your drawing. As you work, ask yourself: "Have I made these figure forms too simple — is my drawing nothing but another basic figure — or have I put in too much detail and destroyed all the form, ending up with a medical chart instead of a figure drawing?" The ideal, of course, lies between these extremes. One of the best ways to judge how well you

are using your knowledge of artistic anatomy is to study the examples of figure drawings and paintings by other artists and compare them with your own.

When you study the figure in action, you will observe that an amazing variety of action is disclosed in every movement, yet these movements do not in the least alter the basic construction of the figure. Many of the variations of small forms and structural details which are significant in their places are lost in the larger and basic form of some stronger action. Always remember this important fact, for with this broad point of view you will avoid many problems in drawing the figure.

Memorizing the names of the bones and muscles is not an important part of your study of anatomy. In some cases a certain amount of this is unavoidable, but most of your time and interest should be devoted to studying and drawing the forms and actions of the bones and muscles as they affect the appearance of the figure.

You will find that you can draw clothed figures much more convincingly if you know the form beneath the cloth and how it changes with different actions. You may have seen a drawing of the figure in which the clothing or drapery has been beautifully handled — but it seems to have no connection with the figure it is supposed to clothe. The reason for this is that the artist did not have enough knowledge of the figure itself before he drew the drapery, so that he could not make you "feel" the figure underneath. The forms and directions which drapery takes are almost always entirely dependent upon the structure and action of the figure underneath. Since most of the figures you will draw will be clothed, this is another reason for studying simple anatomy.

You cannot disregard the great importance of anatomy in figure drawing any more than you can build a house and disregard its foundation and the basic construction in it which holds the house together — from the inside. Anatomy is fundamental in figure drawing. It will help you to know the figure and interpret it, both from life and photographs. As you improve your knowledge of anatomy you will be able to draw better from memory, too. You will not be limited to showing the figure in just a few attitudes, but will be able to draw it skillfully and confidently in any action you wish to portray.

MICHELANGELO Studies for the Libyan Sibyl
The Metropolitan Museum of Art, Purchase, 1924, Joseph Pulitzer Bequest

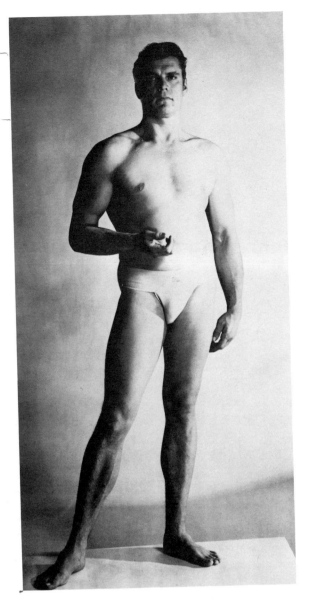

The breast bone of the male is longer and less curved.

The arms of the male are longer in proportion to the trunk. Note the position of the elbows and where the fingertips reach.

The legs of the male are longer but the male torso is generally shorter.

While the female is generally shorter than the male — to simplify comparisons we show you the figures at the same height, since the "8 heads" measure applies to the proportions of both figures.

Relative proportions of the adult figure

The figures reproduced here present the comparative proportions of adult male and female figures. While the outlines of the female figure differ greatly from the male and although the female is usually shorter, the head is in the same proportionate size to the rest of the figure. Therefore the same idealized 8-head measure can be used for both male and female figures.

Here are some of the major anatomical differences. The bones of the male are longer and they have more rough surfaces than those of the female. The "breastbone" or sternum is longer and less curved. The pelvis or "hip section" is narrower and deeper — this makes the male much narrower in the hips than the female. The distance from the pelvis to rib cage or "upper body" is shorter in the male due to the deeper and narrower pelvis. In the female, the shoulders are not as broad and the collar bones shorter and straighter: this accounts for the more sloping shoulders and the longer and more graceful neck in the female.

The male arms are longer in proportion to the trunk than those of the female due to the longer humerus or "upper arm bone" and because of this the elbow is lower. The length of the torso in the male is proportionately shorter than that of the female. The legs are longer and the skull larger. The center of the male figure is at the pubic bone (just above the crotch) while in the female it is slightly higher. The width of the female hips is about equal to the width of the chest and one arm combined, and they are wider than those of a male of the same height.

In the female, the muscles in the area of the hips are not well defined, partly because of their less vigorous use, but mainly because of a larger quantity of fat, which is especially thick over the thighs, the hips and buttocks.

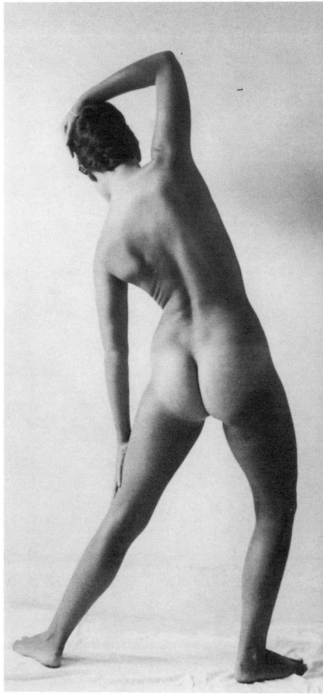

The shoulders of the female appear relatively narrow in relation to the width of the hips; while in the male the shoulders usually look wider in relation to the narrower hips.

Reproduced from *A Handbook of Anatomy for Art Students*, Oxford University Press.

If you always remember that the center of the figure is at the crotch, you can judge how many heads high the figure should be when drawn in different attitudes.

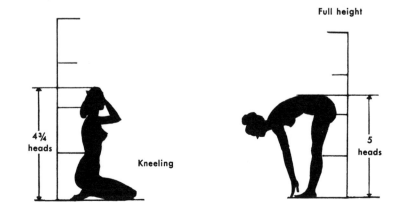

4¾ heads

Kneeling

Full height

5 heads

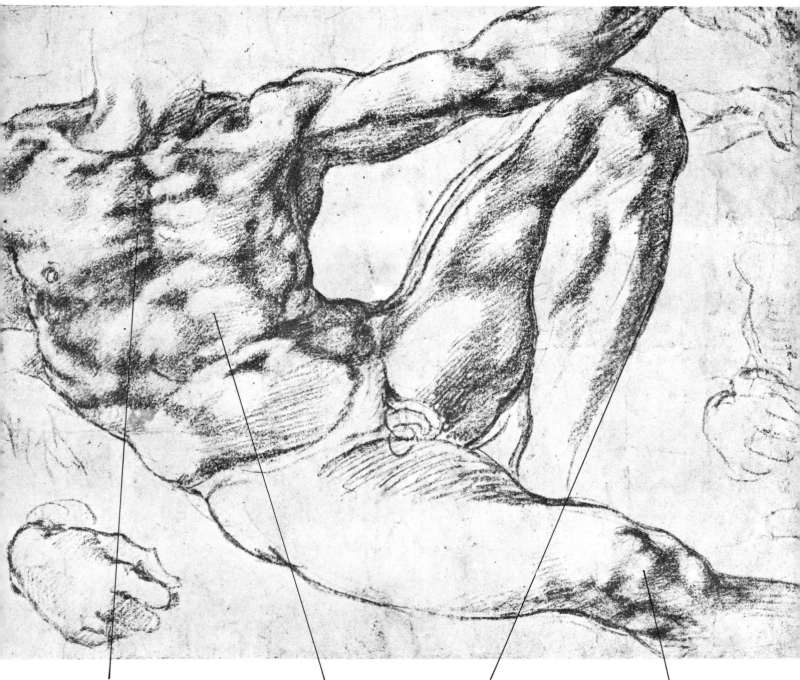

The pectoral muscles of the chest are clearly visible, as are indications of the rib cage beneath.

Below are the softer forms of the rectus abdominus muscle.

The sharp-edged shinbone lies almost exposed for its whole length. Covered only with skin, it stands out sharply here as the major break from the simple basic cylinder form of the leg.

The kneecaps (particularly in the male) stand out as bony rectangles. Note the straighter lines and harder edges separating this bony structure from the softer, rounded mass of muscle that lies above it toward the inner side of the leg.

Bones and muscles affect the surface of the figure

The figure drawings here demonstrate some of the important points to be aware of in studying anatomy and how to use them in drawing the human figure.

The artist should be aware of those parts of the body where bone determines the form, other areas where muscles create the contours, and those places covered with softer, fatty tissues.

Many students tend to overstate their new-found knowledge of anatomy. It should be obvious here that each artist has been knowledgeable about the underlying anatomy, yet has not allowed that knowledge to take over by distorting the solid figure forms.

Both female and male figures reveal their anatomical structure, but since the bones and muscles are smaller in the female their effect on the surface is more subtle. This makes it even more important to be able to recognize the underlying anatomical indications and give them appropriate emphasis.

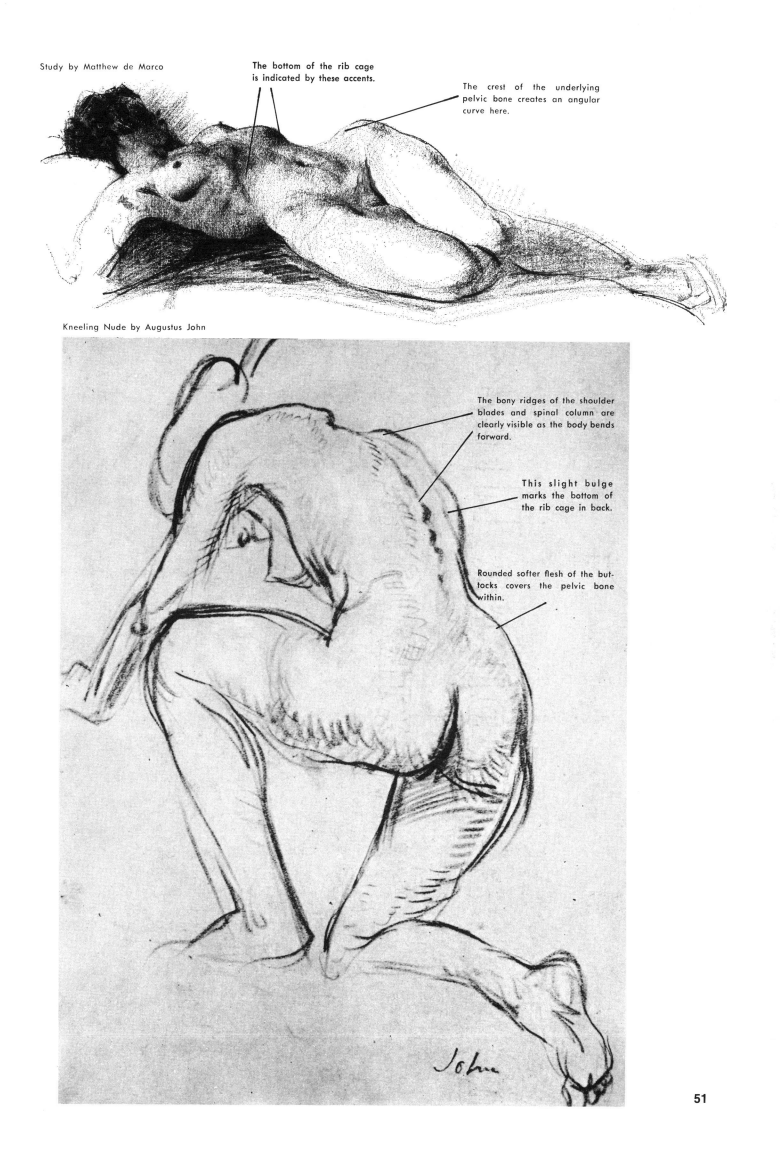

Study by Matthew de Marco

The bottom of the rib cage is indicated by these accents.

The crest of the underlying pelvic bone creates an angular curve here.

Kneeling Nude by Augustus John

The bony ridges of the shoulder blades and spinal column are clearly visible as the body bends forward.

This slight bulge marks the bottom of the rib cage in back.

Rounded softer flesh of the buttocks covers the pelvic bone within.

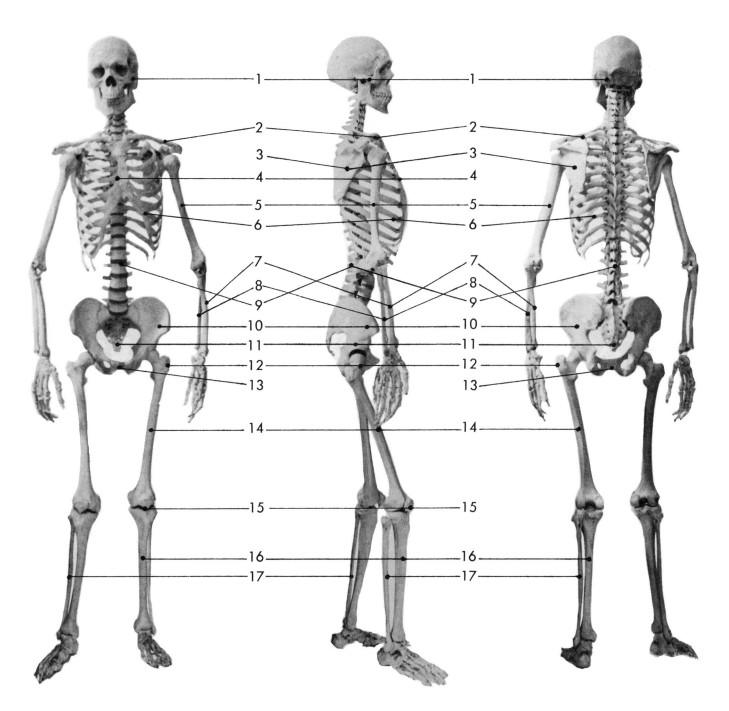

The skeleton figure as a whole

Although the skeleton is quite strong, it really is not as rigid as it appears. The spine has a rigid base in the pelvis but it has great flexibility, and the ribs, though they too are fastened to the spine, are also flexible. All the bones are held together by muscle and cartilage, and the joints operate and move on a ball and socket principle which nature has marvelously devised.

In beginning the study of the bone structure of the human figure, let us start with the head and go on down the figure explaining the basic bone structures and their functions. As we proceed, study the illustrations carefully.

The skull

The skull — a hard bone structure poised on the upper end of the spinal column — consists of two portions: the upper part, which encloses the brain, and the lower one, which protects the lower part of the face. It is so

perfectly balanced on the spinal column that it is possible to hold the head erect with very little muscular effort. All of the bones forming the skull are united and immovable with the exception of the lower jaw bone which is hinged on either side in a socket in front of each ear.

The spinal column

The spinal column or backbone is made up of a series of bones placed one on top of the other and are called the vertebrae. This spinal column is the central axis around which is grouped a system of bones which support the figure and protect the organs of the body. At the upper end of this spinal column and directly below the skull is a framework of bones called the ribs. They come around on each side and meet in front along a flat plate called the sternum or breastbone. This total structure is known as the rib cage. On the upper part of this

The principal bones of the body

1. Skull
2. Clavicle
3. Scapula
4. Sternum
5. Humerus
6. Thorax (Rib Cage)
7. Radius
8. Ulna
9. Vertebrae (Spinal Column)
10. Pelvis
11. Sacrum
12. Great Trochanter
13. Pubic Bone
14. Femur
15. Patella
16. Tibia
17. Fibula

framework is the shoulder girdle from which the arms are suspended.

Attached to the lower portion of the spinal column, and heavier in construction, is the pelvic girdle to which the legs are attached.

The spinal or vertebral column is made flexible by the fact that it is composed of separate bones, and its ability to remain erect or twist, bend and turn is made possible by a group of powerful muscles which lie behind the column and on either side of it.

An immovable wedge-shaped joint at the lower end of the spinal column connects it firmly to the pelvic girdle — it is made up of a union of five vertebrae called the sacrum. Attached to either side of the sacrum are the heavy bones of the pelvis. The rigidity of this construction allows the upper part of the body to be carried easily by the lower limbs.

The shoulder and arm bones

The shoulder girdle which connects the upper limbs to the central structure of breast and ribs consists of two bones on each side — the clavicle or collar bone and the scapula or shoulder blade. These bones are joined at either side and at a point to which is attached the top or head of the humerus or upper arm bone. The attachment to the structure of the trunk is at the upper end of the sternum. The shoulder blades do not connect directly with the trunk but function in connection with the clavicle or collar bone. The range of movement in this joint is controlled by the muscles by which it is attached to the structure of the trunk.

The rounded head of the arm bone pivots in a small, shallow socket on the shoulder blade; this differs considerably from the manner in which the deeply set head of the thigh bone sets in the socket of the pelvis. The lower portion of the arm consists of two bones of equal size. They are joined to permit free movement and both meet at the lower end of the humerus. When the arm is turned so that the palm of the hand faces out, they lie side by side and meet at the wrist, in this position the bone on the inside is known as the ulna, the bone on the outside is known as the radius.

The thigh and leg bones

The width of the pelvis separates both femurs or thigh bones which slant inward to a position where they are side by side where the knees touch (in the female this slant is more pronounced because of the wider pelvic girdle). The lower leg contains two bones, the larger one is the tibia or shin bone. Located on the outside, and slightly behind it, is the smaller bone known as the fibula. At the knee where the femur meets the tibia is a small flat bone called the patella or knee cap.

Bones of the foot

The lower ends of the two leg bones, the tibia and the fibula, project to form the ankle joints. The inside ankle joint is formed by the lower end of the tibia. The outside ankle joint which is slightly lower, is formed by the lower end of the fibula. At this point the ankle receives the astragalus or articulating joint of the foot. The foot is arched. The top is not fixed, but moves freely between the ankles bones. The rear end of the arch is reinforced by the heel, the front end by the big toe. The heel on the rear and outside of the foot and the larger toe on the front and inside give the footbones a crosswise as well as rotary movement. The footbones are all wedged together and are bound by ligaments, giving the foot solidity, resistance and movement.

Here is an important fact to keep in mind always: no bone is absolutely straight. The arms or legs drawn with perfectly straight bones would appear stiff looking and rigid. The curvature in the bones has a great deal to do with the movement and action of the figure and helps to make the figure look alive.

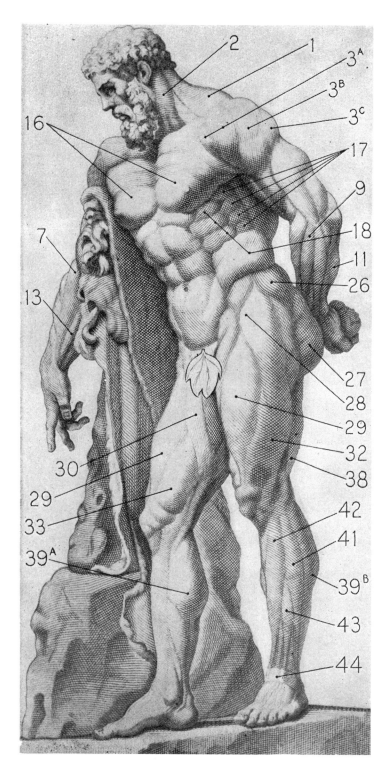

The exaggerated muscular development displayed in this heroic statue of the mythical Hercules, provides an excellent means of illustrating the major muscles that affect the surface contours of the body.

In a normal male figure, of course, the shapes of these muscles would have much less effect on its surface appearance.

The female figure has the same muscles, but they are smaller and less developed. They are also covered by a thicker layer of fatty tissue which tends to hide the muscle contours.

Certainly it will be useful to learn the names and shapes of the muscles shown on these and following pages. More important than memorizing their names, however, is learning about their functions and appearance in tensed or relaxed positions.

This knowledge will enable you to draw from a live model or photographs with much better understanding of what you see.

As the bones represent the framework and architecture of the body as well as its pressure system, so do the muscles make up its power and leverage system. In a relaxed state, they are soft and flabby — when straining, they are lifted and bulged.

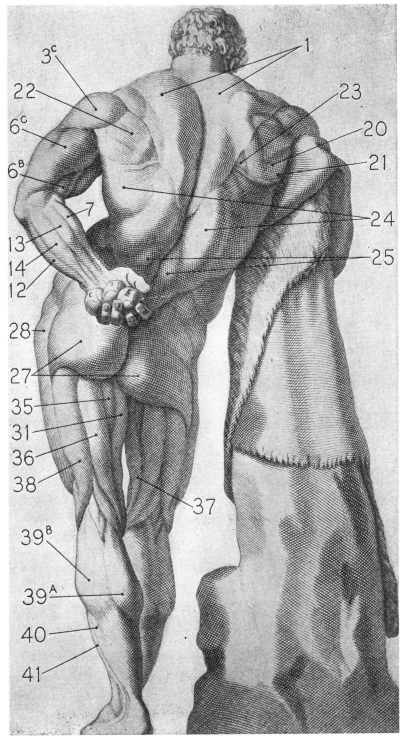

The muscles of the body

1. Trapezius
2. Sterno-mastoid
3. A.B.C. Deltoid
4. Biceps
5. Brachialis
6. A. Triceps/lateral head
6. B. Triceps/medial head
6. C. Triceps/long head
7. Brachioradialis
8. Extensor Carpi Radialis Longus
9. Extensor Carpi Radialis Brevis
10. Extensor Digitorum
11. Extensor Carpi Ulnaris
12. Flexor Carpi Ulnaris
13. Flexor Carpi Radialis
14. Polmaris Longus
15. Lunate Prominence
16. Pectoralis Major
17. Serratus Anterior
18. Externus Oblique
19. Rectus Abdominis
20. Terres minor
21. Terres major
22. Scapula (floating shoulder blade)
23. Infraspinatus
24. Latissimus Dorsi
25. Sacrospinalis
26. Gluteus Medius
27. Gluteus Maximus
28. Great Trochanter
29. Rectus Femoris
30. Sartorius
31. Semimembranosis
32. Vastus Externus
33. Vastus Internus
34. Adductor Longus
35. Adductor Magnus
36. Semitendinosis
37. Gracilis
38. Biceps Femoris
39. A. B. Gastrocnemius
40. Soleus
41. Peroneus Longus
42. Tibialis Anterior
43. Extensor digitorium Longus
44. Transverse ligament

Muscles are paired throughout the body. For every flexor (bender) on the front, there must be a corresponding extensor (extender) on the back. Or, for every muscle pulling in one direction there must be a corresponding muscle pulling in the opposite direction. Notice particularly where each muscle begins and ends.

Study of the muscles of the body is much more complicated than the study of the skeleton. We will simplify for you as much as possible this important phase of figure construction, concerning ourselves only with those muscles which have the most to do with the outward appearance and action of the body.

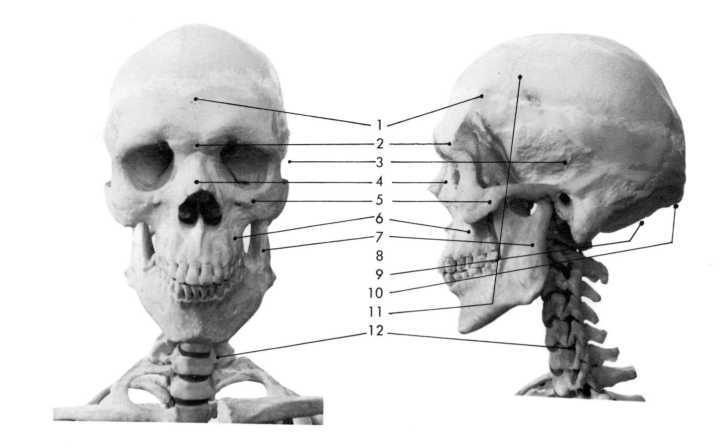

1
2
3
4
5
6
7
8
9
10
11
12

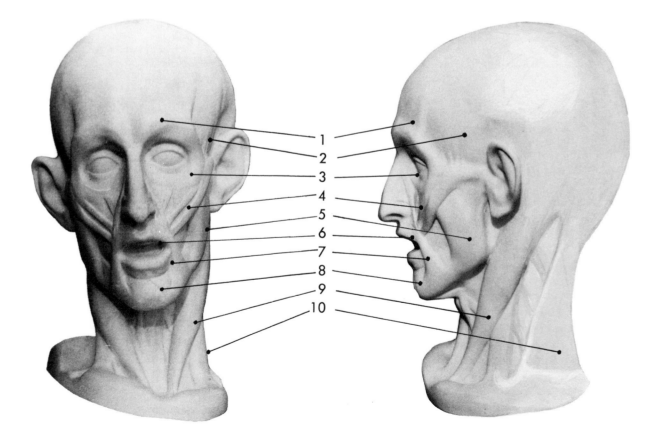

1
2
3
4
5
6
7
8
9
10

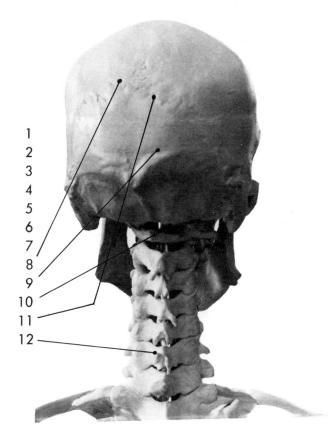

The head and neck — skull and muscles

Bones

1. Frontal Bone
2. Brow Ridge
3. Temporal Bone
4. Nasal Bone
5. Zygomatic Bone
6. Maxilla
7. Mandibula (jaw bone)
8. Parietal Bone
9. Occipital Bone
10. Occipital Protuberance
11. Cranial Sutures
12. Cervicals

Although the shapes of skulls can differ widely in height, breadth, and length in various individuals, the construction is always the same. The interlocking joints of the skull are rigid and the only moving part is the lower jaw which is hinged by powerful muscles in front of the ears. The layers of muscle and fat are relatively thin over the skull and for that reason the bone structure more directly influences the outward shape of the head than do the bones of the rest of the body.

Compensating the lack of movement in the head, the neck is capable of a great variety of movement up and down as well as in twisting and turning. Two sets of muscles are most important in affecting the shape of the neck — the sterno-mastoid, which attaches at the back of the ears and the pit of the neck, and the trapezius, supporting the back of the head.

Muscles

1. Frontalis
2. Auricular Muscles
3. Orbicularis Oculi
4. Zygomaticus
5. Masseter
6. Orbicularis Oris
7. Triangularis
8. Mentalis
9. Sterno-mastoid
10. Trapezius

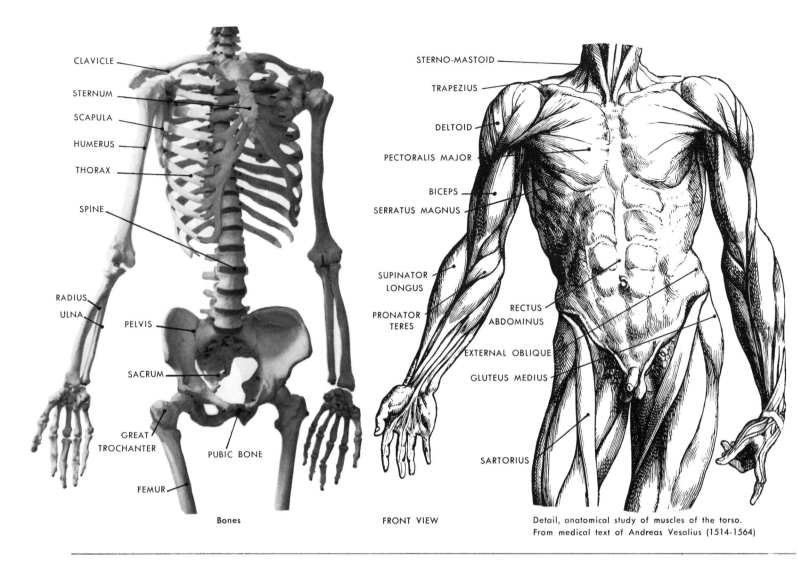

CLAVICLE

STERNUM

SCAPULA

HUMERUS

THORAX

SPINE

RADIUS

ULNA

PELVIS

SACRUM

GREAT TROCHANTER

PUBIC BONE

FEMUR

Bones

STERNO-MASTOID

TRAPEZIUS

DELTOID

PECTORALIS MAJOR

BICEPS

SERRATUS MAGNUS

SUPINATOR LONGUS

PRONATOR TERES

RECTUS ABDOMINUS

EXTERNAL OBLIQUE

GLUTEUS MEDIUS

SARTORIUS

FRONT VIEW

Detail, anatomical study of muscles of the torso.
From medical text of Andreas Vesalius (1514-1564)

The torso

The torso, from the front, is made up of three masses: the chest, the abdomen and the pelvis. The rib cage or chest is shaped like a cone with the base below. The upper portion of the rib cage appears broader than it actually is, due to the presence of the shoulders and collar bones. This, to some extent, causes the shape of the actual rib cage to be lost from view. The chest and pelvis are fairly stable; the abdominal area is quite movable. When seen in profile the three sections of the trunk are even more apparent. The upper part containing the rib cage, the central part containing the abdominal mass and the lower part which contains the pelvis. The trunk, when seen from the back, consists really of two parts: the back of the thorax (rib cage) and the loins or buttocks.

The only visible bony form in the central mass of the torso is the part of the vertebral column in the small of the back connecting the upper region to the lower one. In the lower region the bones are deep-seated and heavy, showing on the surface and affecting the external form. These points are at the crest of the pelvis, the coccyx (lowest tip of the spine) and the head of the femur (thigh bone).

The upper part of the torso is quite remarkable for its

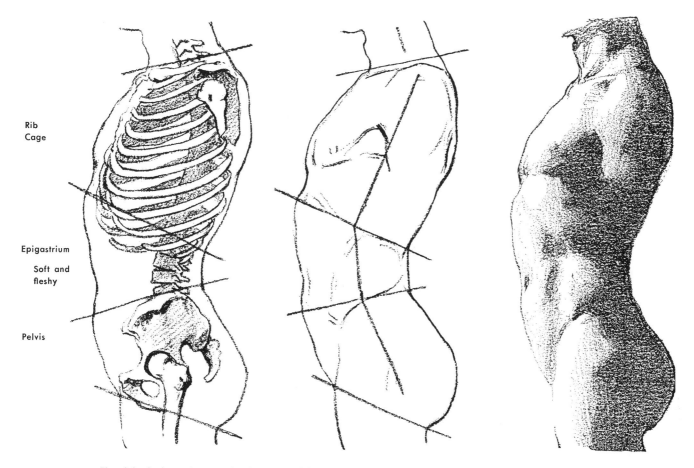

Rib
Cage

Epigastrium

Soft and
fleshy

Pelvis

The abdominal area between the chest and pelvis is fleshy and allows for considerable
movement. Study the action of the spinal column.

Drawings by J. H. Vanderpoel

bony character. The rib cage, the sternum, the scapula
(shoulder blade) and clavicles, supported by the spine,
enclose and protect the vital organs of the body. The
muscles that cover this bony form greatly influence the
planes and the effect of light and shade in constructing
the figure. The abdominal area between the chest and
the pelvic mass is fleshy, except for the spinal column.
The movement of the vertebrae of the spine is visible
along its course down the center of, and especially at the
small of, the back. The scapula (shoulder blade) slides
against the surface of the rib cage in any direction and
may be lifted from it so that it becomes quite prominent
under the skin. More than one-half the entire movement
of the shoulder is caused by the scapula.

The front of the torso is divided by a furrow that runs
vertically down the full length of the torso dividing it
evenly in two. It begins at the pit of the neck between
the clavicles (collar bones), as it passes over the breast it
marks the breast bone and is deepened here considerably
by the pectoral muscles on either side. At the end of the
rib cage it marks the area where the rib cage diverges,
this point being about one-third down the torso. The next
third down brings us to the navel, and the last third
ends at the symphysis (at about the pubic bone).

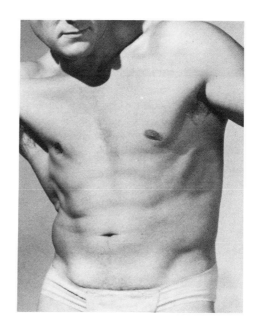

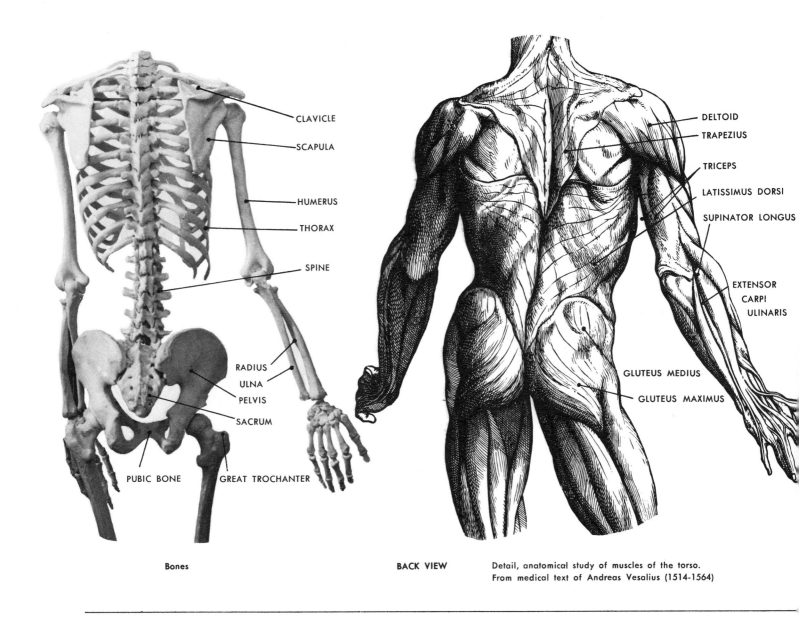

CLAVICLE
SCAPULA
HUMERUS
THORAX
SPINE
RADIUS
ULNA
PELVIS
SACRUM
PUBIC BONE
GREAT TROCHANTER

DELTOID
TRAPEZIUS
TRICEPS
LATISSIMUS DORSI
SUPINATOR LONGUS
EXTENSOR CARPI ULINARIS
GLUTEUS MEDIUS
GLUTEUS MAXIMUS

Bones

BACK VIEW

Detail, anatomical study of muscles of the torso. From medical text of Andreas Vesalius (1514-1564)

A similar vertical furrow marks the center of the back for its full length. The depth of this furrow is caused by the large mass of muscle which projects on each side of it and gradually increases in width but loses in prominence as it progresses upward. At the upper part of the buttocks the furrow gives place to a slightly depressed area, below which it again becomes the deep furrow which separates the buttocks.

The back of the torso presents many prominences and depressions. This is due to the number of thin layers of muscle which cross and recross its bony structure. The movement of the back is limited to the extent that the bony structure of the spine allows. From the rear the torso presents a great wedge with its apex pointed downward, the base of the wedge being at the shoulders. This wedge is driven in between the buttresses of the hips and from this region come all the important actions that the human body is capable of. The hip and pelvis form the points of transmission of action from the lower to the upper part of the body.

While the muscles of the chest have a great deal of effect on the form of the breast, it is the mammary gland which gives the breast its individual shape. In the male breast we find at either side and at about on a line with the lower end of the sternum (breast bone), the location points for the breast. The gland that develops this point is small, it has a definite but soft form that lies at the lower center and just at the corner where we locate the nipples.

The breast of the female is noticeably different in its character. The rib cage, being smaller in the female, gives more space between the arm and the torso proper. The mammary glands in the female are much larger and fuller; however, the mistake is often made of drawing them too large. Another mistake in drawing the breasts from a front view is in placing the nipples in the center — they are at the side and near the outline of the breasts. The female breast projects like a half-sphere that is rather conical in shape due to the nipples. The breast does not lie on the front plane of the chest but rather at the junction of the front and side planes of the torso. This causes the breasts to point slightly away from each other.

60

The back of the torso in both males and females is divided by a strong vertical furrow.

MALE FEMALE

Looking down on both the female and male breasts — the female breasts do not lie on the front plane, but at the junction of the side planes. They are rather conical in shape and point slightly away from each other.

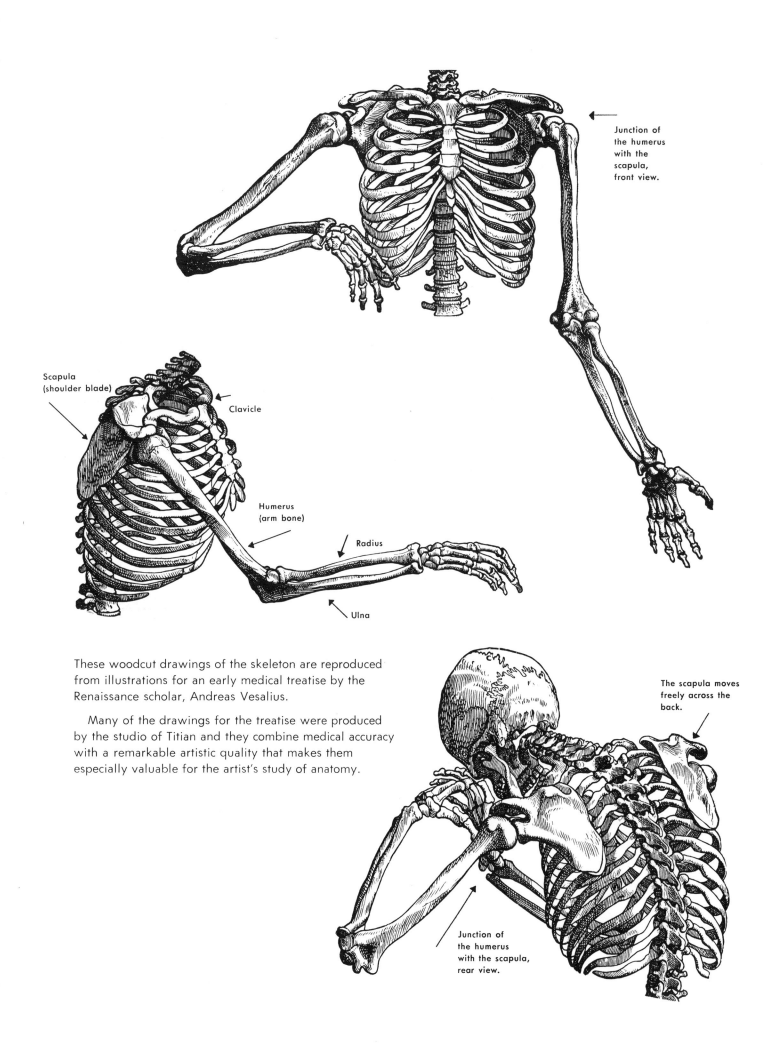

Junction of
the humerus
with the
scapula,
front view.

Scapula
(shoulder blade)

Clavicle

Humerus
(arm bone)

Radius

Ulna

These woodcut drawings of the skeleton are reproduced
from illustrations for an early medical treatise by the
Renaissance scholar, Andreas Vesalius.

Many of the drawings for the treatise were produced
by the studio of Titian and they combine medical accuracy
with a remarkable artistic quality that makes them
especially valuable for the artist's study of anatomy.

The scapula moves
freely across the
back.

Junction of
the humerus
with the scapula,
rear view.

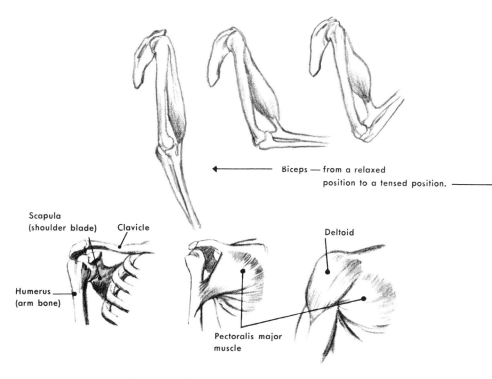

← Biceps — from a relaxed
position to a tensed position. →

Scapula
(shoulder blade) Clavicle

Deltoid

Humerus
(arm bone)

Pectoralis major
muscle

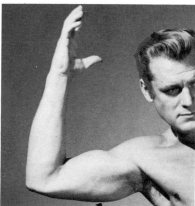

The shoulders and arms

The combination of bones and muscles that make up
the shoulder girdle is one of the most complex in the
body. Together with the action of wrist and fingers of the
hand, the possibilities of movement seem almost without
limit.

The shoulder girdle is comprised of the head of the
sternum (breast bone), the clavicles (collar bones) and the
two scapulas (shoulder blades). It is the means of
connecting the arms with the trunk. The junction of the
humerus (arm bone) with the scapula (shoulder blade),
and the scapula with the clavicle should be carefully
studied so that you can understand the planes presented
in the living model. Parts of these bones show on the sur-
face and to be drawn correctly they must be understood.

The entire length of the clavicles can be seen under
the skin and especially at the points not far from the ends
of the shoulders. There is always a small V-shaped
depression at these points which mark the separation of
the pectoral (chest muscles) from the deltoid (shoulder
muscles). The junction of the scapula and the clavicle is
also quite visible and the head of the humerus, which
forms the apex of the shoulder, can be easily felt beneath
the deltoid muscle. The extreme width across the
shoulders lies at these points.

The only connection the shoulder blades have with the
chest is through the clavicles. The clavicles are attached
to the sternum in front and have a wide range of move-
ment in all directions, including a slight rotary movement.

The base of the arm is in the shoulder girdle. Its one
bone, the humerus, is slightly curved, with its head fitting
into the cup-shaped cavity of the shoulder blade. It has
a ball and socket joint which is covered with a lubricating
capsule and is held together by strong membranes and
ligaments which cross at different angles and brace the
arm as well as allow it great freedom of movement. The
lower end terminates at the elbow in a hinge joint.

Biceps bend the
elbow.
→

Triceps straighten out the arm. ╱ Arm pit ↑

→
The scapula is
quite prominent
in muscular or
thin men.

→
The entire length of
the clavicles can be
seen under the skin.

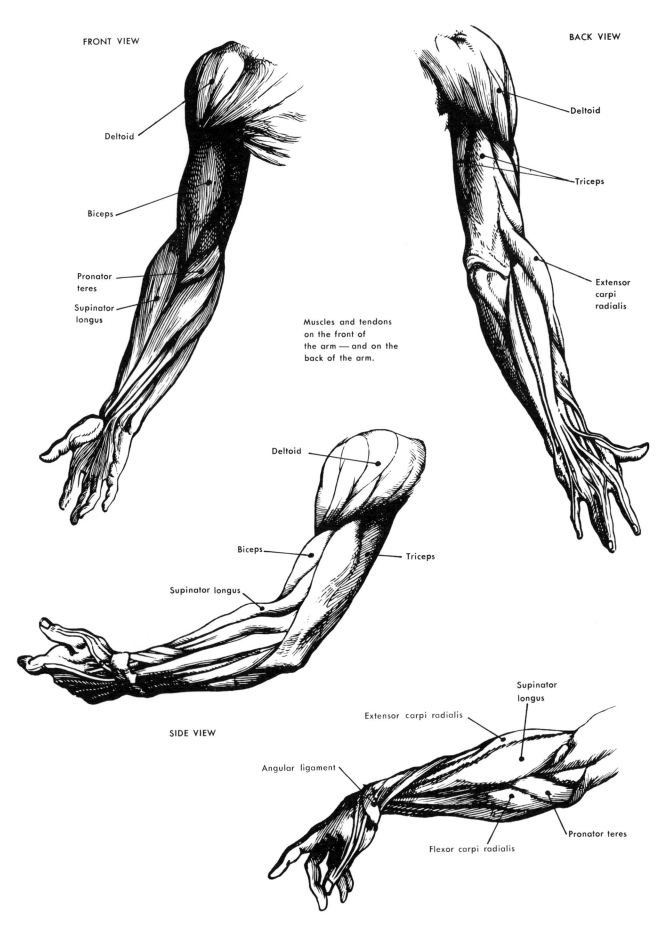

FRONT VIEW

Deltoid

Biceps

Pronator
teres

Supinator
longus

BACK VIEW

Deltoid

Triceps

Extensor
carpi
radialis

Muscles and tendons
on the front of
the arm — and on the
back of the arm.

Deltoid

Biceps

Triceps

Supinator longus

SIDE VIEW

Supinator
longus

Extensor carpi radialis

Angular ligament

Pronator teres

Flexor carpi radialis

Details, anatomical study of muscles of the torso.
From medical text of Andreas Vesalius (1514-1564)

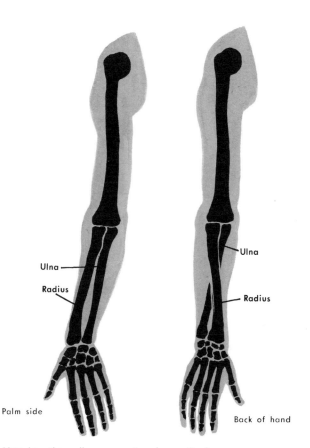

Ulna

Radius

Palm side

Ulna

Radius

Back of hand

Note how the radius crosses the ulna as the lower arm is rotated.

Six views of the arm, from prone to supine positions, as seen from the front and the back.

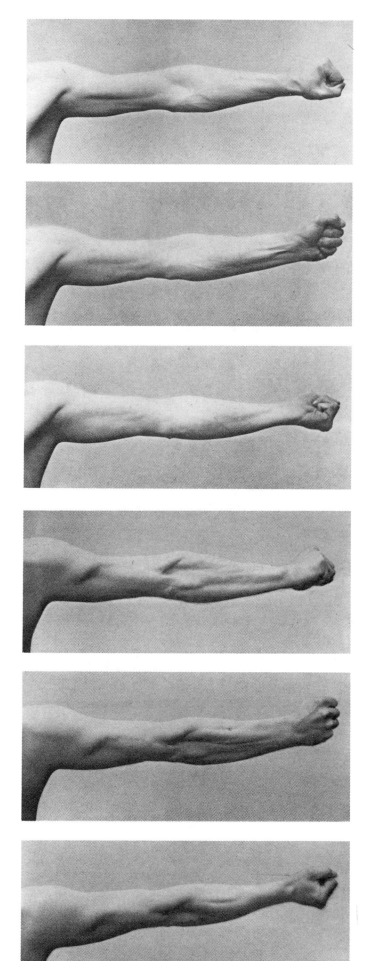

The muscles of the forearm may be divided into two groups, flexors and extensors. These operate upon the wrist and hand through tendons, which pass under the wrist band or angular ligament. The two most important muscles in the forearm are first, the supinator, the long outside muscle extending from the wrist to one-third the way up the humerus, and second, the pronator teres, a short round muscle which passes obliquely downward across the forearm from the inner condyle of the humerus to halfway down the outer border of the radius. These two muscles pull the radius with a rotary motion over the ulna and back again, carrying the thumb side of the hand toward or away from the body.

The hand does not join the arm directly, but joins the wrist which in turn attaches to the arm and is always seen as a wedge-shaped mass in any action. This wrist joint is one that is universal in its scope permitting it to move in a rotary, up and down or side to side movement. In unison with the supinator and pronator of the forearm, its range of action is almost unlimited.

From the armpit, where the arm detaches itself from the body, just opposite its greatest fullness at the deltoid, the arm gradually gets smaller in width to the elbow. This is more noticeable in profile than in the front view. The fleshy mass of the forearm near the elbow widens in excess of the breadth of the upper arm and in turn becomes narrower again at the wrist.

Reproduced from A Handbook of Anatomy for Art Students, Oxford University Press.

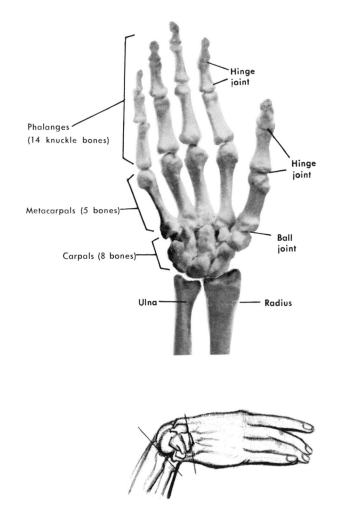

Phalanges
(14 knuckle bones)

Hinge joint

Hinge joint

Metacarpals (5 bones)

Ball joint

Carpals (8 bones)

Ulna

Radius

The carpal bones make the wrist flexible.

When hand and arm are placed flat on table, wrist slants down to hand. It does not touch table.

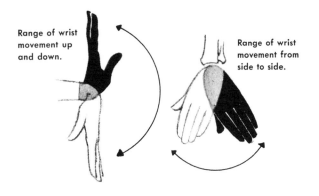

Range of wrist movement up and down.

Range of wrist movement from side to side.

The hand and wrist

The hand is composed of two masses — that of the thumb, and of the hand proper.

The double row of carpal bones of the wrist are mortised with those of the hand, making one unit. The hand always moves with the wrist. The wrist, twice as wide as it is thick, can also be called a universal joint for it is capable of a side-to-side and up-and-down as well as rotary movement. It also enters into the large movements of the arm, giving it gracefulness and power as the action of the arm is transmitted to the hand by the wrist.

Lay your arm and hand flat on a table, palm down, and notice that your wrist does not touch the table top. You will see that the mass of the wrist rises from the hand at a slight angle where it joins the arm.

The thumb side of the hand is larger than the side of the little finger. The hand is broader at the fingers than at the wrist; however, at the wrist it is deeper. You will also notice on your own hand that the palm is longer than the back of the hand.

The palm gives the appearance of a shallow bowl with square sides, and it is well cushioned on both sides near the wrist. A line across the wrist at a right angle marks the lower limit of the palm. The upper limit of the palm is also definitely marked by lines across the base of the fingers. Collectively they form a definite curve which rises highest at the base of the middle finger and then drops to cut the corner of the hand at the base of the little finger to join the curve running from this point to the wrist.

The thumb is set into the palm by an independent and a highly mobile "ball of the thumb," giving it a great range of movement, independent of the rest of the hand. With your hand held with its palm facing you directly, move you thumb in any direction. You can see it on almost every side.

In the palm of the hand most of the modeling is caused by a system of cushions and pads with which it is thickly upholstered. On the front of the thumb and

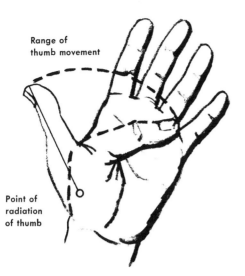

Range of thumb movement

Point of radiation of thumb

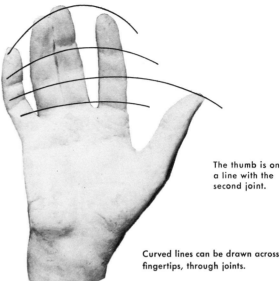

The thumb is on a line with the second joint.

Curved lines can be drawn across fingertips, through joints.

fingers, as well as a considerable area of the palm, the substance built upon the bony foundation is literally padding.

The fingers all taper, individually and as a group, with the middle finger, being the longest, forming the apex. When the hand is open, the fingers have a tendency to converge towards the middle finger. In clenching the hand, notice that the fingers ends point to a common center. The body of the thumb is heavier than the other fingers but, unlike them, only the last joint tapers.

The sections of the fingers are more square than they would seem at first glance, with the last section containing the nail being quite triangular in shape, the nail with the flesh on either side forming its base.

To draw the hand correctly, you must have a knowledge of its internal structure — the bones that make up its framework and define its proportions. Therefore, we emphasize here the anatomy of the hand for you. You will do well to memorize the anatomy of the hand and fingers for if you know the bone construction of a hand, you will never have trouble in drawing it with character and expression.

It is important to know the joints — their degree of limitation and movement. The first joint of the thumb and the first two joints of the fingers are hinge joints — that is, they move in one direction only, at right angles to the length of the fingers as when folding them toward the palm. They have no movement in a side direction at all. Fully extended, the topmost joint of each finger is bent very slightly backwards. The lower joints of the fingers and the joint of the thumb will bend forward to an acute angle, while the upper joints or finger tips cannot bend even to a right angle.

You need never be at a loss for models of hands to study. Even when drawing, you have another hand to serve in that capacity at anytime and as faithfully as you choose. The addition of a mirror in front of you in which to reflect your free hand will give you an infinite variety of poses to choose from.

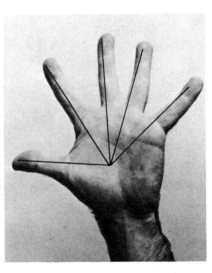

With an open hand the directions of the fingers converge to a line with the middle finger.

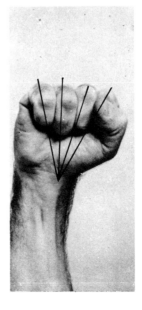

When the hand is closed the fingers also point toward center.

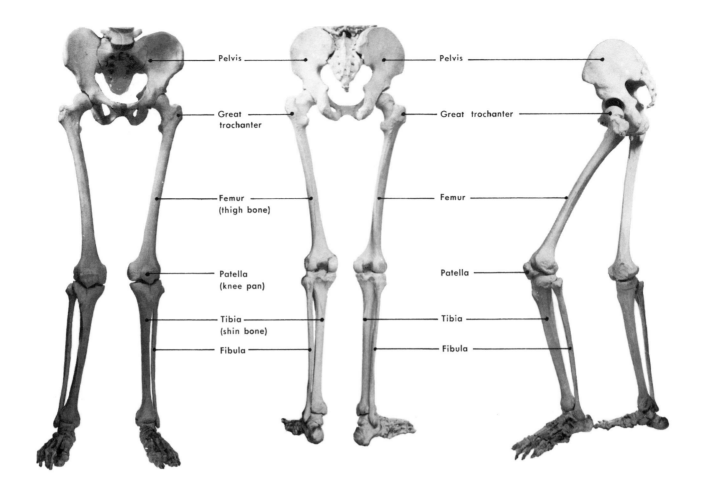

Pelvis

Great trochanter

Femur (thigh bone)

Patella (knee pan)

Tibia (shin bone)

Fibula

Pelvis

Great trochanter

Femur

Patella

Tibia

Fibula

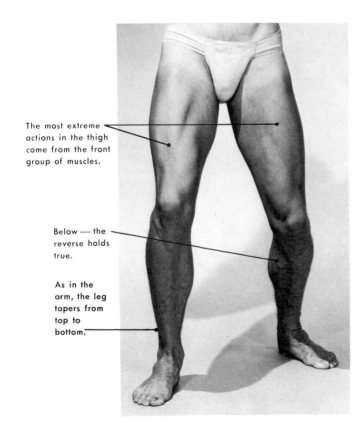

The most extreme actions in the thigh come from the front group of muscles.

Below — the reverse holds true.

As in the arm, the leg tapers from top to bottom.

The leg and foot

Like the upper limb composing the arm, forearm and hand, the lower limb, the leg, is also made up of three basic parts: the thigh, the lower leg and the foot. The thigh extends from the pelvis to the knee and the lower leg from the knee to the foot. While the cup at the shoulder blade into which the arm bone fits is shallow, the cup at the pelvis into which the femur (thigh bone) fits is deeper and more solid. This is because the lower limbs are designed not only for the locomotion of the body but also because they must carry the weight of the entire body. They must have firmness as well as action.

The femur ends at the knee in a hinged joint. The leg requires only a backward and forward motion for which this hinge is adequate. As in the arm, the entire leg tapers from top to bottom — even more so because of the especially heavy part of the thigh. However, in its tapering it resembles the arm — the heavier masses being in the thigh (upper leg) and the taper more gradual, while below the knee, as below the elbow, the leg widens again because of the thick muscles and then tapers to the ankles where the foot is joined.

68

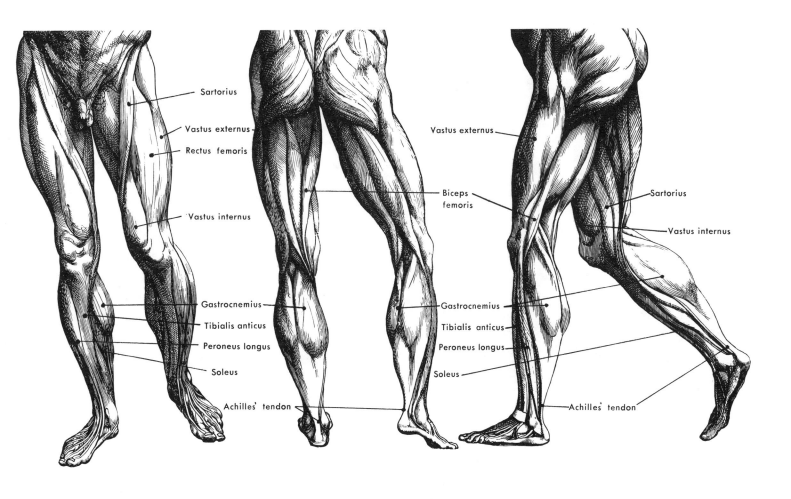

Sartorius

Vastus externus

Rectus femoris

Vastus internus

Gastrocnemius

Tibialis anticus

Peroneus longus

Soleus

Achilles' tendon

Vastus externus

Biceps femoris

Gastrocnemius

Tibialis anticus

Peroneus longus

Soleus

Achilles' tendon

Sartorius

Vastus internus

Achilles' tendon

Observe that when the leg receives the full weight of the body, the knee is pulled back and a reverse curve runs the entire length of the leg from the trunk to the ankle, the knee being the point where it reverses itself. The femur describes a curve with its convex side forward. This curve is more pronounced because of the large rectus femoris muscle in front and by the corresponding concave line at the back of the leg caused by the over-hang of the buttocks and the projecting calf below.

The planes making up the mass of the thigh are well rounded but as they approach the mass of the knee they become more defined and angular. The planes directly on each side of the knee are quite flat. When the knee is bent, the broad bony surface of the knee becomes quite prominent. From the back the hips and buttocks are quite square as they overhang the thighs. The back of the calves are convex, rounding as they enter the flat surfaces on either side of the tibia (shin bone). The shaft of the leg just above the ankle is quite round and changes into more angular surfaces at the angle and the joining of the foot.

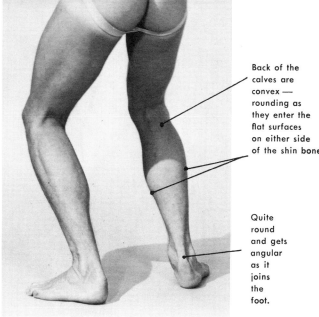

Back of the calves are convex — rounding as they enter the flat surfaces on either side of the shin bone.

Quite round and gets angular as it joins the foot.

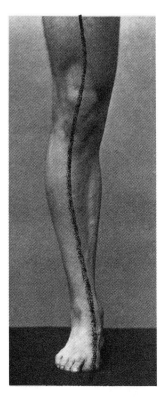

FRONT VIEW

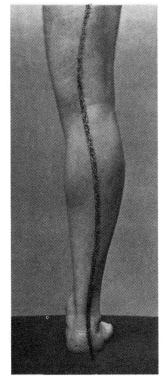

BACK VIEW

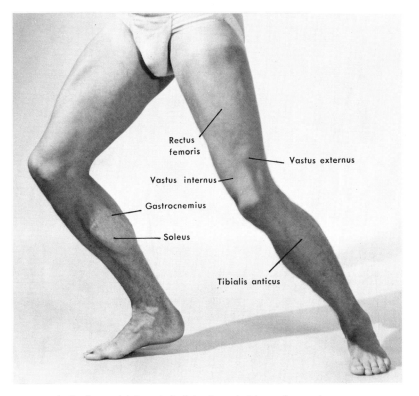

In the live model, learn to look for the underlying major muscles as they determine the surface contours.

Note the reciprocal curves of the leg, from both front and back, as well as in profile below.

LEG — SIDE VIEW

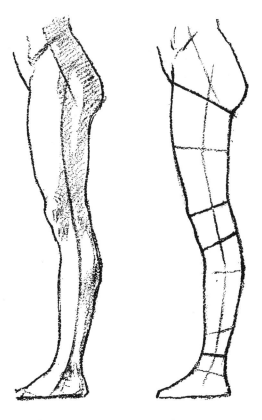

Illustrations by J. H. Vanderpoel

The leg and foot

The outside line showing the contour of the thigh is the most varied. Note in profile, the fullness of the front of the thigh for you will see that the most usual and more extreme actions in the thigh come from the front group of muscles and not from those on the back of the thigh. Below the knee, the reverse holds true. Here the joint of the ankle and the foot must be observed mainly through the angle of its attachment. The big bone enters the ankle and foot at an angle slanting from front to back and in this way throws the weight over the arch of the foot instead of on the heel.

The important muscles of the thigh, and those which most affect its outward appearance, are first, the rectus femoris, the straight muscle of the thigh bone; second, the vastus externus, the large muscle on the outside; third, the vastus internus, the large muscle on the inside. These three primarily extend the leg and are the most visible on the surface. In back of the thigh we have the biceps femoris which bends the knee and rotates the thigh outward. The most pronounced muscles on the leg below the knee, and in front are the peroneus longus which raises the outside of the foot and extends the ankle and the tibialis anticus which raises the inner side of the foot while it flexes the ankle.

Dominating the back of the leg, we find the gastrocnemius which is the calf muscle and ends below in a broad tendon which joins with the soleus muscle to form the Achilles' tendon — this is inserted into the heel bone.

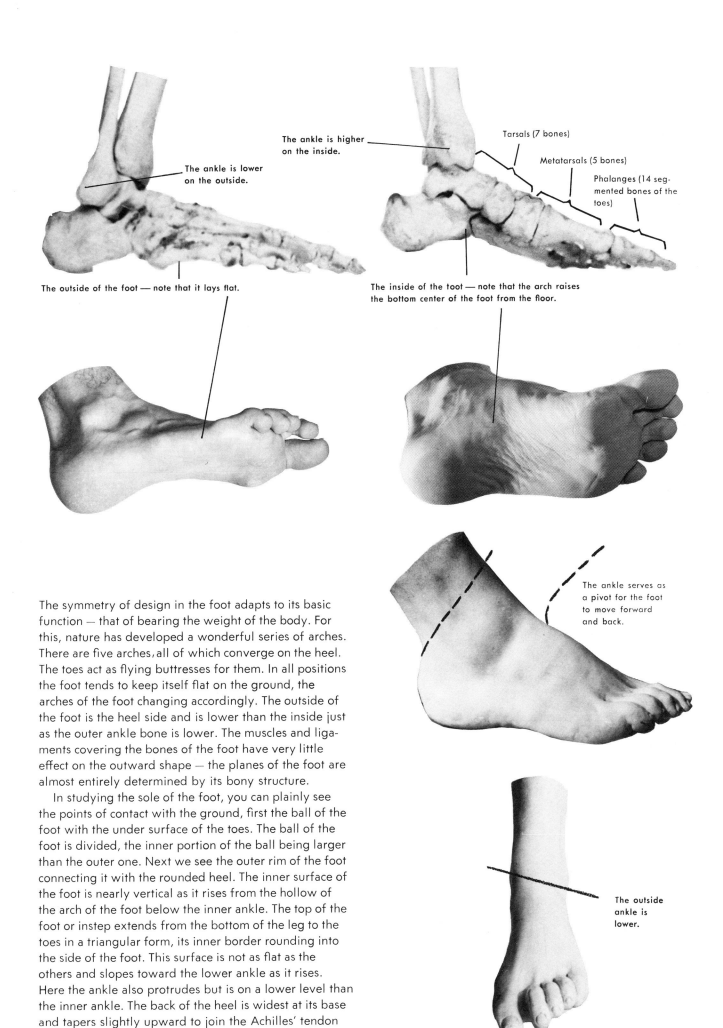

The ankle is lower
on the outside.

The ankle is higher
on the inside.

Tarsals (7 bones)

Metatarsals (5 bones)

Phalanges (14 seg-
mented bones of the
toes)

The outside of the foot — note that it lays flat.

The inside of the toot — note that the arch raises
the bottom center of the foot from the floor.

The ankle serves as
a pivot for the foot
to move forward
and back.

The outside
ankle is
lower.

The symmetry of design in the foot adapts to its basic function — that of bearing the weight of the body. For this, nature has developed a wonderful series of arches. There are five arches, all of which converge on the heel. The toes act as flying buttresses for them. In all positions the foot tends to keep itself flat on the ground, the arches of the foot changing accordingly. The outside of the foot is the heel side and is lower than the inside just as the outer ankle bone is lower. The muscles and ligaments covering the bones of the foot have very little effect on the outward shape — the planes of the foot are almost entirely determined by its bony structure.

In studying the sole of the foot, you can plainly see the points of contact with the ground, first the ball of the foot with the under surface of the toes. The ball of the foot is divided, the inner portion of the ball being larger than the outer one. Next we see the outer rim of the foot connecting it with the rounded heel. The inner surface of the foot is nearly vertical as it rises from the hollow of the arch of the foot below the inner ankle. The top of the foot or instep extends from the bottom of the leg to the toes in a triangular form, its inner border rounding into the side of the foot. This surface is not as flat as the others and slopes toward the lower ankle as it rises. Here the ankle also protrudes but is on a lower level than the inner ankle. The back of the heel is widest at its base and tapers slightly upward to join the Achilles' tendon which connects it with the leg.

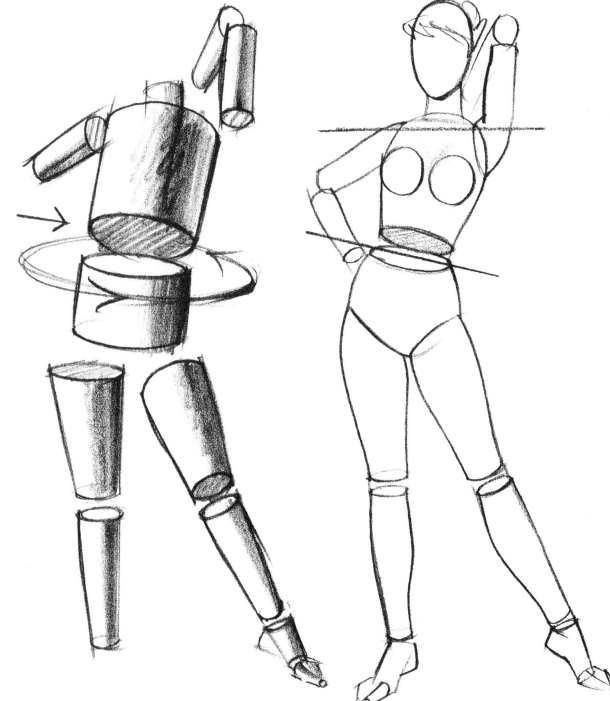

The first step is a mental one, in which the figure is conceived as a series of solid three-dimensional forms that can turn, twist, and move toward or away from the viewer.

The second step, after a careful study of the figure, is to sketch its basic forms, carefully checking the form and proportion of each against those of the other parts

Figure drawing, step by step

Now let us review what has been learned and apply it in drawing a figure. Assume that you wish to make a drawing using the girl in this photo as your model. Before beginning to draw, look the figure over carefully. Study the main lines of action, the direction of the arms, legs, and torso. This preliminary observation is a very valuable part of your whole approach to drawing the figure. When you have a good grasp of your subject, then start to draw.

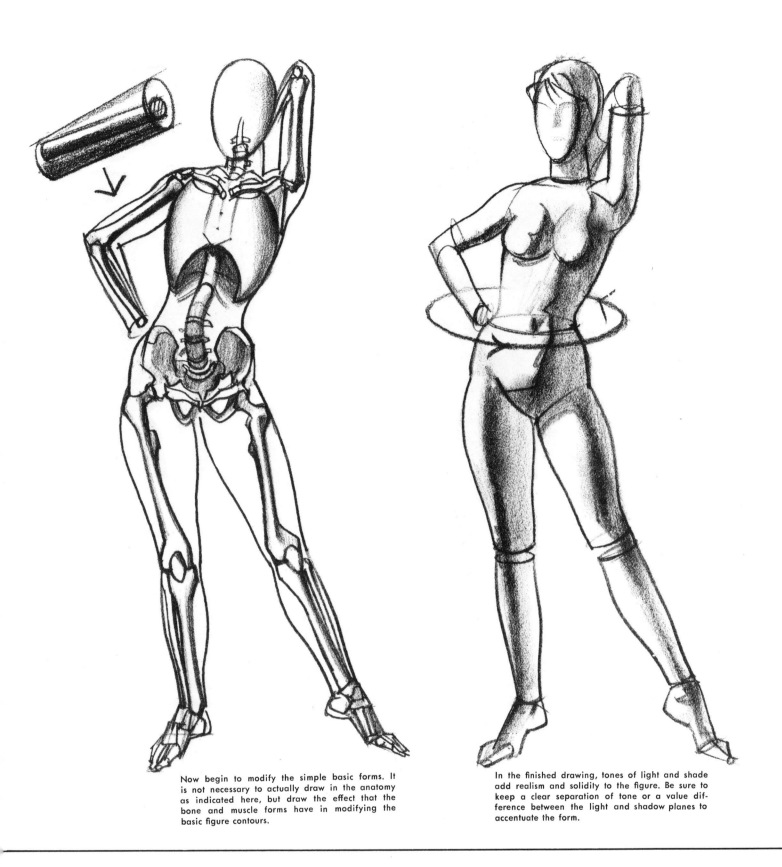

Now begin to modify the simple basic forms. It is not necessary to actually draw in the anatomy as indicated here, but draw the effect that the bone and muscle forms have in modifying the basic figure contours.

In the finished drawing, tones of light and shade add realism and solidity to the figure. Be sure to keep a clear separation of tone or a value difference between the light and shadow planes to accentuate the form.

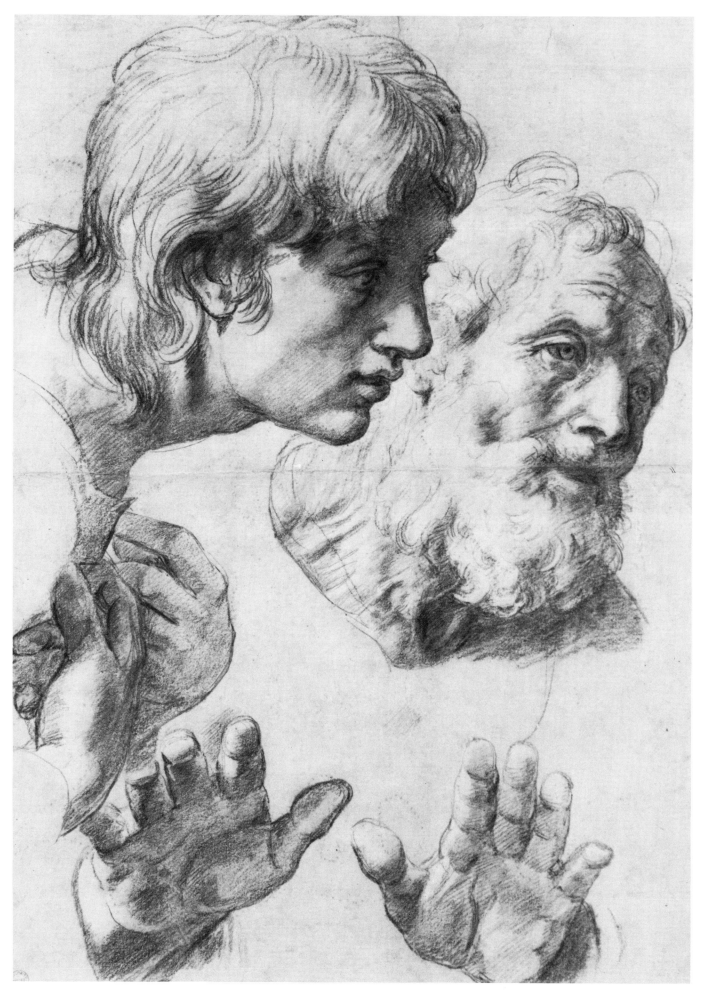

Raphael
Study for The Transfiguration
Ashmolean Museum, Oxford

Heads and Hands

Two aspects of the human figure are most important in revealing one's individuality and character: the head and, secondarily, the hands.

Almost invariably if you think of someone, you think of their face first. A person's face identifies and sets apart every single individual on earth as well as ourselves. Our own face is just as much a part of our personality as our emotions, our thoughts, our likes and our dislikes. These characteristics show plainly to others, whether we think so or not. We think of, and constantly judge, those we do or do not know by what we see in their faces and we cannot deny that in these faces we are moved by feelings of love, hatred, amusement, disgust and pity — in fact, all the emotions can be observed and felt.

The primary importance of the head is again apparent in that such important functions as the business of living begin here — the senses of seeing, hearing, tasting and the sense of smell — as well as the head being the storehouse of the brain which, of course, controls the voluntary actions in the human body.

While all faces have a great deal in common, it is easy to place them in different categories: the broad, the lean, the round, the flat, the strong, the weak, the ugly and the beautiful.

In most pictures the head is the focal point of all attention and through its attitude and expression is found the quickest means of communication. In picture making it expresses the human relationships between people — bridging the gap between the subject who has been painted and the person who views the picture.

The eyes are the most expressive feature of the face. When the eyes are closed or hidden, the most vital impact of the face is lost and most means of expression are gone. The eyes can sometimes tell, more vividly than words, our emotions and moods, and usually we can tell these emotions even against the will of the subject who does not wish us to know his feelings. The eyes can, more than any other feature of the face, betray all the emotions from hatred, contempt, indignation — to love, tragedy and joy; in fact, almost every human emotion can be seen and transmitted through the eyes.

By subtle shifts in position the eyebrows, along the upper crest of the eye socket, also play a vital role in complementing the expression of the eyes and the other features in indicating the subject's mood.

Although the nose is stationary except for the capability of a slight movement in the cartilage of the nostrils, it can be used very successfully to help portray and develop many human characteristics and types.

The ear is deceptively complex and requires a considerable amount of study and practice to draw properly. The shape of the ear varies mostly at the top and the bottom. At the top it may look like a high or shallow arch and the turning of the rim may be broad or narrow. The bottom of the ear forms a lobe or it may simply join the neck without one. The ear has often been compared to a seashell due to its whorls and convolutions.

Next to the eyes, the most expressive feature of the face is the mouth. The easiest way to consider the mouth is in repose when its normal shape can be most easily studied. The mouth in movement can denote many emotions. The lips, turned slightly upwards at the outer ends, may show good humor — when turned down they denote unhappiness or melancholy. They can denote determination or frustration, or they can signify, without words, the desire to be kissed as well as to show distaste. The mouth laughs — it cries — it shouts — it whispers — it sings. Both narrow and broad mouths can be beautiful, depending on their proportion to the rest of the face. The shape of the mouth may also decidedly show character in both men and women. The broad mouth usually denotes generosity and friendliness — the thin mouth, pettiness of nature. These assumptions are not always true, but in making pictures, they do serve to indicate character.

The chin can have a marked effect upon the character of the face. When it juts forward and is pronounced, it can give a feeling of aggressiveness and determination. When it recedes, it can denote a lack of strength. In women, the rounded chin is considered more desirable. In general, a prominent line of the jaw is more desirable in a man than in a woman.

Finally, consider the head and hands as we examine their relation to each other. Stand in front of a mirror — look at yourself. Then frown, then smile, cry, laugh, look mean, look happy, look sly, look sick. Try to act these emotions out — and feel what is happening to your hands. You find that your hands unconsciously go through the same emotions. You cannot, for example, get really mad without clenching your fists, or feel completely reposed without your hands relaxing. In a sense, these theories will apply to the drawing of the rest of the limbs. We give you this to condition your mind in its approach to drawing this — the most important phase of all art — the human equation.

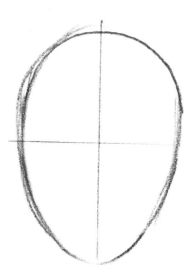

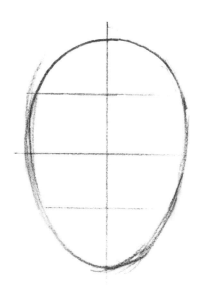

Sketch an egg-shaped oval sphere, tapered at the bottom. To locate the features on this sphere, the oval is divided into halves both vertically and horizontally.

The two horizontal halves are again divided in half, providing four equal segments of the head.

The eyes are located on the center line, the brows a quarter of the distance above the eyes. The nose and ears are placed in the dimension shown; both are the same length. The mouth is placed one-third of the distance below the nose to the chin.

Blocking in the head

In blocking in the head and planes of the face, let us first begin by observing the proportions of the head. As the oval is generally used for the basis of starting, let us divide the oval head and place all the features in their proper relationship to one another. We first divide the head into four equal parts — from the top of the head to the hairline is one-quarter the distance, the forehead is the next quarter, from the eyes to the nostrils is the next quarter — and for the last quarter we go to the point of the chin. Next draw a line down the center of the head from the top to the bottom.

We now place the eyes on the center line and on each side of the nose. The distance between the eyes should be the length of one eye. The length of the ear is about the same as the nose and is on a line with it. When the head is seen in profile, the ear is just above the middle of the neck. The bottom of the lower lip is halfway between the bottom of the nose and the chin. The top of the nose starts at the upper lid of the eye. The width of the nose at the nostrils is the width of one eye. When seen in profile, the distance from the tip of the nose to where the nostril unites with the cheek is also about the length of one eye. The distance from the chin to the throat is equal to the space between the mouth and the bottom of the chin. After a while and with practice, proportions of the head and its features will become instinctive and you will sense their right positions on the head when it is turned in perspective or in a foreshortened position.

At this point it is well to remember that "blocking in," whether it be features, planes, forms or establishing attitudes, should always be done sketchily and lightly so that when you are ready to draw the finished result, the blocking in lines can be easily erased.

It can be a useful — and illuminating — exercise to try out your first attempts at blocking in a head by selecting an eye-level photograph to use as a guide. Even a newspaper photograph will serve the purpose. Simply place the photo under a piece of tracing paper and draw the outer shape of the skull. Then block in the same proportional lines over the photo.

You may be surprised to realize how well virtually every head (barring photographic distortion) will fit these measurements and how minor and subtle are the facial characteristics that serve to identify each person as an individual. This should serve to underline the extreme importance of establishing a sound basic construction of form and proportion (or knowing it through years of practice) before making any attempt at recording details of the sitter's personality, in drawing or painting a portrait.

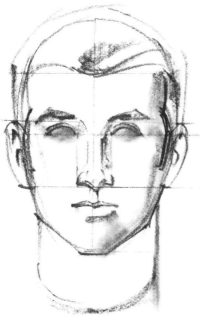 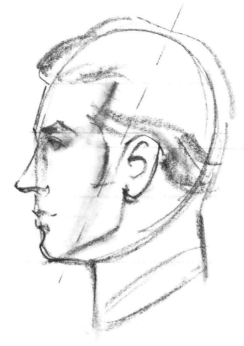 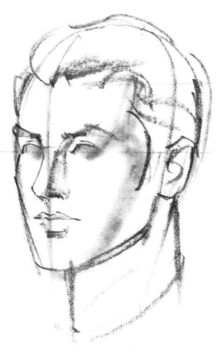

With all of the measurements established, the features can now be placed. The hairline, which of course varies considerably with age, sex, and hairstyle, occupies approximately the top quarter of the head at the brow.

In profile, the oval is tilted and the ear is placed behind the center line as shown. Otherwise, the features are located on the same parallel lines. Note how the hair grows forward over the temple.

As the head is turned, the features can be located by the same divisional lines. The line in front of the ear also establishes the line of the jaw. The center line now follows the profiled shapes of brow, nose, lips and chin as they recede or project from the head.

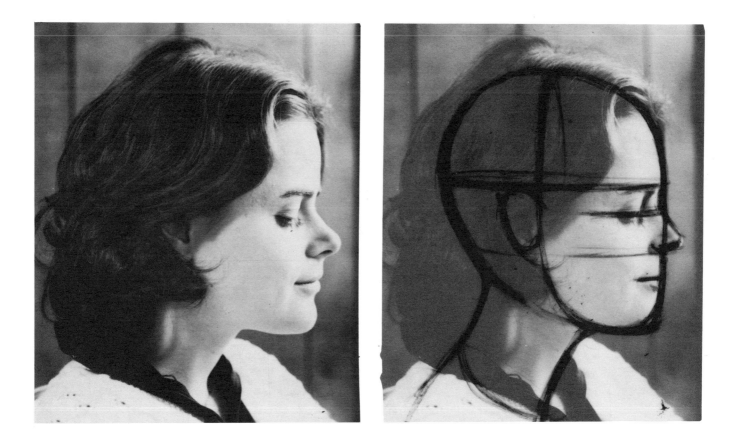

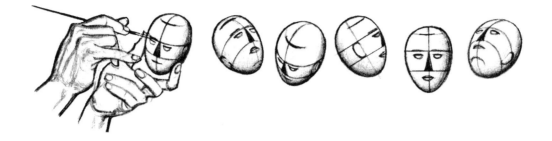

Drawing the head in different positions

We have shown how to block in the head and locate the features in a few simple views. Actually, a head is hardly ever seen in these "straight-on" views. It is usually tilted or leaned to one side or the other; it may be looking up or down or be turned in a different direction from the body. In these tilted positions it will not be possible to measure off the locations of the features the same way we did in the straight views. We will have to rely on our eye to tell us if the head is correctly drawn. The drawings on these two pages show why this is so.

In the drawings, the first thing you will notice is that the "measuring lines" become curves or ellipses as they run around the solid form of the head. A good way to study how tilting affects these lines is to draw a simple set of guide lines and features on the shell of an egg, as we demonstrate at the top of the page. By studying what happens to these guide lines as the egg is tilted and by making many sketches similar to those at the bottom of the page, you will learn to estimate the placement and direction of these various lines correctly. As you work,

remember to draw through so that you will understand what happens on the far side of the form as well as on the side which you can see. In this way you can relate the various features and planes of the head correctly.

You will notice on the drawings below that a line runs down the middle of each face. This is not the simple guide line you first put down the center of the face. It actually goes in and out over the various features, back under the chin, down the neck and onto the chest. This line helps place the features in the correct position and at the same angle as the head. It also establishes the proper depth of the nose and underpart of the chin. In actual practice it is not always necessary to draw this line, but you should at least imagine it.

At this stage, draw the neck as a simple cylinder which fits onto the upper torso. Notice that it is somewhat lower in front than in back. In your more finished drawings you will suggest the muscles and tendons of the neck — but take care not to lose the feeling of its solid cylindrical form.

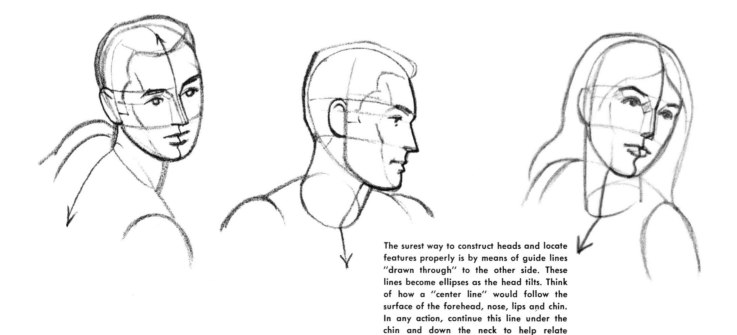

The surest way to construct heads and locate features properly is by means of guide lines "drawn through" to the other side. These lines become ellipses as the head tilts. Think of how a "center line" would follow the surface of the forehead, nose, lips and chin. In any action, continue this line under the chin and down the neck to help relate head, neck, and chest to each other.

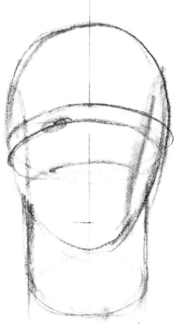 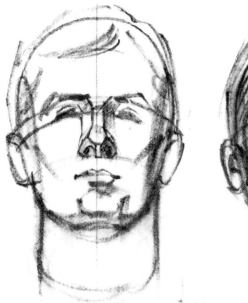 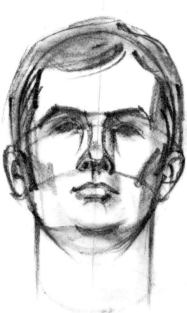

Front view, above and below
As the head is viewed from above or below eye level, the horizontal measuring lines become curved or elliptical in shape. The divisions are no longer equal, exact dimensions that can be measured with a ruler, but must be estimated by eye.

 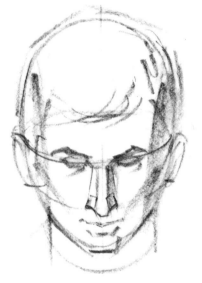 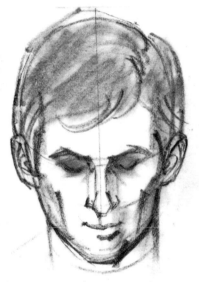

Three quarter view, below
Here the vertical center line is no longer straight, but goes in and out as the shapes of the features dictate.

 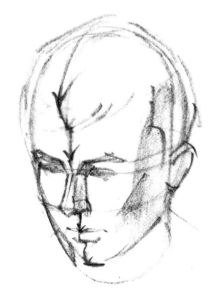 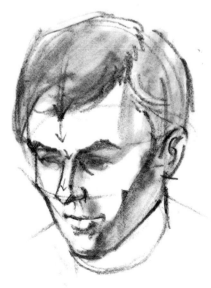

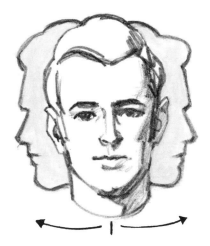

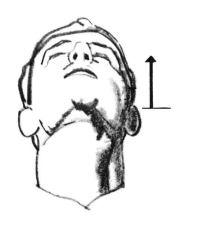

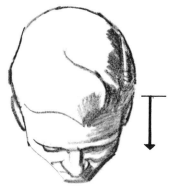

Movement of the head

The head moves in two ways; forward and backward or from side to side in a rotary movement. It is limited in its side movements to a quarter circle in either direction. Consequently we can see the head in a different view with each movement. Therefore, it is very important when drawing the head in any action, to place the ears in proper relation to the rest of the face and to establish a definite line or point as a starting point. The head, in a normal upright position, shows the nose and ears on a level. A line connecting these points gives a good fixed basis for other measurements. These parts must keep the same relation to each other no matter what the position of the head. Any movement of the head backward or forward will make the end of the nose appear to be either above or below the ear. The guiding line, when drawn through these points, ceases to be a straight line but, according to the backward or forward movement of the head, will vary in its curve. The variation of curve in these guide lines and their relation to each other is a problem of perspective or foreshortening. Foreshortening in a head is usually slight unless looked at from a point quite close to the eye of the observer. However, as you move away from the subject, the foreshortening becomes more normal.

The action of the neck is an equally important consideration in depicting the movement of the head. Almost invariably the neck bends or twists along with the head and considerably increases its mobility. While the shape of the head is basically tubular, the actions of the trapezius at the back of the neck and the sterno-mastoid muscles on the sides and front, influence its contours as the position of the head is altered.

Drawings by J. H. Vanderpoel

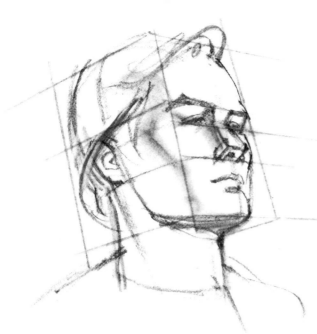

Locating the features of the head in various perspectives, starting with the basic oval shape.

In drawing the head in other than front or side views, the knowledge of perspective becomes very important because, unless the planes and features are truly related to each other in proper perspective, your entire drawing will be out of kilter. Your perspective should be secured in the first lines of your drawing.

When the head is above your eye level, you are looking up at it, and the head is in perspective. The features must all follow this upward trend or its reverse. The features must follow the mass of the head in whatever angle it is posed. Perspective must have solid shape, mass and form as its basis. A head or cube seen from directly in front will be bordered by two parallel vertical lines and two similar horizontal lines. However, the moment they are placed so that they are seen at any angle, they seem to converge. This converging causes the further side of the head or form to appear smaller than the near side.

Perspective is a complete science in itself and can be pursued at great length. For our present needs it is sufficient to remember that perspective refers to the appearance of one or more objects as influenced by the distance and position of objects from the eye itself: as objects recede from the eye, they appear smaller.

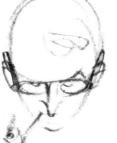

We cannot stress too much the importance of studying the action of the guide lines in establishing the proper position of the features on the head — in action and perspective.

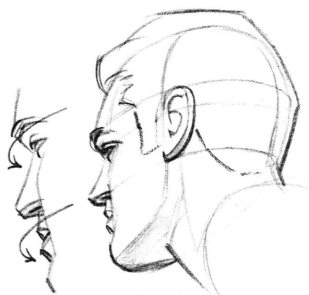

In this position the features go "around" the head and disappear.

Helpful reminders in drawing the head

Here we show you how to solve some common problems in drawing the head. In each case the solution lies in (1) deciding which way the head and features are tilted, (2) thinking of the features as solid, related forms and (3) drawing through. Notice that as the head turns away, some features overlap or hide others from view, some disappear completely.

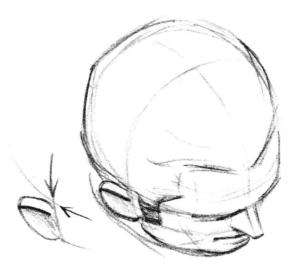

The vertical center and side lines cross at the top center of the skull. Both are crossed by the brow line as it is drawn around the head to locate the ear and nose.

The forehead hides the eyes and part of the nose, and the nose hides part of the mouth.

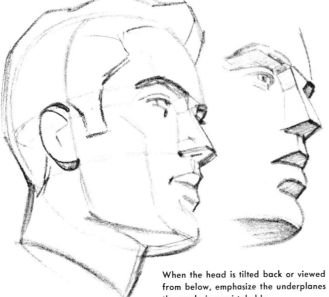

When the head is tilted back or viewed from below, emphasize the underplanes so that the angle is unmistakable. Notice how the nose hides one eye and most of the eye socket.

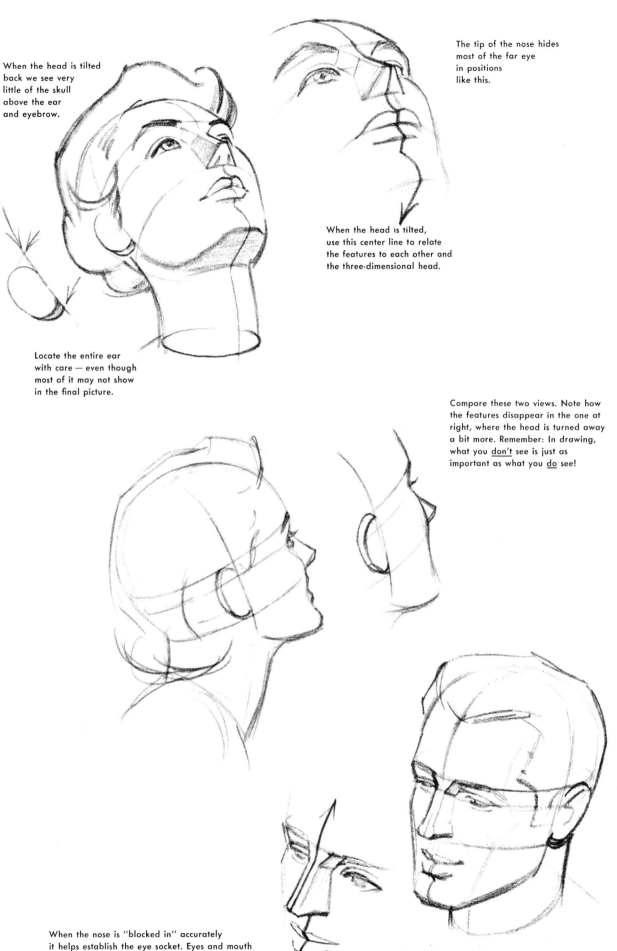

When the head is tilted back we see very little of the skull above the ear and eyebrow.

The tip of the nose hides most of the far eye in positions like this.

When the head is tilted, use this center line to relate the features to each other and the three-dimensional head.

Locate the entire ear with care — even though most of it may not show in the final picture.

Compare these two views. Note how the features disappear in the one at right, where the head is turned away a bit more. Remember: In drawing, what you don't see is just as important as what you do see!

When the nose is "blocked in" accurately it helps establish the eye socket. Eyes and mouth curve around the head.

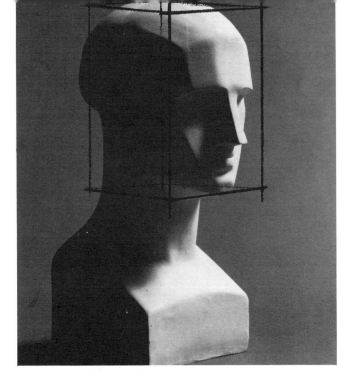

In its simplest form the head has six basic planes, like those of a box.

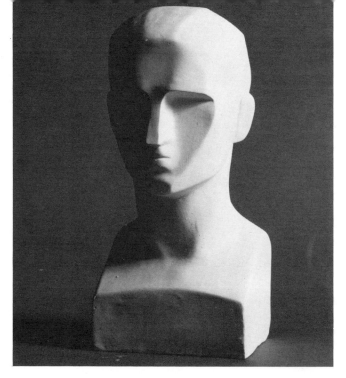

The basic planes are shaped by the contours of the skull and the features.

Planes of the head

Early in the study of drawing, you should learn to mentally appreciate all the planes that surround the head, although, from any given point of view, only certain ones will be visible. This conscious understanding of the planes will enable you to understand much more readily three essentials that will help you make a good drawing. First, the action of the head, second, its basic construction and third, the character and type of the person you are drawing.

Six basic planes compose the head, five of which are visible. They are the top, the front, the back and the sides, with the last and sixth being hidden by the entrance of the throat and neck, leaving the under surface of the jaw the only portion of this plane intact.

As seen in near-profile, the side of the head is a single large plane having small variations within it.

The artist should always keep these small facial details subordinate to the overall planes.

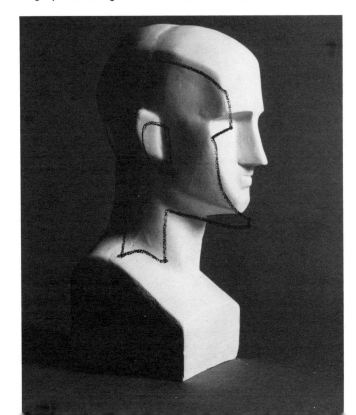

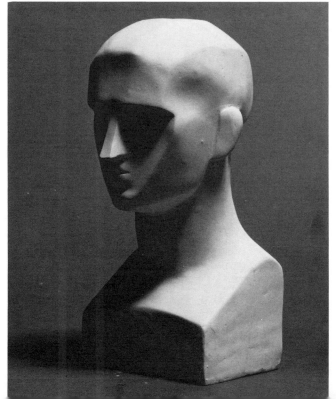

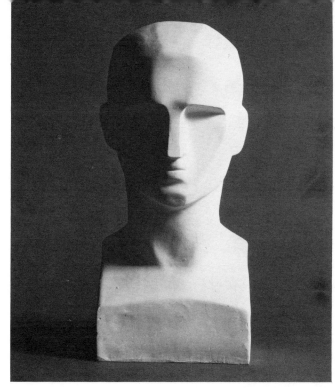

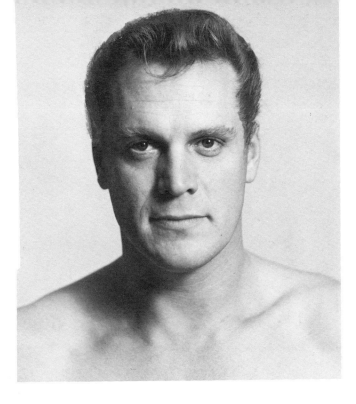

Compare this simplified cast with the photo of the model to the right. Look for these basic planes in the photo.

Following the proportions already established, let us draw a front view of a man's head from the photo above, but also basing the drawing on the knowledge of the planes of the head as indicated by the photo of the cast.

While the planes are simplified and may seem unnatural looking, they do provide a clear delineation of their basic shapes. Remember that when you look at a normal face you do not always see these planes, but they are there and it is the knowledge of them that helps you find the basic construction as you draw.

Draw many heads in different positions and angles, paying special attention to establishing the planes. This is important study.

Here the basic planes have been established and refined as they match the features of the model.

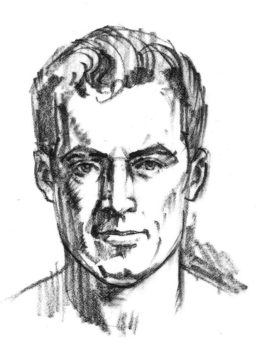

In this drawing the separation of planes was emphasized. Note how the feeling of solidity has been developed.

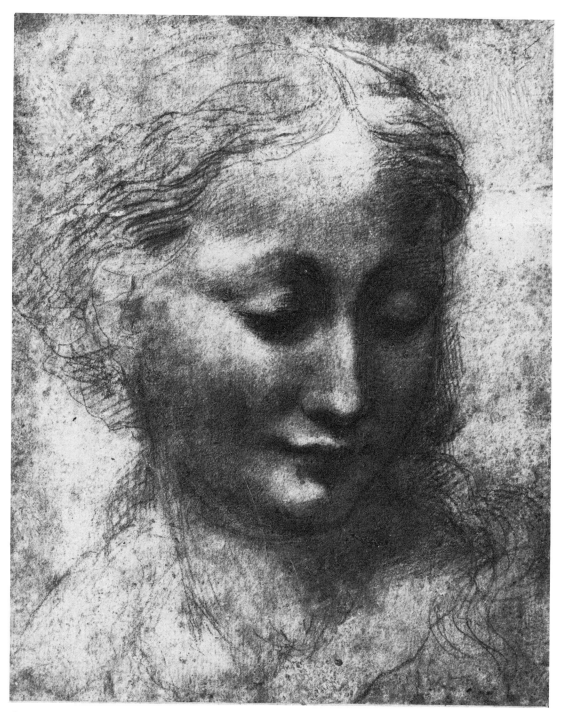

Correggio
Head of a Woman
Museum of Florence

The features

Artists through the ages have found the features of the human head to be among the most intriguing and challenging subjects to draw or paint. Other than identical twins, every individual is different. Furthermore each individual can vary his or her expressions in broad or subtle degrees. It is especially important therefore, to understand the structure of the various parts that make up these features and expressions. However, a thorough and separate knowledge of each feature of the face will be of little value without a clear understanding of the relation-ship of all the parts to the whole.

There are some parts of each feature that are externally significant and when you learn these, as reduced to a simple drawing analysis, the difficulties of drawing them together will be overcome. In studying the features, one should first become familiar with the inner structure of the various parts and in this way learn to understand its influence on the surface form. This structural knowledge will enable you to draw the features with greater assurance and skill.

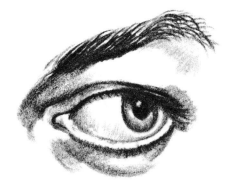

The eye

The eye socket is protected by the frontal bone of the forehead bordered by the brows. The cheekbones beneath are re-enforced and the entire bony structure surrounding the eye is designed to protect this most expressive, and yet most delicate, feature of the face. The upper lid moves over the curved eyeball. When open, the outer border follows the eye back, folding back as it does so. When closed, the upper lid of the eye is drawn smooth. The lower lid is nearly stationary and moves but little. The eye, cushioned in fat, rests in this socket. The eyeball is somewhat round in shape and its exposed portions consist of the pupil, iris, cornea and the "white of the eye." Because the cornea or "transparent covering" fits over the eye much like a watch crystal fits over a watch, making part of a smaller sphere laid over a larger one, it causes the eye to be slightly projected in front.

The lashes, which fringe the upper and lower lids from their outer margin, shade the eye, serving as delicate feelers to protect it. The upper lid instinctively closes when touched. The lower lid is stable but may be wrinkled and lifted slightly inward.

The eyes must be placed carefully within the borders that form the walls of the eye sockets. These walls slope inward and down from the forehead to the cheekbone.

The difference between the inner and outer angles of the eye is very noticeable. At the outer angle, an upward turn of the lower lid is overhung by the fold and margin of the upper lid, while at the inner angle, the lids do not unite, but are separated by a narrow U-shaped recess floored with a pinkish membrane. From this point, when the eye is open, the upper lid rises abruptly and curves over the spherical form of the eyeball to its outer angle, continuing on to the cheek. The lower lid, thinner than the upper, starts with a slight downward curve to a point slightly beyond the center of the eye and then turns sharply upward, meeting the upper lid at a right angle.

The simplest form suggesting the opening between the eyelids is the oval. For the front view, it should be narrow with blunt ends. For the three-quarter view, the shape is a long egg-shaped oval. The shape of both eyes in three-quarter views are generally similar, the only difference being that the nearer eye is longer than the farther one. Note carefully the way in which the lines of the eyelids follow the fullness of the eyeball, and also the way in which they terminate beyond it. Note also that the lines of the upper lids are about the same. The exposed portion of the eye is always moist and therefore strongly reflects the light cast on it. This forms a highlight, the position of which is determined by the direction of the light. This is a very important detail and should always be defined.

How to sketch the eye and lids

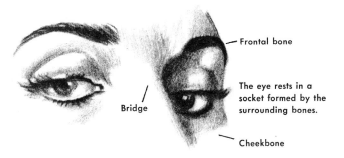

Frontal bone

The eye rests in a socket formed by the surrounding bones.

Bridge

Cheekbone

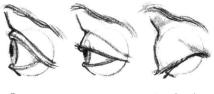

Eye open — lid folds under

Eye closed — lid is smooth

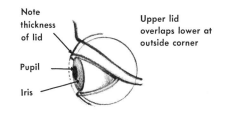

Note thickness of lid

Upper lid overlaps lower at outside corner

Pupil

Iris

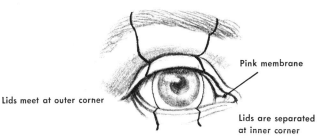

Lids meet at outer corner

Pink membrane

Lids are separated at inner corner

Dark lines show how forms go in and out

In front view, opening between lids is an oval.

Sketch lids so they follow the roundness of the eyeballs.

In three-quarter view, opening between lids is egg shaped.

Sketch lids so they "go around" far side of eyeball. Near eye is larger.

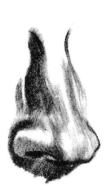

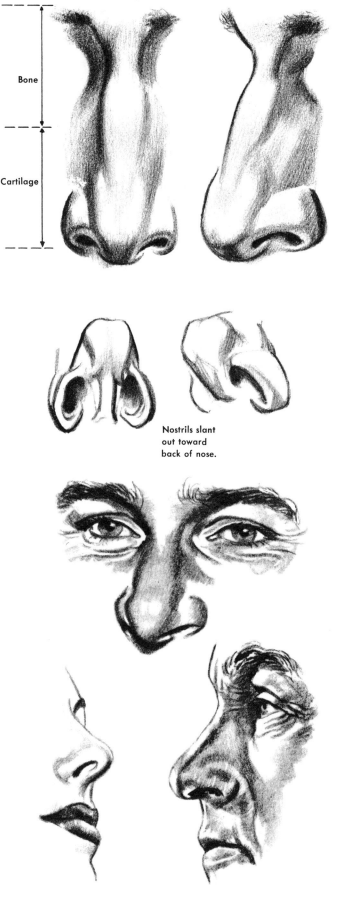

Bone

Cartilage

The nose

The nose is wedge shaped, narrow at its upper extremity and wider at its base. The upper part, reaching halfway down, consists of bone and is mortised into the forehead. The lower part is composed of five cartilages: Two upper and two lower laterals and the septum which divides the nostrils. The nose is wider at its lower end than at its attachment above and is composed of two sides: The front, and an under surface. Each of these is divided into smaller planes. The surface of the front plane leaving the root of the nose is well rounded and widens as it forms the bridge where it is flattened. Narrowing as it descends, it again becomes rounder as it wedges between the bulbs forming the tip. The front surface continues downward and under, meeting the central cartilage and forming the narrow plane of the under surface of the nose. This plane separates the two nostrils, which in turn are enclosed by the wings. The wings form the lower sides of the nose and also form the triangular shape of its under surface which is readily seen when the head is thrown back. Both the wings and the end of the nose curl up into the nostrils.

On each side of the nose the planes begin at right angles to the planes of the face and, continuing down, bulge out just above the center even with the bridge. They then sink in and form large hollows extending down to the tops of the wings. The wings emerge from the sloping roof of the nostrils slightly back of the bulb and grow rounder and thicker as they recede, turning sharply as they attach to the face. The broadest parts of the wings are attached to the face slightly higher than where they curl up into the nostrils. The character of the nose depends entirely upon its differences in form and degree of projection of the bridge. We need not tell you how many different shapes and types of noses there are.

Nostrils slant out toward back of nose.

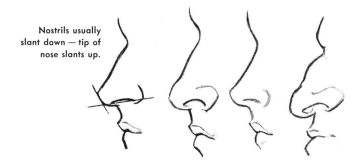

Nostrils usually slant down — tip of nose slants up.

Noses come in an endless variety of shapes. They affect the appearance of the face more than any other single feature.

While the knowledge of the construction of each individual feature is very important, the relation of each feature to the others is even more important. It is the combination of all the features that establishes character.

88

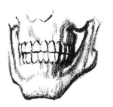

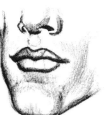

The shape of the mouth and the lips depends on the teeth.

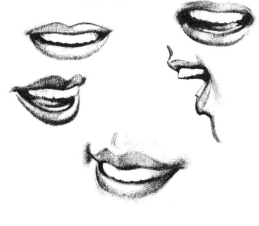

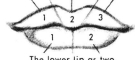

Think of the upper lip as three sections.

The lower lip as two.

The normal upper lip projects above the lower one except in specific characters.

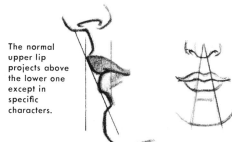

Since the usual light source is from above, the upper lip — in shadow — is normally darker than the lower lip which is lighted directly.

The mouth

The shape of the mouth and lips depends on the shape of the teeth. The more curved the teeth, the more curved the mouth. The mouth, though convex in the mass and slightly raised from the general plane of the face, expresses its convexity differently in each lip. The mucous portion of the upper lip is divided into two equal parts and is of greatest width where the two parts come together in the middle of the mouth, diminishing in thickness as they retreat with a downward curve to the depressed corners.

The planes of the upper lip are comparatively flat and angular, while those of the lower lip are very convex and rounded.

Seen in profile, the thickness of the lips, their projection and their junction with the face becomes very apparent. We can then see how far the upper lip projects beyond the lower one, and how the lower lip overhangs the chin. In a well shaped mouth in profile, the lips are on a plane sloping backward to the furrow at the top of the chin, and the corner of the mouth will be seen to be slightly below the center of the lips. When smiling or laughing, both corners of the mouth are pulled back, which causes the lips to press against the teeth. The line of the upper lip then becomes horizontal while the general form of the lower lip appears concave.

The curvature of the mouth with its depressed corners is best observed in the three-quarter view. No matter what the pose of the head, nothing is more important in the construction of the mouth than having its corners placed in true relation to its center. This assures correct drawing and symmetry. Both lips should always be considered in relation to each other and not drawn separately.

At the outer ends of the lips, a depression is caused by the convexity of the lips and the fleshy eminences around the corners of the mouth which also must be considered carefully in its modeling.

Like the eyes, the mouth is capable of great expression and movement and is the means of an infinite variety of expressions.

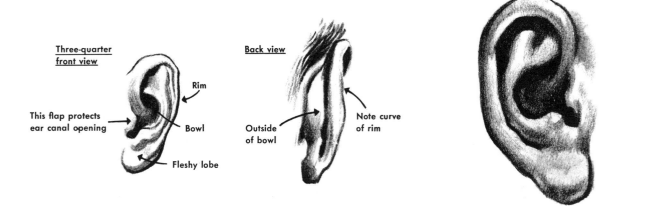

Three-quarter front view

This flap protects ear canal opening

Rim

Bowl

Fleshy lobe

Back view

Outside of bowl

Note curve of rim

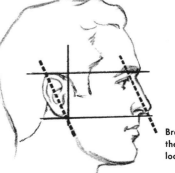

Broken lines show that ear slants the same as the nose. Solid lines locate the position of the ear.

The ear

In drawing the ear, its exact position on the head is of utmost importance. Its length is equal to that of the nose which it parallels on the head. At its widest part it is about half its own length and, if divided into three parts, the middle would be its orifice.

To understand the construction of the ear and to be able to appreciate its modeling, each part should be studied separately. The construction of the ear consists of a convoluted cartilage, having elevations and concavities requiring close study.

On the face side, the bowl or shell of the ear is protected by a small flap or raised form which shields the opening and is connected below to the cartilage that forms the immediate rim around the bowl. The lobe is the softest portion of the ear, while the cartilage that surrounds the bowl, by which it is attached to the head, is its most firm portion.

Seen from the front, the ears slant down and in and are parallel to the sloping planes of the sides of the head. The ear is usually placed close to the head and not projecting away from it — except when specific characters are being drawn.

The whorls and wrinkles making up the ear, while varying greatly, have certain definite forms. There is an outer rim often ending with a tip; an inner elevation, in front of which is the hollow of the ear. The opening to the canal is projected from behind by small flaps and in front by a larger one.

Ears normally lie on head at this angle.

The external cartilage or outer rim of the ear originates from within the bowl.

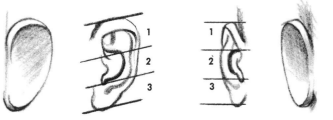

Think of the ear as a simple disk divided into three sections with the bowl in the center.

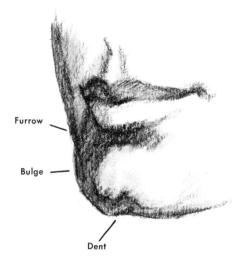

Furrow

Bulge

Dent

Nearly straight across here.

The chin

The greatest prominence of the chin lies just above its center. Its lower border is usually straight with a slight depression in the center. The form of the chin may vary greatly in each individual, in some cases being round or pointed, narrow or broad, flat and square and sometimes having a distinct dimple or furrow.

You, as the student should be untiring in your search for minute details, making many studies of all parts. Only in this way can you gain the detailed knowledge that becomes intimate and deep. It is by this knowledge that a foundation is laid which is solid and sure.

While a study of the head with its planes, forms and features provides the solid foundation on which your finished drawings can be developed and while the knowledge of them is of immeasurable help in finding the basic construction of the human face while you draw, the final answer to drawing people is to draw real people. Look around you — note all those people who help to make up your life — your family, your friends, even strangers who are a vital part of your life as an artist. Carry a sketch book with you constantly. Draw all the characters you see when riding the train, when waiting anywhere. Observe every person you see — their eyes, the shape of their nose, their mouths, the special characteristics of their faces. All humans are different in appearance and have a great deal to teach you if you will only see, observe and draw them. Make quick sketches of their basic differences in character. Your sketchbook can fit into your pocket and always be available to record what you have seen. You learn to draw — by drawing.

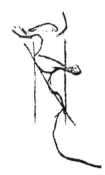

Drawings by J. H. Vanderpoel

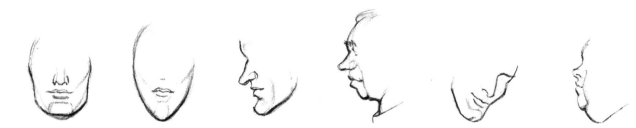

As with the nose and other features, types of chins are infinite. They often suggest a person's character.

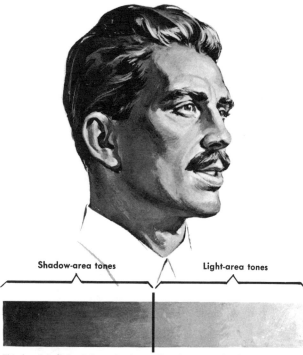

Shadow-area tones Light-area tones

This head is lighted from the front. The planes on the front of the face are in light while the side and back are in shadow. In general, the light-struck planes are painted in with values from the right portion of the scale. The shadow tones are found on the left side of the scale. Note that parts of the eye socket, nose, and lips are definitely shadow areas.

Front
Flat, frontal lighting on the head creates a minimal pattern of shadows.

Light and shade on the head

Whenever you draw or paint a head from a posed model or a photograph, you will also be confronted with the way it is lighted. In fact, as the artist you should be aware of, and control, the direction of the light source in order to bring out the effects you want.

The first rule is to keep the lighting simple. A single light source, such as the afternoon sun or a lamp on a table, is better than lighting from two or more directions which tends to confuse the forms.

With a single light source you will be readily able to determine two broad areas — those which are in light and those in shadow. Generally the edges of the light and shadow areas on the head will be determined by the planes. Within the broad light and shadow pattern will be found the graduations of tone that result from its variations in angle. And, within the shadow areas will be found a certain amount of reflected light from the surrounding setting.

However, none of the values in the light areas should be as dark as any of the tones in the shadow areas. Nor should areas of reflected light ever be as light as the darkest tones in the light area. This is a common pitfall for students. They see too much detail in the light areas of the flesh and overmodel them, using some of the darker values that should be reserved for shadow areas alone, as they paint some of the values of reflected light so light that they break up the shadow pattern.

If you will aways keep in mind the simple effect of light and shadow on an egg and relate it to the head, it will help you maintain a consistent overall pattern of light that will give your pictures solidity and conviction.

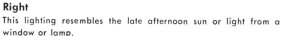

Right
This lighting resembles the late afternoon sun or light from a window or lamp.

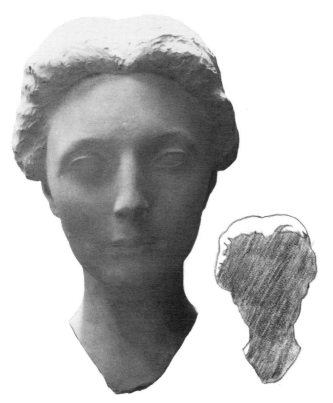

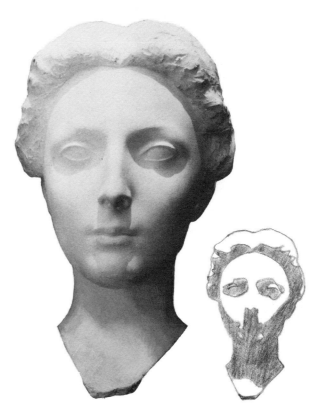

Above, back
Here the whole area of the face is in shadow.

Above
The light source from above is typical of sunlight at midday.

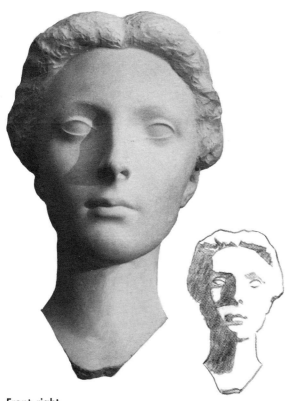

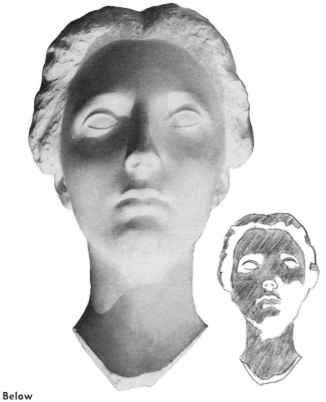

Front right
As the head is turned into the light from the side, a strong shadow is cast by the nose.

Below
Light from below is created by artificial light, its eerie effect is a favorite one for producers of mystery films.

93

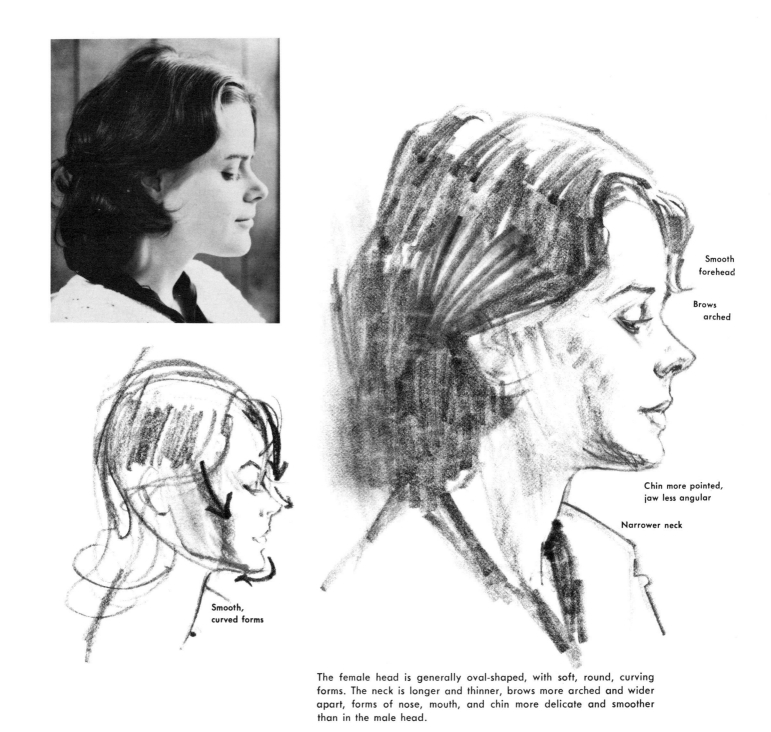

Smooth
forehead

Brows
arched

Chin more pointed,
jaw less angular

Narrower neck

Smooth,
curved forms

The female head is generally oval-shaped, with soft, round, curving forms. The neck is longer and thinner, brows more arched and wider apart, forms of nose, mouth, and chin more delicate and smoother than in the male head.

Male and female heads – differences

Considering the head as a whole, though we begin with the oval premise, it is not as smooth and rounded as a first glance seems to indicate. Instead, it has many depressions and ridges caused by the skull and affecting the surface form (as we showed you in Chapter 2). This form is also affected by the swell of the muscles under the skin. These depressions and ridges mark the planes of the head and knowledge of them is of the greatest importance in enabling you to understand the relation of modeling detailed features to the mass as a whole form.

The features of the face all have their individual structure and should be carefully studied one by one.

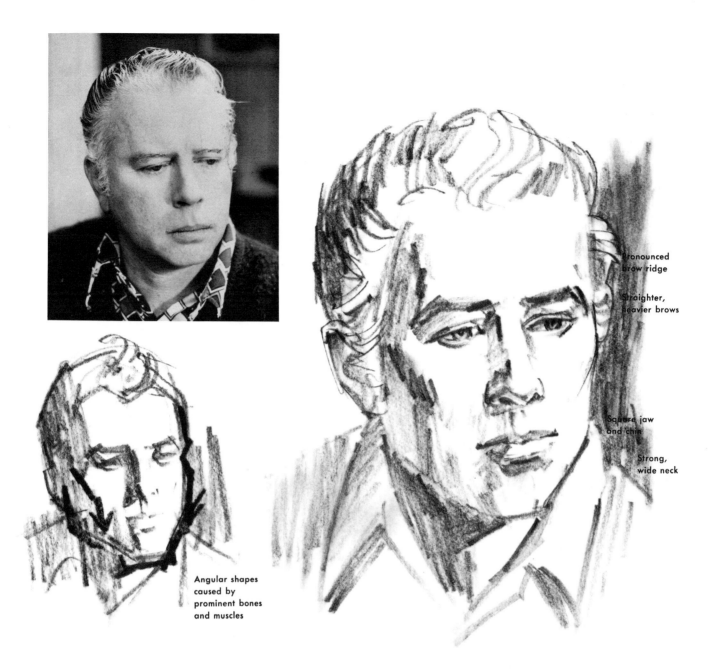

Angular shapes
caused by
prominent bones
and muscles

Pronounced
brow ridge

Straighter,
heavier brows

Square jaw
and chin

Strong,
wide neck

The male head tends to be square and angular, with a strong jaw, thicker, shorter neck, overhanging forehead, heavy brow, strong angular forms of nose, mouth and chin, with generally rugged features.

Note that in the male, the features take on a more angular appearance, while in the female, the softer oval shape to the face is distinctly feminine. This is particularly apparent in the jaw. In the male the jaw is more definitely squared, giving it an angular masculine appearance, while in the female, the jaw line tends to be soft and round.

The cheeks should also conform with the general character of the outline of the head, beginning from the bony area just in front of the ears on each side that mark the greatest fullness of the face and running down to the outside of the chin. In men, they should be more or less vertical, conforming with the outline and squareness of the jaw; in women, they should follow the oval outline of the face.

The brows also show a definite difference between male and female. Some brows are thick, some thin, some are straight and others arched, all asserting themselves differently and having their own personal characteristics. You will also note that the woman's eyebrows are usually farther apart than the man's and that they arch slightly upward; in the man, they are closer together at the top of the nose and then arch downward around the eyes.

How the head changes — from infant to teen-ager

Proportions of the infant head differ greatly from those of an adult; a baby's head is much larger in proportion to the features as well as to the body. These proportions change very rapidly at first, then more gradually as the child grows older. In addition to the relative enlargement of the features, children's heads become more angular with age, although less obviously so in females.

There is a considerable difference in the development rate of the sexes, both in appearance and in physical abilities; girls tend to mature slightly earlier than boys.

Therefore, the proportions indicated here are intended for guidance only, since there is also considerable variation in the rate of development of individual children.

It will be a valuable practice to study and draw the heads of children of all ages, as well as adults, while noting and emphasizing the special characteristics of each age group.

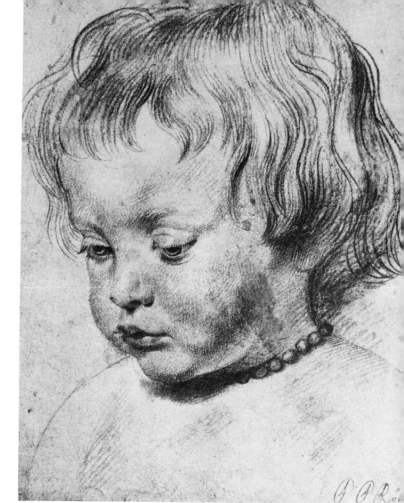

Portrait of a Little Boy
Peter Paul Rubens

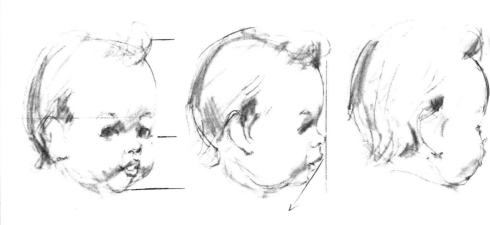

Maud Tousey Fangel

AT ONE YEAR: the head is large in proportion to the face and features, which seem enclosed by chubby, full cheeks. The chin and nose are quite small and the neck is short and fat. The eyebrows are very light. If we drew a line halfway between the top of the head and the chin, the eyes would be below it.

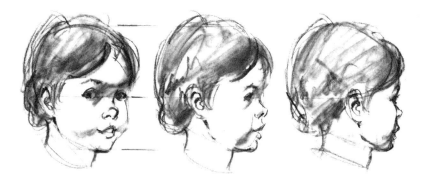

Photo by Gerry Alain Turner

AT SIX YEARS: the face is growing larger in proportion to the skull, and the chin is becoming more pronounced. The mouth and the nose show a more definite shape at this age and the neck is growing larger. The eye is only slightly below the halfway line.

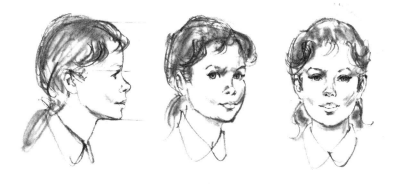

AT ELEVEN YEARS: a pronounced change has taken place. The face has lengthened, with the jaw and chin becoming quite definite. The nose has grown longer and the halfway line crosses the top of the eyes. The mouth is firmer. The neck grows longer and begins to develop.

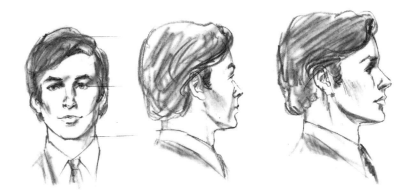

AT SEVENTEEN: we have almost an adult head with adult proportions. The eyes, lips, nose and chin have developed practically to their full size and now begin to look mature. The jaw and cheekbones have become much more prominent, neck construction more pronounced. The eyes are on the halfway line.

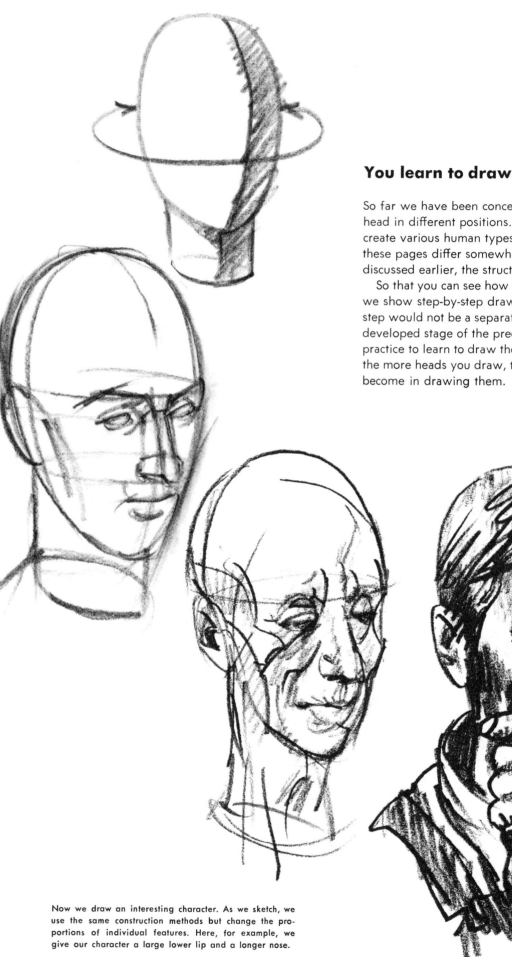

You learn to draw by drawing —

So far we have been concerned with drawing the basic head in different positions. Now we will begin to use it to create various human types. While all of the heads on these pages differ somewhat from the simple head discussed earlier, the structure of each is still based on it.

So that you can see how these heads are developed, we show step-by-step drawings of each. Actually, each step would not be a separate sketch, but is a more developed stage of the preceding one. It takes some practice to learn to draw the head well — but, remember, the more heads you draw, the more skillful you will become in drawing them.

Now we draw an interesting character. As we sketch, we use the same construction methods but change the proportions of individual features. Here, for example, we give our character a large lower lip and a longer nose.

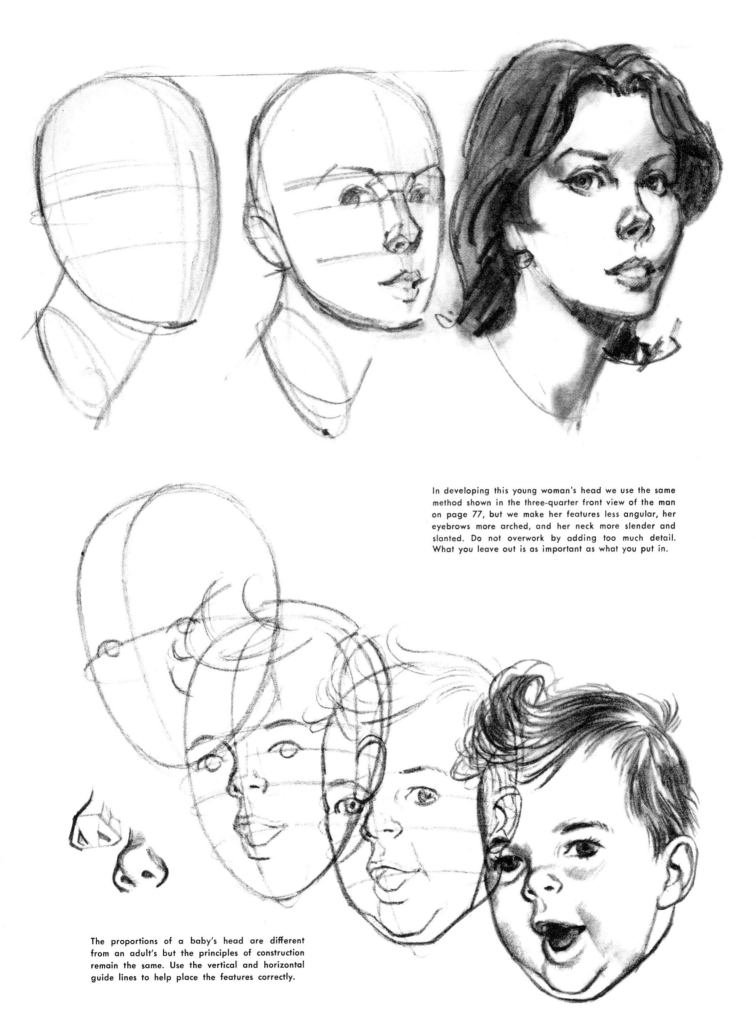

In developing this young woman's head we use the same method shown in the three-quarter front view of the man on page 77, but we make her features less angular, her eyebrows more arched, and her neck more slender and slanted. Do not overwork by adding too much detail. What you leave out is as important as what you put in.

The proportions of a baby's head are different from an adult's but the principles of construction remain the same. Use the vertical and horizontal guide lines to help place the features correctly.

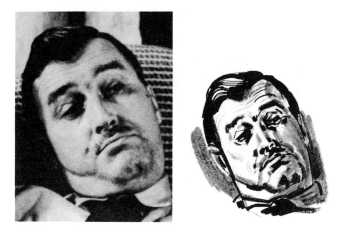

Creating many types from the same model

It is a good practice to study the faces you see every day and note the distinctive features that give each type its individuality. You must also learn to get what you need for your pictures from available models and photographs.

Naturally it is best to find a model that looks like the character you wish to draw. This isn't always possible, however, particularly in a small community. What you must do then is get the most suitable model or photographic reference you can — and use your knowledge and imagination to improvise. With experience, you can learn to develop many different characters from a single model, as shown by the late Robert Fawcett and by Mike Mitchell in the two demonstrations here.

Carefully compare each of the artists' drawings with the photograph on which he based it. See how he has changed the head shape or emphasized some of the features to create the character he wants. You will notice that, no matter how much he exaggerates or changes, he still makes use of the structural information, lighting, and expression in his model. You can, of course, take further liberties, but using your model or photograph this way will help you create really believable, convincing people.

Using a photo of himself, Robert Fawcett first did a rather straight self-portrait. Fawcett posed for many of the people in his pictures, but often changed his characterization, as shown here.

Now, working with the same photo, Fawcett visualizes and paints himself as a portly British colonel. Having a definite character in mind before he starts, he consults the photo merely for facts of construction, expression, and lighting.

This is basically the same face as before, but the length of the head has been exaggerated and the neck narrowed. This could be a bartender, a western character, or an English butler.

Here Fawcett has drawn one of the exotic-looking characters he is so fond of. This man is quite different from the colonel, but it is easy to see that both derive from the original photo. Observe how the artist has used the structure of eyelids, eye sockets, and mouth to exaggerate the skeptical expression in the snapshot.

Here Mitchell starts with this photograph of a housewife — but see what a wide range of characters he develops from it! Even though you are creating characters quite different from your model, they will usually be much more convincing than when you draw from memory. Pictures based on memory images alone tend to become clichés.

Although the faces of these women have the same structure and wrinkles that we see in the photo, Mitchell has completely changed their personality and appearance from each other and from the photo.

To create this society woman, Mitchell has lengthened the head considerably, eliminated wrinkles where the flesh sags around the jaw, and changed the hair and costume. Although this face is quite different from the one in the photo, it clearly derives from it in structure.

In this scrubwoman we have a real character! She is a far cry from the woman in the photo but you can still see that it furnished the basic structural information. It is better, of course, to find a model that more closely resembles the character you wish to portray, but — as this demonstration shows — through exaggeration and invention you can create many characters from one model.

Facial character and expression

When drawing expression, the most important point to remember is that one part of the face almost never acts alone. There must always be a related action in conjunction with other facial muscles. You must also realize that when the mouth laughs, the eyes must wrinkle.

Try it yourself in front of a mirror. Try to laugh with your mouth without letting the action affect your eyes — see how false you look. Now relax and laugh naturally — see how every feature, muscle and plane in your face breaks into movement from the top of your head to your chin and back to your ears. Walk away from the mirror and do it over again — you can actually feel your whole face breaking into movement. Try every violent emotional expression you can think of — terror, anger, rage, sneering, helplessness, joy — everything moves. Remember this always when you draw expressions, and it will serve you well.

La Pensee, Pierre Auguste Renoir

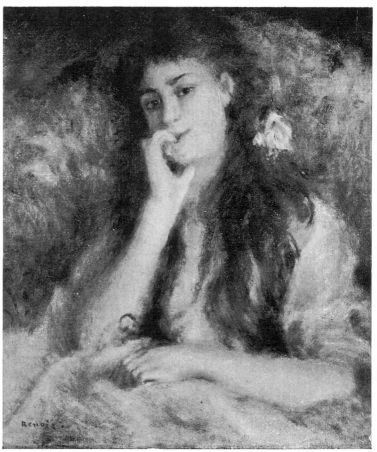

Laughter . . . partly closes the eyes, elevates the corners of the open mouth as well as the outer parts of the eyebrows and nostrils.

Terror and horror . . . produce dilated eyes and nostrils to a marked degree, an open mouth and lowered head — though it is sometimes thrown back.

Meditation or reflection . . . generally causes a slight frown and the eyes usually assume a vacant expression.

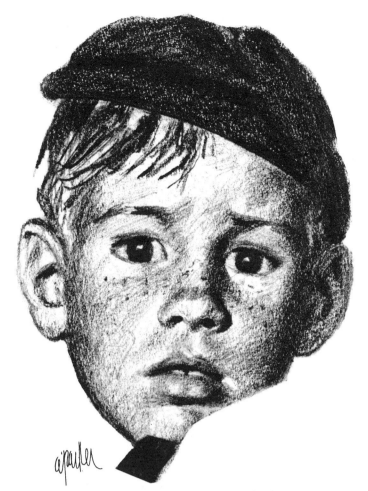

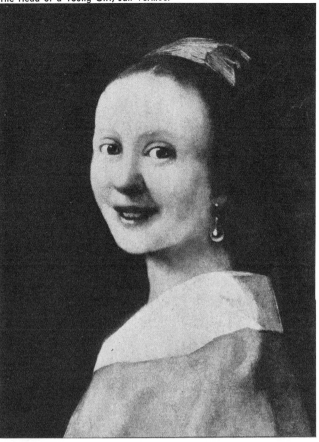

Grief . . . causes relaxation of the facial muscles, which causes the eyelids, corners of the mouth and outer parts of the eyebrows to droop. The eyebrows are elevated at their inner ends.

Smiles . . . have the same characteristics as laughter, but to a lesser degree.

La Tabagie, Adrien Brouwer

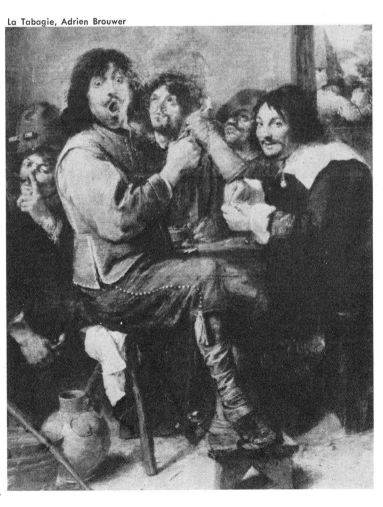

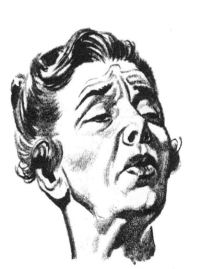

Sneering and disdain . . . are indicated by an upturned and averted face with the eyelids partly closed, with a twist of the mouth to one side or down.

Here is an interesting variety of expressions, ranging from amusement to shock and horror.

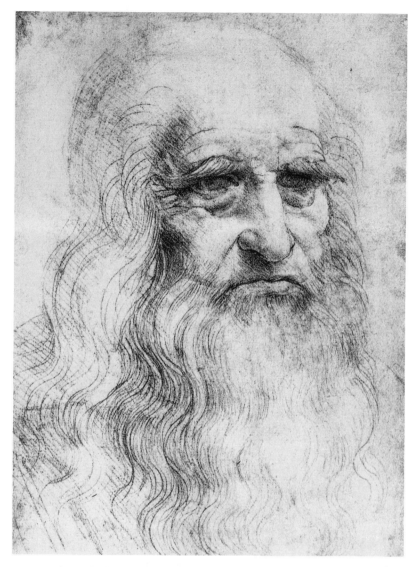

Leonardo da Vinci (1452-1519)

Self Portraiture

Artists through the ages have found self-portraiture to be a valuable practice. Most of them have done at least one; some have depicted themselves repeatedly. The painter best known for this practice was the Dutch painter Rembrandt, who painted at least 50 self-portraits during his long lifetime and among them are some of the finest masterpieces in the history of art.

In learning to portray heads convincingly, the best training is to draw or paint them constantly, preferably from a live model. One model always available is yourself. Not only can you pose yourself from the front by facing a mirror, but with the addition of a second mirror you can angle them to each other and reflect a profile or other points of view.

Eventually you will be able to dispense with the preliminary construction stage as you draw, but until it becomes "instinctive" through practice, it is important to establish the basic construction before attempting any details of likeness. Draw the lines lightly so they can be erased or covered as the drawing progresses to the finish.

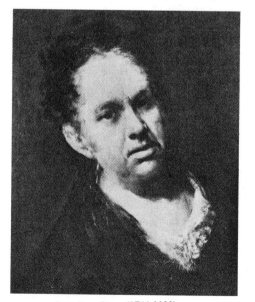

Francisco Goya (1746-1828)

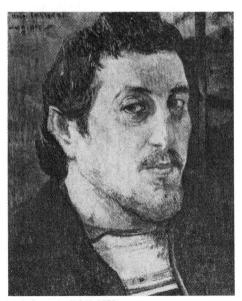

Paul Gauguin (1848-1903)

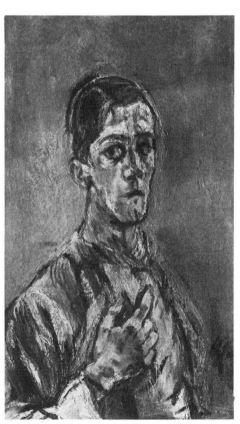

Kokoschka, Oskar (1886-1980)

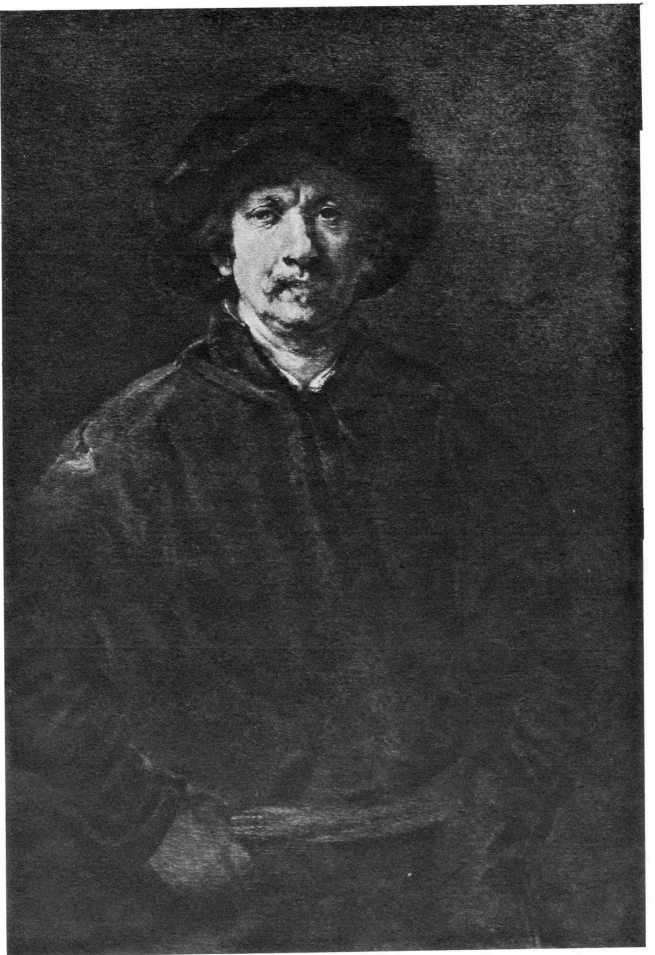

Rembrandt van Rijn (1606-1669)

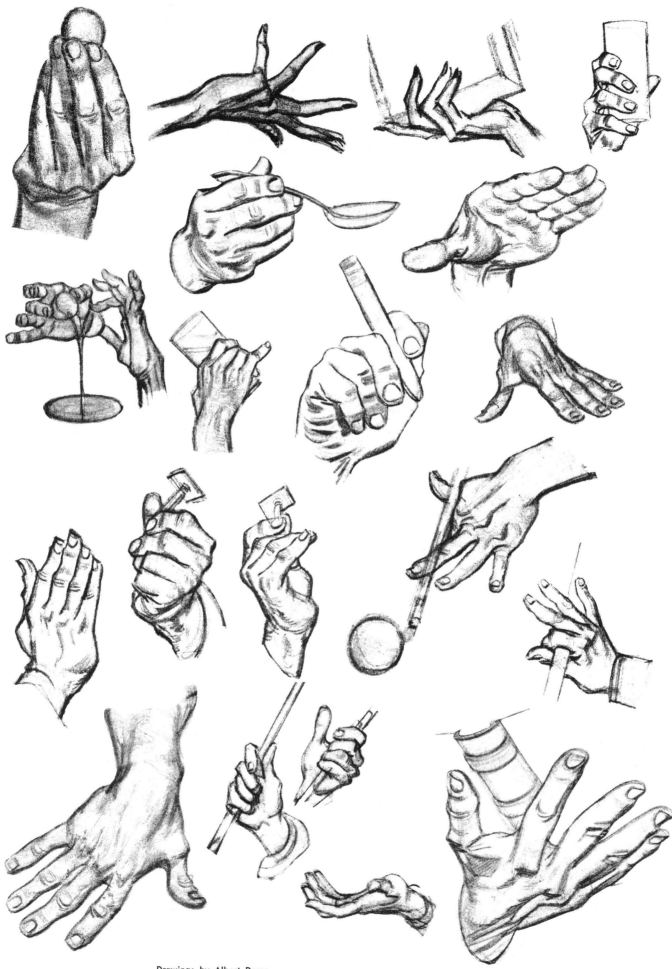

Drawings by Albert Dorne

Drawing by Paul Calle

The Hand —
Its Powers of Expression

The hands, along with the face, should receive the careful attention of the artist. First, because aside from the face, they are the only generally exposed parts of the body. Second, and more important, because next to the face, they are the most expressive parts of the human body. They are capable of showing an amazing range of actions and emotions. Third, due to the many parts and because of the many masses and planes, the hands are quite difficult for the student to draw well without a great deal of study. It has often been said that the hand is the most difficult part of the figure to draw. Yet once you have mastered the drawing of the hands, you can greatly enhance the effectiveness of your figure drawing or painting.

A common failing with many students when drawing hands in conjunction with the rest of the figure is a tendency to make them too small. Let us repeat again, next in importance to the face comes the hands. Make them large enough. If you hold your hand flat against your face, the tips of your fingers to the end of your hand where it joins the wrist should reach almost from the top of your forehead to the point of your chin. Except when requirements of beauty, as in women, call for some restraint in size, the hands should always be drawn with vigor and good size.

Be sure to draw the hand large enough. It is about the same length as the face from chin to hairline — a little more or less.

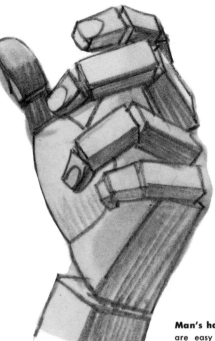

Man's hand: The planes and blocklike shapes are easy to see on this man's hand. Notice that the finger joints work just like hinges and the hand "hinges" at the wrist.

Blocking in the hand

Earlier you were shown the anatomy of the hand and how its structure influenced its action and contours. Now, we'd like to consider how to apply this knowledge with a practical, easy method for drawing the hand in any of the limitless positions the human hand can assume.

When we learned to draw the figure, we started with the basic forms, and we will again use simple forms to draw the hand. On this page there are photographs of two hands on which we have diagrammed blocklike forms with their top, side, and bottom planes. Study them carefully and, from now on, think of the hand and fingers this way as you sketch them in. As you gain experience you may omit these cube forms from your preliminary sketches, but you should continue to think of them as you work.

The other drawings on these pages show how you first establish the general size and action of the hand — then how to solve construction problems with the cube forms — and, finally, how to soften the edges and add realistic detail. As you work, think of the rhythmic flow of action through the wrist, palm, and fingers, and of the solid structure that makes the hand look convincing, and try to show both in your drawing.

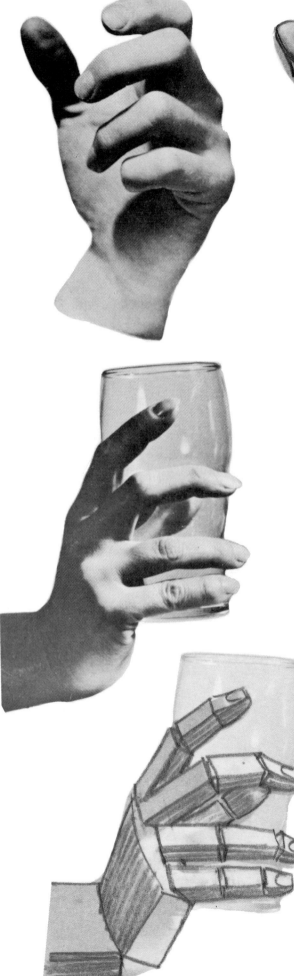

Woman's hand: A woman's hand is more slender and graceful, but we can reduce it to the same blocklike structure.

Block in the palm, thumb, and wrist first.

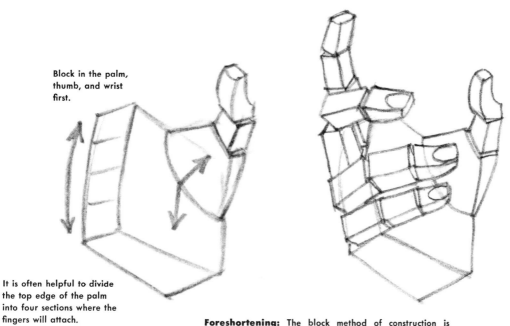

It is often helpful to divide the top edge of the palm into four sections where the fingers will attach.

"Draw through" block forms of fingers to establish top, side, and bottom planes in relation to rest of hand.

Foreshortening: The block method of construction is particularly useful in working out foreshortened views of the hand because it is easier to imagine what happens in perspective to a cube than a finger. Here we simplify the problem by establishing the position of the palm in relation to the thumb and then "build" the fingers on.

Hinge action of the fingers: By drawing the bottom plane of the fingers carefully, you can be sure they bend at the proper angle. Note how each joint "hinges" on next one — they do not rotate or twist.

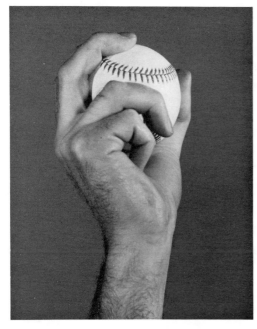

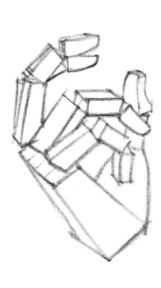

Complicated positions:
We can work out the position of hands in any complex position, such as holding a ball, by drawing through and making sure the wrist, palm, and thumb are properly related before drawing the details of the fingers.

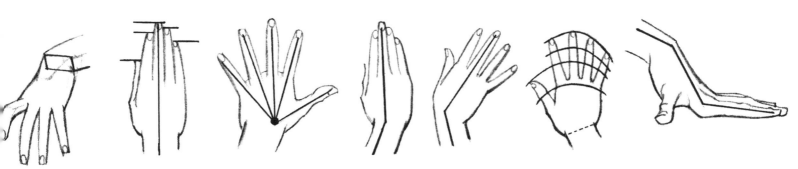

Important points in the action, proportion, and movement of the hand, wrist, and fingers.

"Humanizing" the block forms: Our purpose in drawing the hand is, of course, to make a convincing picture. The block forms serve merely to help us achieve this result. Here are some things to remember when translating these forms into a lifelike hand.

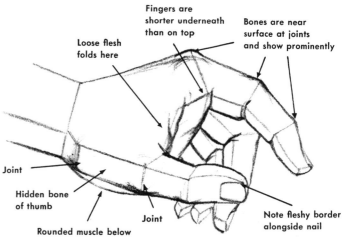

Fingers are shorter underneath than on top

Loose flesh folds here

Bones are near surface at joints and show prominently

Joint

Hidden bone of thumb

Rounded muscle below

Joint

Note fleshy border alongside nail

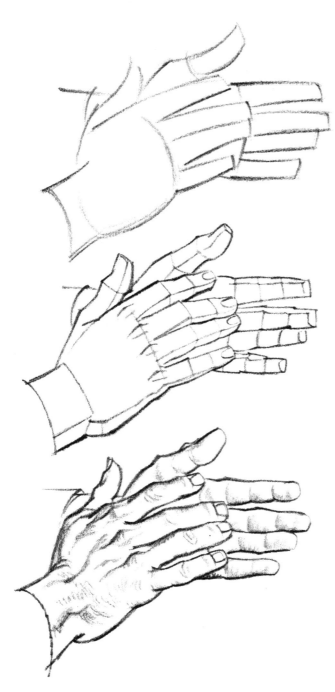

"Humanizing" the block forms

As in using the basic figure construction for working out problems of pose and proportion in the figure, the blocked forms of the hand serve the same purpose.

The next step of converting the basic forms into more realistic contours is a matter of refining the shapes. Here, you'll need to rely on the anatomical information as presented in Chapter 2. A review of it at this point should be a helpful reminder of the underlying structure of bones and muscles. You will be particularly concerned with their effect on the outer surface of the hands as you interpret them from photos or posed models.

Look for the overall gesture of the pose as a preliminary to drawing the hand. Notice here how the wrist, back of the hand and the pointing finger form a reciprocating curved shape.

 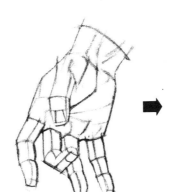 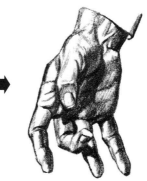

Step 1 — Spacing and Placing
Sketch in the action and approximate area of the hand, fitting each part as it appears.

Step 2 — Solidity of Construction
The block method of drawing the hand is of great assistance in defining the planes and surfaces of the hand and fingers.

Step 3 — Details
We now carefully draw the details of the hand and the fingers, erasing Steps 1 and 2 as we proceed.

Step 4 — Planes of Light and Shade
Finally we put in light and shade, taking care not to spoil the forms of the hand and fingers.

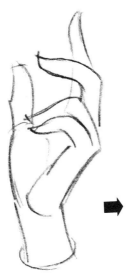 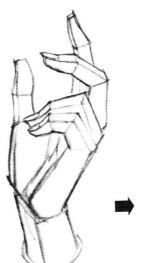 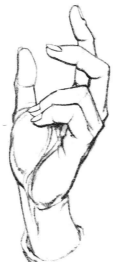 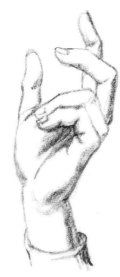

Once you achieve some proficiency, you'll find hands fascinating to draw. Study your own hands and draw them. With the aid of a mirror, you can pose them in almost any position.

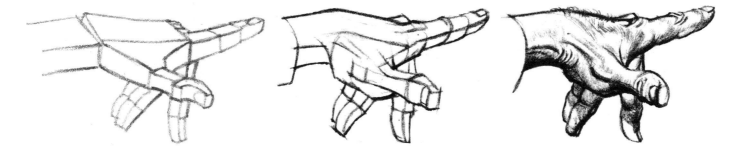

Observing the hand from different viewpoints

In the series of photos below, the same pose of the hand has been held in each row, as the camera moved around it. You will note the striking changes that take place in the visible relationship of the fingers, thumb, and base of the hand, in just a small change of camera position, even when the eye level remains the same.

This serves to emphasize, again, how important it is to understand the basic construction of the hand and how all of the parts relate to each other. By "drawing through" you can locate the parts that are not visible, but which will help you to determine the proper locations of those that are.

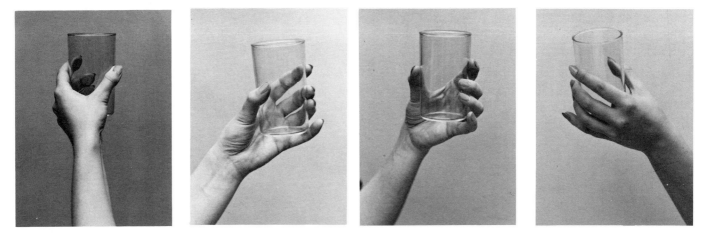

The transparent glass enables you to study the form and action of the palm and underside of the fingers.

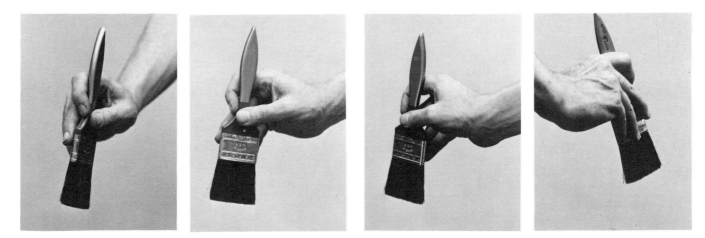

This shows how the hand and fingers adjust to the shape of the object they hold. Notice how the thumb works in opposition to the fingers.

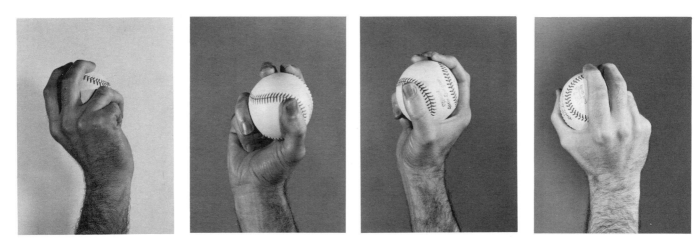

Note that not only the fingers but also the body of the hand "wraps around" the solid spherical form of the ball.

Do's and don'ts

There is general agreement among artists that hands are among the most difficult parts of the anatomy to draw. In fact, one of the giveaways of an inexperienced artist is a weakness in the construction of the hands in an otherwise competent drawing or painting.

Illustrated here are some of the most common pitfalls. By consistently following the principles demonstrated in this chapter you should not fall into them.

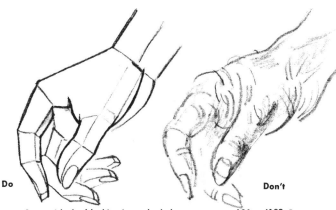

Do **Don't**

Start with the blocking-in method shown on pages 108 and 109. Be sure the various parts of the hand fit together before putting in surface details. No amount of detail will save a poorly constructed hand — but the cubes can prevent one.

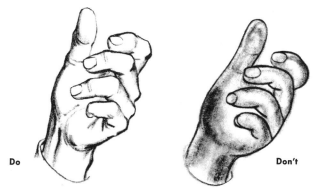

Do **Don't**

Keep in mind the bone and muscle structure beneath the surface. In some places the surface is influenced by the angular bones, in others by the soft muscles. Don't round off all the forms of the hand or it will look rubbery.

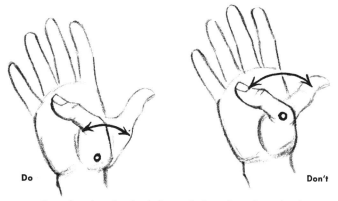

Do **Don't**

Remember that the thumb is attached at the wrist and swings independently of the rest of the hand. Don't limit the action of the thumb by swinging it only from the middle joint, but make it work in a natural, lifelike way.

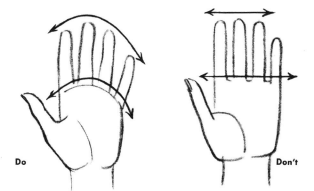

Do **Don't**

The fingertips form a curved line, and another curved line is formed where the fingers join the palm. Make sure these lines really look curved — not straight — in your drawing. The arch of the curve is highest at the middle finger.

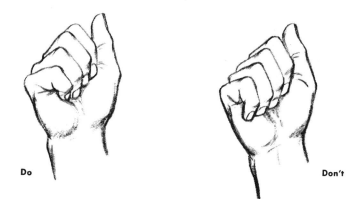

Do **Don't**

When the hand is closed, the fingers should point slightly toward the center of the palm. Don't fold the little finger straight down the side of the palm or it will look stiff and unnatural. Its tip should be well in from the side.

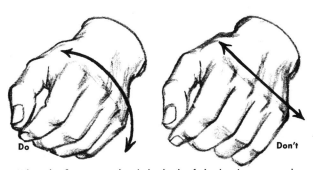

Do **Don't**

When the fingers are closed the back of the hand curves, and this curve is most noticeable along the line of the knuckles. Don't flatten them out.

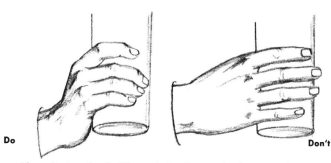

Do **Don't**

The wrist is quite flexible, and the fingers, thumb, and palm adapt themselves flexibly to whatever the action may be. Don't make hands look stiff.

113

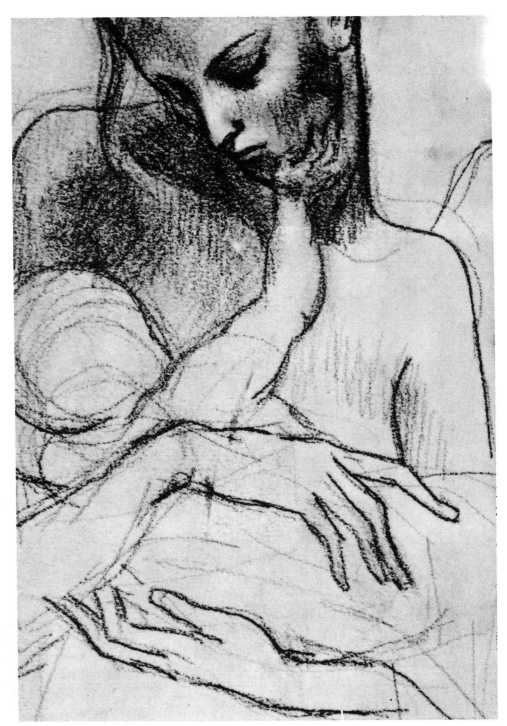

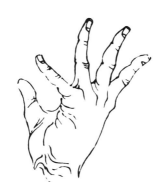

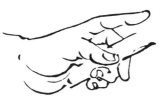

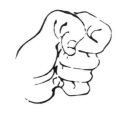

Hokusai
Movements of the Hand

Pablo Picasso
A Mother Holding a Child and Four Studies of Her Right Hand, detail
Courtesy of the Fogg Art Museum, Harvard University
Bequest of Meta and Paul J. Sachs

Albert Dorne
Pencil Study for illustration, "100 Neediest Cases"

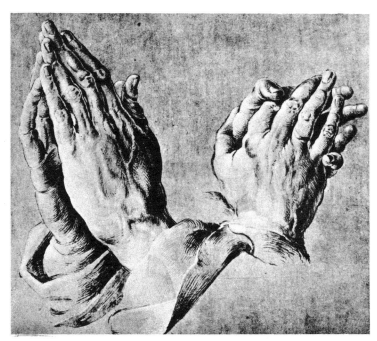

Albrecht Durer
Study of Hands

Robert Fawcett
Study of Hands, Stage Coach Driver

Hands express feelings and character

These examples of hands, each drawn or painted by a different artist, clearly demonstrate how effectively hands can express feelings and communicate ideas. In addition, hands can indicate age, sex, and sometimes even the occupation and character of the person in the picture.

© Curtis Publishing Co. 1943

Norman Rockwell
Freedom of Worship, detail

Austin Briggs
Clenched Fist

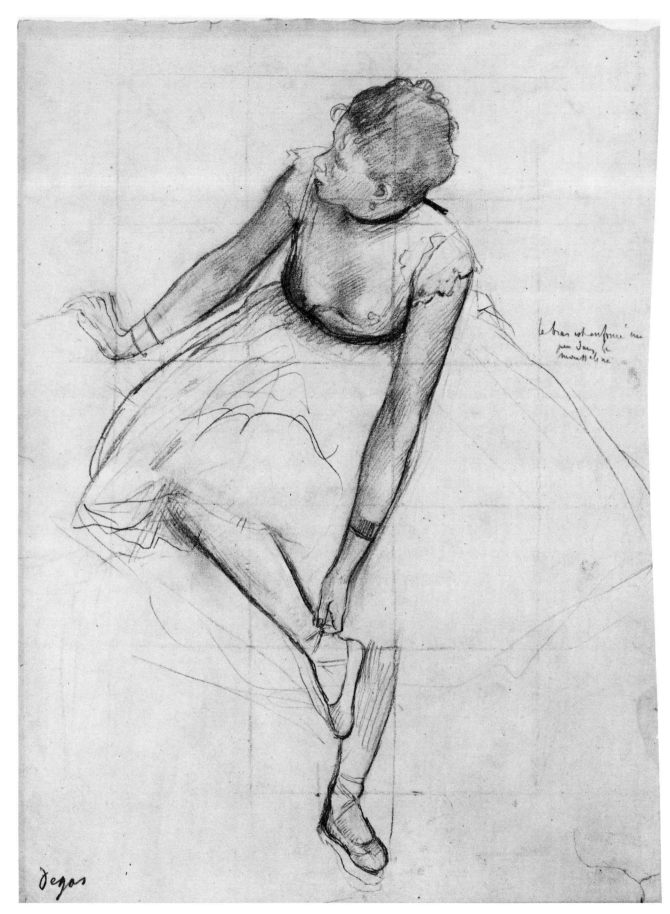

Edgar Degas, Dancer Adjusting Her Slipper
The Metropolitan Museum of Art, Bequest of Mrs. H. O. Havemeyer, 1929, The H. O. Havemeyer Collection.

The Figure in Motion

This heading refers not only to the more active movements of the body, but also to all of the myriad positions and actions of the body that occur in the course of normal human activity. In this chapter, we will demonstrate how the figure is balanced and that changing the position of one part of the body almost always requires a countering change in the rest of it. You will learn how to choose a pose that will make an action clear and explicit.

There is a vast difference between the pose of a static and an active figure. In order to bring a figure to life, you must first observe people in the process of living and moving about in their daily activities. This is one of the great benefits to be gained from the habit of carrying a sketch book with you and from recording the typical actions of people: as they cross a street, run for a bus, or slump in an armchair. These drawings need not be at all detailed. It would be impossible to make a careful drawing of a figure on the run, for instance. However, you can record the overall movement of the figure that makes up the action, even if only in a scribbled silhouette. Later you can apply your knowledge of the figure and

its anatomy to reconstruct the details of the pose.

You will find your powers of observation improving as you develop this sketching habit and will eventually learn to automatically interpret the action and spirit of any pose as you observe it. You will note the telling details that carry out an action, such as the angle of the neck, the turn of the foot, or how the hands are used.

Even without a sketch book you can mentally analyze the action as though you were drawing it. As an experiment, watch a television program with the sound off. See how the actors convey what is going on by their actions as well as in words. One of the marks of a good actor is his ability to use "body language" convincingly. As an artist, you are like a stage director — selecting the actor and choosing the action you want as well as how it should be presented.

Before you can do that competently you must have the insight based on the accumulated experience in observing people of many backgrounds and how they might typically act and behave in given situations. In addition you'll need to develop the artistic facility to present what you know with authority and conviction.

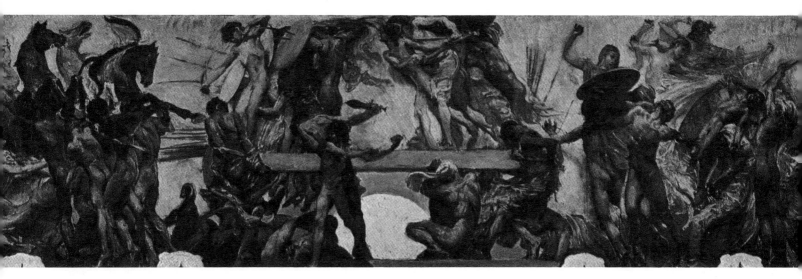

Aristide Sartorio, Decorative border, House of Parliament, Rome

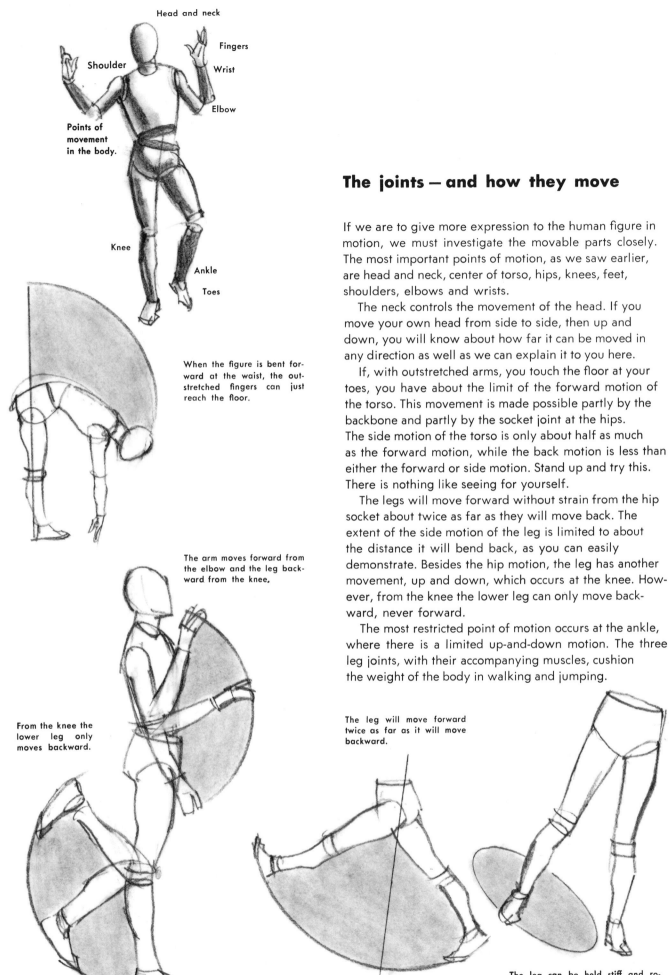

Head and neck

Fingers

Shoulder

Wrist

Elbow

Points of
movement
in the body.

Knee

Ankle

Toes

When the figure is bent forward at the waist, the outstretched fingers can just reach the floor.

The arm moves forward from the elbow and the leg backward from the knee.

From the knee the lower leg only moves backward.

The joints — and how they move

If we are to give more expression to the human figure in motion, we must investigate the movable parts closely. The most important points of motion, as we saw earlier, are head and neck, center of torso, hips, knees, feet, shoulders, elbows and wrists.

The neck controls the movement of the head. If you move your own head from side to side, then up and down, you will know about how far it can be moved in any direction as well as we can explain it to you here.

If, with outstretched arms, you touch the floor at your toes, you have about the limit of the forward motion of the torso. This movement is made possible partly by the backbone and partly by the socket joint at the hips. The side motion of the torso is only about half as much as the forward motion, while the back motion is less than either the forward or side motion. Stand up and try this. There is nothing like seeing for yourself.

The legs will move forward without strain from the hip socket about twice as far as they will move back. The extent of the side motion of the leg is limited to about the distance it will bend back, as you can easily demonstrate. Besides the hip motion, the leg has another movement, up and down, which occurs at the knee. However, from the knee the lower leg can only move backward, never forward.

The most restricted point of motion occurs at the ankle, where there is a limited up-and-down motion. The three leg joints, with their accompanying muscles, cushion the weight of the body in walking and jumping.

The leg will move forward twice as far as it will move backward.

The leg can be held stiff and rotated like this from the hip joint.

The elbow gives the forearm a full arc of forward motion but none backward.

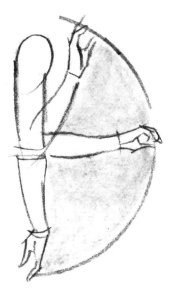

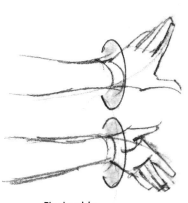

The hand in conjunction with the arm can turn completely around.

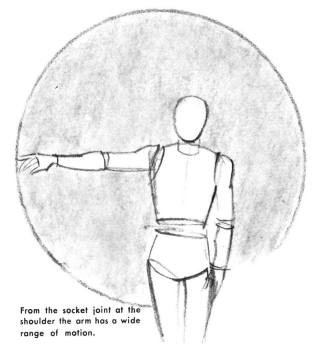

From the socket joint at the shoulder the arm has a wide range of motion.

The arm is similar to the leg in that it also has three major joints. However, unlike the leg, the arm is truly versatile. From the socket joint at the shoulder, it has almost unlimited motion in every direction. This freedom is due to an important difference between the two limbs: the shoulder socket is rather shallow, permitting greater movement than the deeper hip joint. The elbow is similar to the knee in its action, except that the elbow allows the action of the arm to be the opposite of that of the leg. The arm moves forward from the elbow while the leg moves back from the knee. At the elbow, as compared to the knee, it is as if your knee joint were at the back. The movable joint at the wrist has much more latitude of motion than the ankle, although the direction of the motions is the same.

One characteristic of the arm is that it can be turned completely around. Stretch your arm out, try it and see for yourself.

If you could think of all of these motions at once you can easily realize that within the basic human form there are innumerable combinations of motions. Try sketching as many as you can, such as we show here, without violating the limit of the action or destroying the forms. Now you can really have your figure do things for you. In all of your practice keep in mind the basic proportions of the normal human figure as we have taught them to you. Move the parts but be sure to keep the relationship of one part to the other. Draw the "other side" . . . the human form must appear as a solid form with depth no matter in what attitude or action it is pictured.

The range of action in the foot is limited to a side to side and up and down movement.

The great variety of wrist movements in combination with the action of the arm gives a complete range of movement.

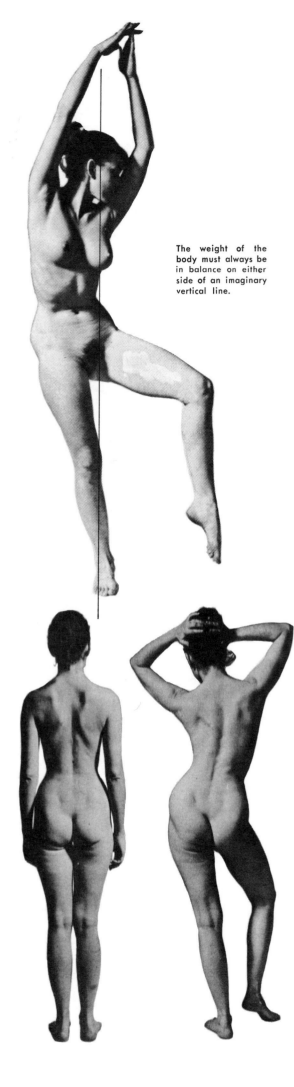

The weight of the body must always be in balance on either side of an imaginary vertical line.

Drawing the figure in balance

Balance is the ability of the human being to stay erect and keep from falling when in motion as well as when standing still. This balance results from the delicate distribution of his weight. When the figure is in motion the state of balance is sometimes fleeting. The artist must look for this fleeting moment and draw it, rather than choose another in which the figure appears unstable and out of balance. Pictures in which the figures are out of balance are always disturbing and unconvincing.

As an aid to drawing figures in proper balance, start your drawing with a light vertical line as a guide for placing the various parts of the figure in the proper position. This line is just as useful when drawing the figure in attitudes of running, walking, bending, crouching, etc.

When you draw the figure in any position, establish the position of both left and right parts at the same time. For example, draw both shoulders at the same time; do the same with the hips and knees. In the female figure, establish the position of both breasts at the same time. You cannot ignore one side of the figure while you draw the other side and still produce a balanced action.

When the figure is standing erect, its weight is distributed equally on either side of a vertical line which passes from the pit of the neck to the middle of the instep of the foot which supports the body. Any motion of the body or change from this first position will automatically displace the pit of the neck from this vertical line, so you must remember that the weight of the body must always be balanced over the foot or feet or between the feet that rest on the ground and support this weight.

In bending to one side, as in the action of lifting a heavy suitcase or reaching, you will find that you naturally extend your opposite arm to preserve your balance — and you will usually raise the heel of the opposite foot from the ground as well. This shows that you must place a sufficient weight on the opposite side to preserve your balance — this applies to every attitude and action. In bending, the body lengthens on one side as much as it shortens on the other — but the length of the central line does not change.

The shift of weight to one foot causes the other leg to relax, with a dropping down of the hip and an effect of stretch on that side. On the side to which the weight has been shifted, the hip has been pushed up and the side folded and shortened, with this movement causing a bend in the body, indicated partly by the position of the spinal column and also resulting in a definite change in the direction of the shoulders.

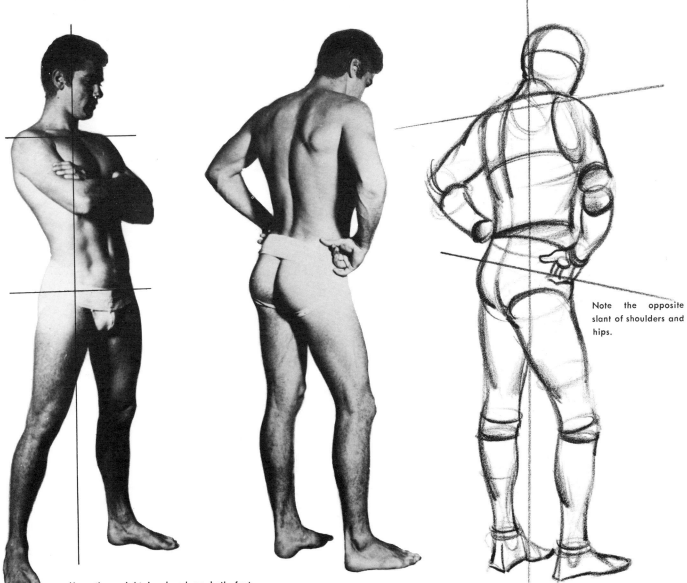

Note the opposite slant of shoulders and hips.

Here the weight is placed on both feet. Since the legs are apart, the line of balance falls between them and the lines of the shoulders and hips are parallel.

In drawing the figure, remember that these vertical lines are only imaginary. When sketching a figure, the line should be sketched in very lightly. This also applies to all other construction lines.

Observe that the weight of the body is equally centered on a vertical line of balance, no matter from which direction the figure is viewed.

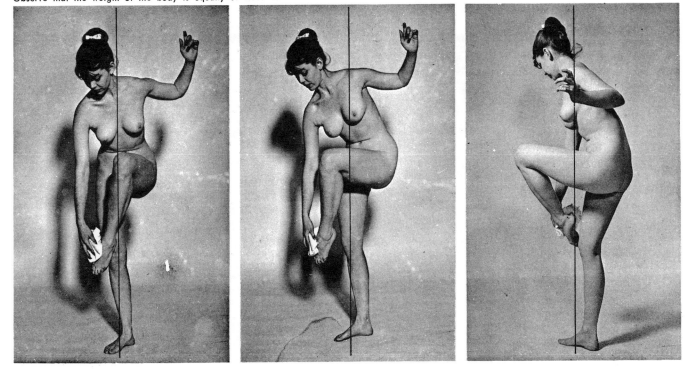

Reproduced from *A Handbook of Anatomy for Art Students*, Oxford University Press.

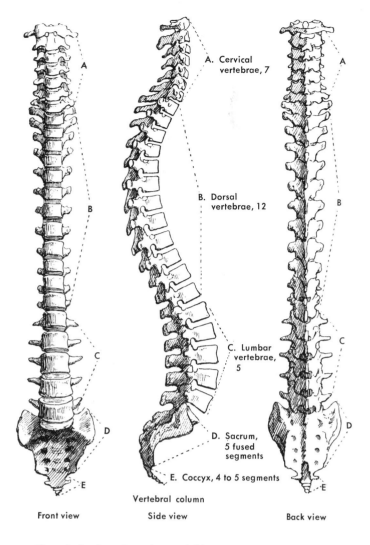

A. Cervical vertebrae, 7

B. Dorsal vertebrae, 12

C. Lumbar vertebrae, 5

D. Sacrum, 5 fused segments

E. Coccyx, 4 to 5 segments

Vertebral column

Front view Side view Back view

A dorsal vertebra, from above.

Two dorsal vertebrae from the side. Spaces between the vertebrae are cushioned by fibrous disks.

Movement of the spine and body

The key to understanding the action of the torso is in the structure of the spinal column. The slant of the shoulders, the hips, the rotation and turning of the body are due to the twisting of the vertebrae which make up the spinal column. Each vertebra of the spine moves a little and the whole movement in the entire spinal column is the result of the aggregate of all these many little movements. You might think of the spinal column as the connecting rod between the upper and lower portions of the torso — as well as the head, at the upper tip of the spine.

As you thoroughly learn the function and movement of the spinal column, it will add greatly to your ability in drawing the figure in action from every angle.

The spinal column is made up of 34 bony segments, each of which can move a little, and added together make up the flexibility of the spine.

The two sections of the torso are connected by the spinal column. As one section moves, the other shifts to counterbalance it.

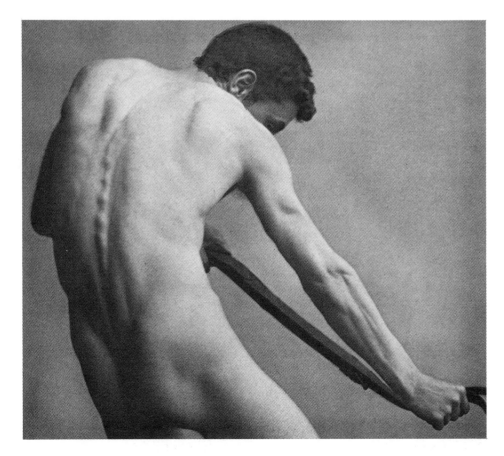

The heavy line represents the shape of the spinal column in these various actions.

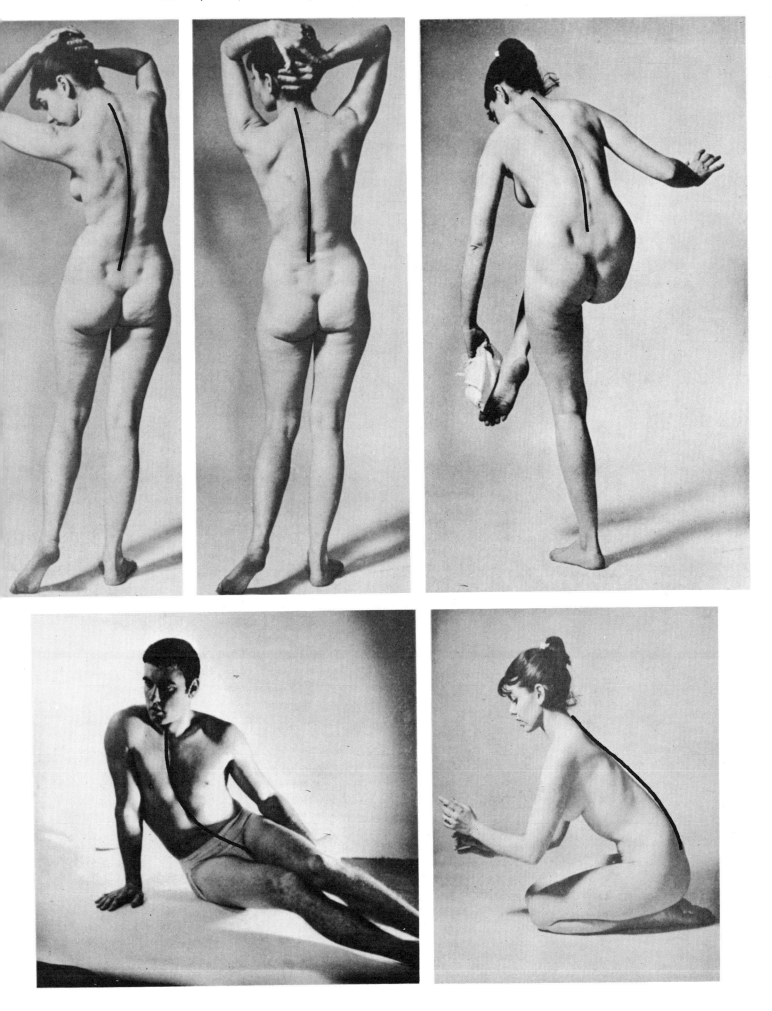

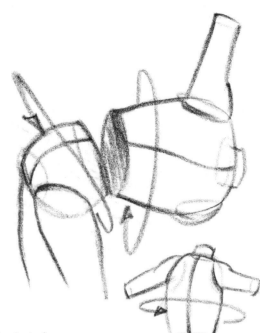

With the basic figure you can easily analyze how the two sections of the torso move in opposite directions as the figure turns or twists.

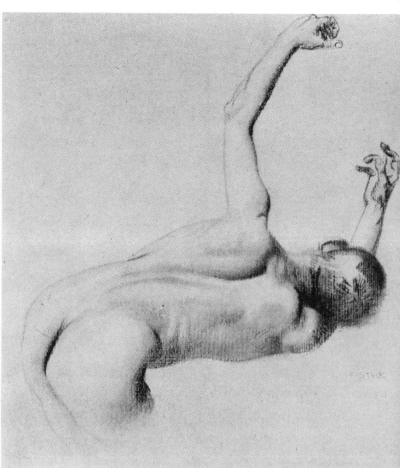

Study, by Franz Stuck

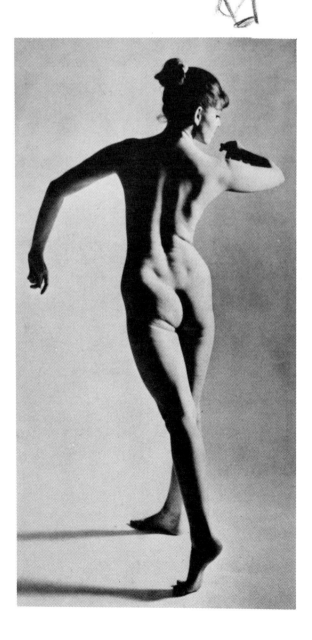

Twisting and turning

When drawing the human figure in attitudes of twisting and turning, consider it first in its masses. These masses — the head, chest and pelvis — are held together in their different movements by the spinal column.

As these masses twist and turn, their relative positions change. You might think of these movements as much like those of an accordion being played. One side is the active side. On this side the forms are forced toward each other, and are compressed and brought together much like the pleats of an accordion. The opposite and "inflated" side shows the longer, sweeping curves.

Try to capture a definite feeling of movement in every pose. The cartoonist adds greatly to the sense of movement of his figures by drawing direction or speed lines back of a moving hand or foot, but you must show this movement in the pose of the figure itself.

To create a convincing effect of a figure turning and twisting, it is important to "feel" the full range of the movement as you draw. The viewer must be made to sense the movement that is in progress. In this kind of drawing, your best approach is to watch people in action and observe their gestures. Make quick mental notes and then record them with a pencil, trying to capture on paper just those lines and forms involved in the motion of gesture. With your earlier studies of anatomy and the figure thoroughly absorbed, you should find that you are now able to make these action drawings convincing and real. Here, as stated before, lies the great value of your pocket sketchbook.

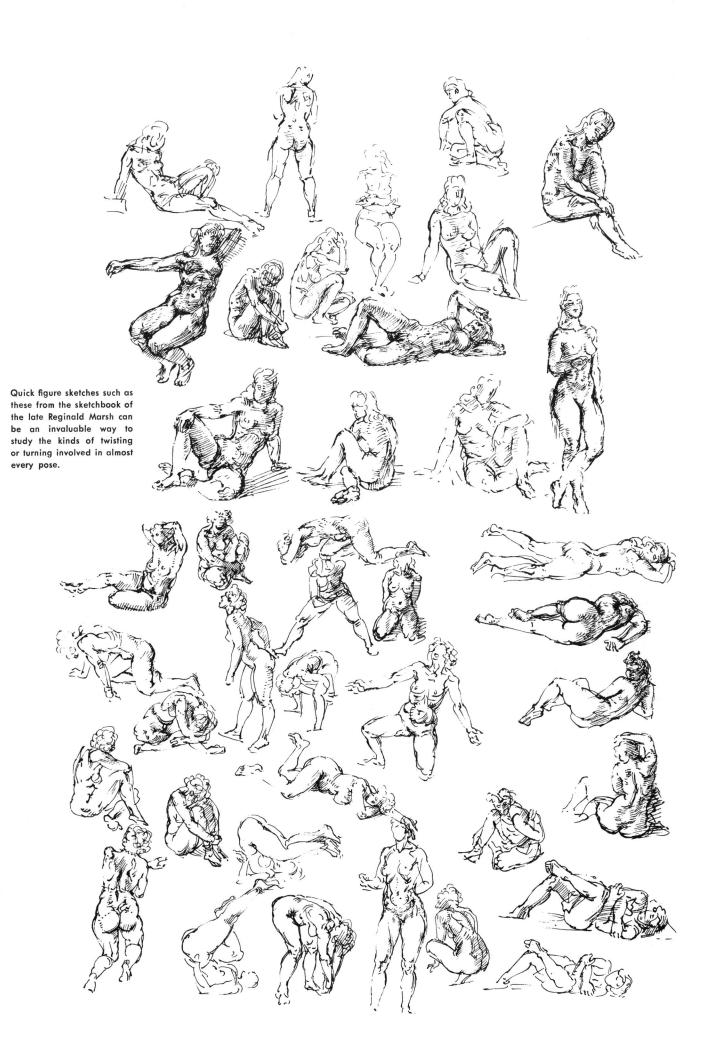

Quick figure sketches such as these from the sketchbook of the late Reginald Marsh can be an invaluable way to study the kinds of twisting or turning involved in almost every pose.

125

Baroque architects often planned the ceilings in palaces and large estates to resemble an open vault
to the sky. Mural painters were employed to heighten this effect by painting greatly foreshortened figures
which appeared to perch on the edge of the vault or to float in midair.

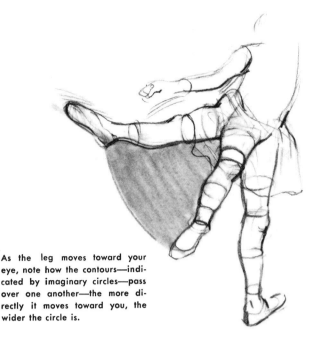

As the leg moves toward your eye, note how the contours—indicated by imaginary circles—pass over one another—the more directly it moves toward you, the wider the circle is.

Foreshortening

When we draw the figure in motion, foreshortening and perspective should be considered together. Foreshortening, as it is known to artists, is the use of perspective in drawing a figure so that the parts nearest us are made to appear larger in proportion to those farther away.

In drawing the figure in outline with no shading, foreshortening requires extra care to represent the parts in true perspective. If the human figure were composed of straight lines and angles, we might draw it by the general rules of perspective, but it is made up of many curves flowing into one another. Practice and study become necessary to learn how to make a foreshortened or perspective drawing of a human figure lying down with either the head or feet toward the artist, an arm and hand reaching out directly at you, or in many similar attitudes.

The best way to make a convincing drawing of a figure in a foreshortened position is to study what you see very carefully. Remember that in foreshortened positions rules of figure proportion do not apply as they do to a normal straight-on view of the standing figure. When you foreshorten arms or legs, pay close attention to their width. The length of the part you foreshorten will be much reduced, but the width should be normal. The head measurement cannot be used. Instead, you should rely on your eye more than ever. Compare the size of one mass of the body to another. Note that certain parts may not be visible because they are hidden by others. Rely on your eye and trust it when drawing the foreshortened figure.

If you were directly in front of a figure standing at attention, no foreshortening would be needed. But if you were above the figure or below it, you would have to foreshorten. Practically every drawing of the human figure — especially when it is in motion — involves some problem of foreshortening.

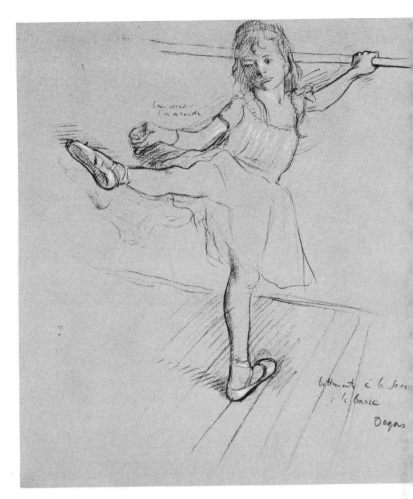

DEGAS. Dancer

As Degas drew the action of the young ballet student, he shifted the height of her leg until satisfied with the balance of her pose, but he was also aware of the degree of foreshortening which caused the leg to appear longer or shorter as the leg was raised or lowered.

Imaginary circles of different degree show how the form and perspective are retained in the figure and limbs whether coming directly at you or going away. Note the feeling of solidity and roundness when the figure is foreshortened expertly.

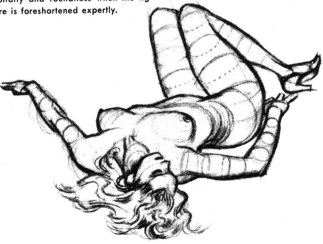

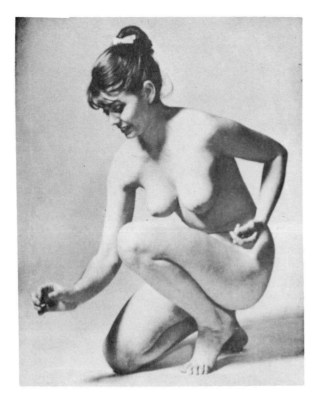

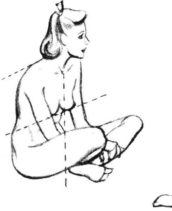

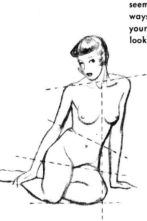

Note that all the figures on this page seem to be in balance. This must always be your watchword in laying in your sketch. Train yourself to always look for the line of balance.

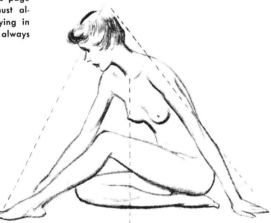

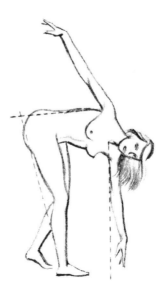

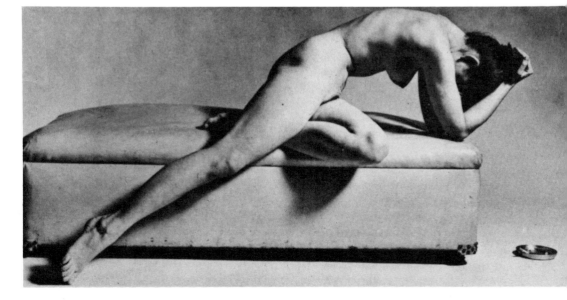

In drawing the figure, the points defining the proportions as well as the direction of the shoulders and limbs should be carefully marked — <u>first.</u>

Sitting — bending — kneeling

Nothing is quite so uninteresting as a figure "just sitting" — feet close together, the arms resting alike on the arms of the chair and the face looking straight ahead. To be interesting, the seated figure must suggest a mood and attitude, whether relaxed or alert.

The seated figure can express a wide variety of attitudes; it can suggest fatigue, dejection, aggressiveness, aloofness, boredom, tension. Each attitude should be studied and drawn differently. Sit down in front of a mirror and act out the different positions and emotions. See how simple it is to dramatize them all. If possible, get someone to act these emotions out for you while you sketch them.

In drawing the seated figure, it is important to understand how the weight is supported by the thighs and buttocks, the back, hands and elbows. Both the thighs and buttocks flatten considerably, especially in the female. Care must be taken to draw the head in the proper position over the body, since it has a great deal to do with completing the attitude as well as telling the story you are trying to picture. Remember that while the seated figure is usually supported and is not so obviously subject to the laws of gravity as is the upright figure, your central line of balance and distribution of the weight is just as important. This must be considered thoroughly or, as in the case of the upright figure, your seated figure will not be convincing.

Care must be taken, in drawing sitting postures, to think out the perspective and foreshortening. Study carefully the forms of the body as they either recede from or come toward you. Study carefully the contours arranged in front of each other. If you don't, an arm will look short or a thigh will not recede properly and the legs will fail to look right in perspective.

In drawing a bending, kneeling or other action, the same rule of interest described above must always apply. "Just bending" is dull and uninteresting; the body must have balance, rhythm, and purpose. There must be a reason for bending or kneeling — for that matter, every movement of the human form is motivated by a specific reason.

Study the drawings on these pages, paying special attention to the points of strain as well as the degree of movement of the parts of the body in the actions. Make many sketches of yourself, members of your family and friends in these various poses. Work for the actions rather than the details — always keeping in mind the imaginary line of balance.

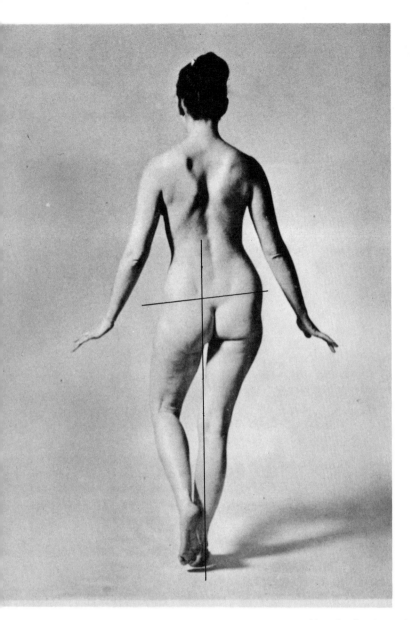
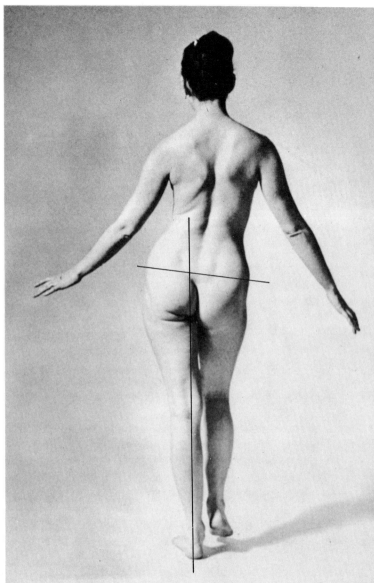

Note the direction and movement of the hips and buttocks as the weight shifts from one foot to the other in a normal stride.

Walking and running

In walking, the body alternately shifts its weight first to one leg and then to the other, with the center of balance over the foot on the ground. The leg is extended slightly in advance of the body — the heel touches the ground first, quickly followed by the toes. With this forward foot resting on the ground, the heel of the other foot is raised, with the knee bending slightly as the leg swings forward past the other. As this leg swings forward, the foot of the other leg bears the whole weight of the body. As the leg swings forward to rest on the ground it takes its turn at supporting the weight of the body. During this process the body is always passing vertically over the supporting foot.

Each time that the foot is raised it thrusts the weight of the body to the side over the other foot as well as forward. The unconscious effort to balance the movement of the limbs in walking causes the arms to swing

alternately in opposite directions to the legs so that when the right leg swings forward the right arm swings back— with the reverse action applying to the other two limbs.

A longer stride, accompanied by a more pronounced alternate swinging of the arms, distinguishes a fast walk from an ordinary normal walk. When you draw either of these actions, remember to show that the knees are bent, to avoid an appearance of stiffness.

When running, the body should always be shown ahead of the center of gravity. The faster the figure runs, the more it should appear to lean forward.

Some of the most important views of the figure in motion show it in the act of walking. Study these actions thoroughly in the people around you — make many sketches of them. Unless these fundamental actions are carefully observed and correctly drawn, they will never look right.

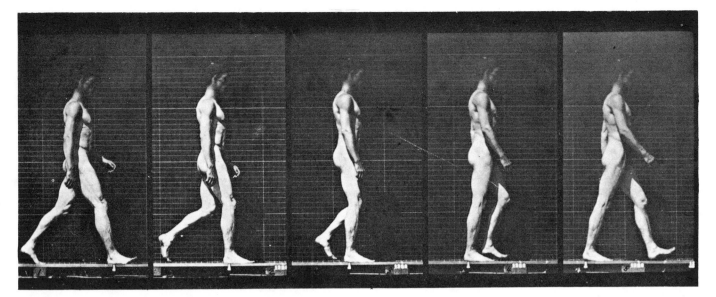

A complete stride performed at a normal walking pace. Study the position of the arms in relation to the legs at every position, as the walker proceeds across the page.

We wish to strongly impress on you that the photographed phases of the figure in motion shown here are not intended as a substitute for personal observation, but to assist you in training your own sense of observation. Their value is not as individual pictures but rather as a series of phases showing the various changes which take place in the disposition of the limbs and body during the evolution of some act of motion — from its inception to its completion.

One of the most important observations you can make, as demonstrated in the drawing and in the photographs, is that the legs and arms swing alternately on opposite sides of the body to maintain the balance of the figure in motion.

The smooth running stride of an athlete—note the apparent "feeling" of balance in every stage of the running action.

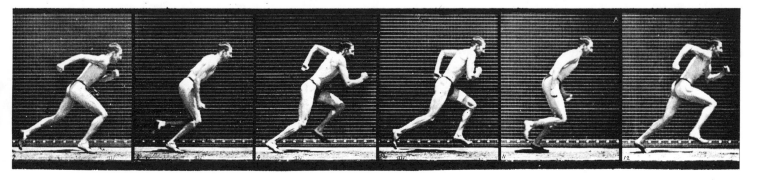

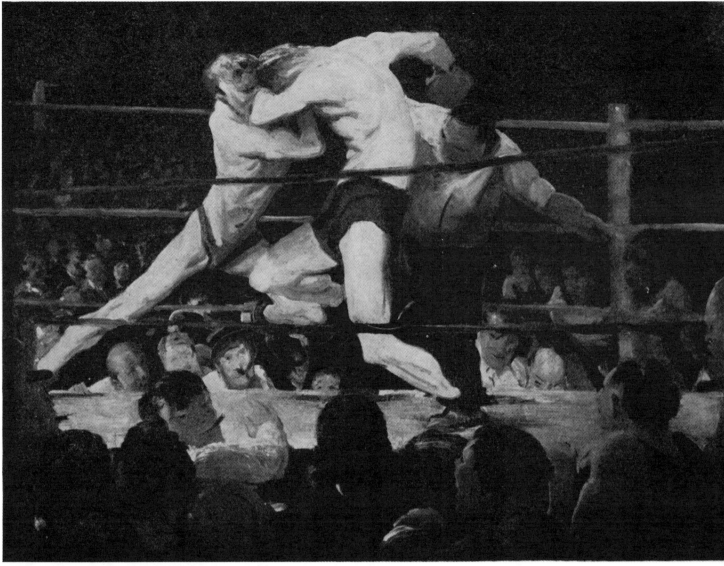

GEORGE WESLEY BELLOWS. Stag at Sharkey's
Cleveland Museum of Art, Cleveland, Ohio
This powerful painting is an excellent demonstration of gesture drawing, in paint. Bellows has concentrated his entire attention on the interaction of the two boxers as they fight head to head, with little concern about rendering their anatomy, facial features, or details of the other figures in the picture.

Gesture drawing

Before the advent of the high speed camera and film, the artist had to observe a fleeting action and try to record its characteristics in a shorthand version that could be developed more carefully as time permitted. While this may have led to some inaccuracies, particularly in drawing complex action such as the gait of a galloping horse, it generally had the advantage of forcing the artist to concentrate on the overall gesture or essence of the action. Today the camera is accepted as an extremely valuable and important tool, particularly for recording action, but it is often apparent that many of today's artists are relying too much on a single split-second frame of a photo taken at high speed, complete with distortion, and are failing to see the essential total gesture of what the figure is doing. It should certainly be possible to work either from a series of high speed photos or from direct observation if you first learn to look for and endeavor to record this composite gesture.

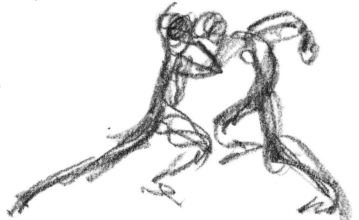

The drawing approach can be as simple as a curve or a scribble, intended only to record the effect of the action while it is happening. Don't try to refine the drawing until later. Make many rapid sketches, concentrating only on the action. This will be much more valuable than trying to record details which can only be useful after the gesture itself is right.

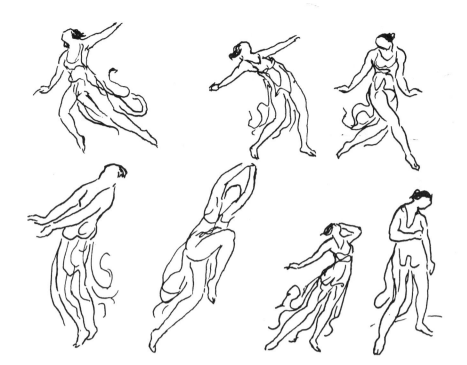

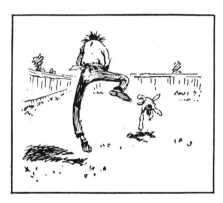

ABRAHAM WALKOWITZ. Studies
Here is a selection from thousands of drawings made by the artist in recording the dancing of Isadora Duncan. The drawings are in a personal artistic shorthand that effectively summarizes the gesture of each pose.

RAY PROHASKA (right)
This noted artist and teacher found it helpful to start a figure study with this type of expressive gesture drawing.

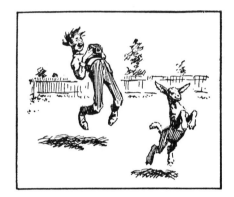

A. B. FROST
This great American humorist and illustrator made a series of drawings of a character who tried to photograph a lamb and found its action so contagious that he became quite lamblike. As the preliminary sketches indicate, his knowledge of the human and animal anatomy allowed him to invent the gestures that carried out his idea.

Lion. Florentine School, about 1500
When the striding figure of the lion is seen from the side, as the sculptor intended, it is clearly visible as a powerful beast. However, when viewed from the front end its silhouetted shape does not convey the same impression at all and its action is quite ambiguous. Later sculptors were more aware of the need to choose poses that would be effective when viewed from all sides.

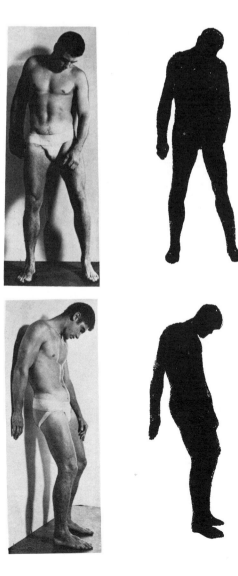

The importance of silhouette

Unlike the sculptor, who can plan his work to be viewed from several vantage points, the painter or illustrator can only present one view of his subject. In choosing his viewpoint it is important therefore, to select one which will be most expressive and that its silhouette reads clearly. Closely related to the subject of gesture, the silhouette, whether the figure is active or passive, should be self-explanatory. The term silhouette as used here is more nearly a synonym for shape. This shape may be dark against light, light against dark, or as seen against a varied background. While this shape should ideally be expressive of the mood or the action of the figure, this does not necessarily mean that this silhouette must always have a maximum of emphasis. There may be times when part of the figure will be lost or concealed within the picture. The important fact here is that the artist should be capable of manipulating the silhouette to the purpose of the picture. The shape of a singer or dancer in center stage would logically command the attention of the viewer by strong contrast. On the other hand, a party of soldiers waiting in ambush might be depicted as camouflaged by the setting and their shapes would be purposely concealed.

The two photos of the figure slumped in exhaustion against the wall are of the same pose from different sides. Observe how the silhouetted figure below conveys the idea much more clearly than the other.

ARTHUR B. DAVIES, Every Saturday
Brooklyn Museum
This painting illustrates the basic use of silhouette. Even the figure in white is held as a darker tone than the sky.

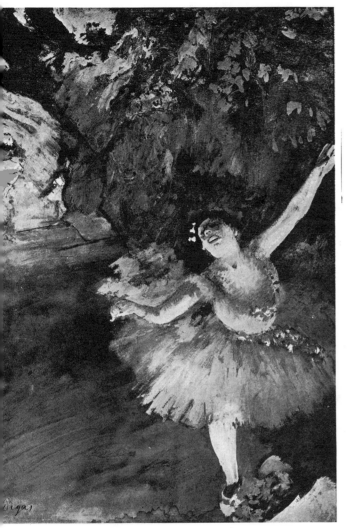

EDGAR DEGAS, Dancer
This is an excellent example of the use of a silhouetted shape of light against dark.

AUGUSTE RENOIR, Portrait of Mme. M.
Private Collection
Here the artist has purposely concealed the silhouette of the figure within the larger shape of the sofa and pillows. This serves to isolate and therefore emphasize the subject's head as the center of interest.

HAROLD VON SCHMIDT, Jungle Outpost
The Saturday Evening Post © 1944 Curtis Publishing Co. The shapes of the foliage are employed as a light pattern to conceal the figures of the soldiers. The artist used a dark area within which to partially reveal the figures as thin strips of light fall on their heads.

135

MARIO FORTUNY
The feeling of grief is clearly apparent in the slumped attitude of the figure and in his clenched hands.

AUGUSTE RENOIR, Woman Lying Down
This sensual figure is composed of rhythmic, flowing, and curved shapes. Angular forms are minimized.

Expression of mood through the figure pose

One of the characteristics of young children is the openness of their feelings. A happy child not only laughs or smiles, but that mood is expressed by an exhuberence of animated action throughout the whole body.

Adults tend to be more restrained, some more so than others, but the artist should take advantage of this human tendency to show inner feelings, not only through facial expression or the hands, but through the attitude of the rest of the body as well. For example, weariness or depression is evidenced by a sagging or drooping of the figure. Anger or excitement brings out tension and angularity of pose — perhaps a bent arm and a doubled up fist or legs braced to withstand a blow as seen in the stance of a boxer or a football player. Some of the mood symbols representing these basic attitudes are shown on these pages.

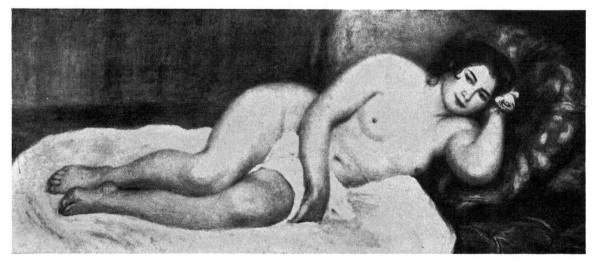

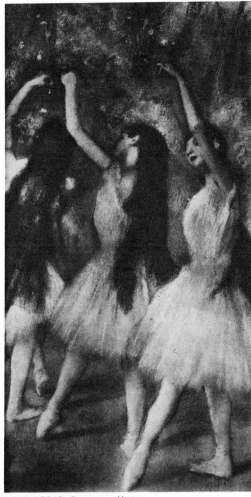

HOWARD PYLE, Thomas Jefferson writing the
Declaration of Independence
In this picture the artist has posed Jefferson as a vertical shape to
convey a sense of dignity, further strengthened by the vertical lines of
the window casement and the clock behind him.

EDGAR DEGAS, Danseuses Vertes
Underlying this pose is the symbol of gaiety
or happiness. The radiating lines of arms,
legs, and skirt work with the background to
make the mood light and airy.

AUSTIN BRIGGS, Dancer
Violent action and a strong feeling of excitement characterize this
vigorous brush drawing by Austin Briggs. The outstretched arms and
attitudes of the legs form a series of active lines and angles that
create a mood of action and drama.

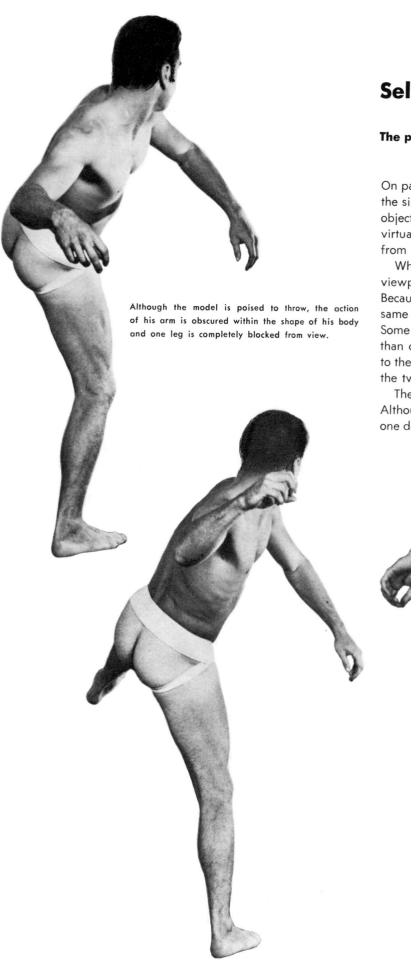

Select the most descriptive pose

The problem: To demonstrate the action of throwing a ball.

On pages 134 and 135 we described the importance of the silhouette in helping the viewer understand the object or subject presented. A subject may be clear or virtually unrecognizable, depending upon the position from which it is viewed.

When we use figures in a picture, there is not only the viewpoint to be considered, but also the pose itself. Because the figure is so highly mobile, it can express the same action through many different gestures and attitudes. Some of these are more descriptive and recognizable than others. We should select one that is most suitable to the purpose, expressing just as much as possible by the two-dimensional shape or silhouette alone.

The illustrations here show why this is necessary. Although all six are possible views of the same action, one describes it with the greatest clarity.

Although the model is poised to throw, the action of his arm is obscured within the shape of his body and one leg is completely blocked from view.

Here the leg is partially seen, but is much too fore-shortened and the action of the arm is still not clearly shown.

At this stage in the action the throwing arm is concealed.

From this viewpoint, the action of both hands is blocked from sight.

This is better, but the throwing action is too far advanced; the model's head is down and he's standing flat footed.

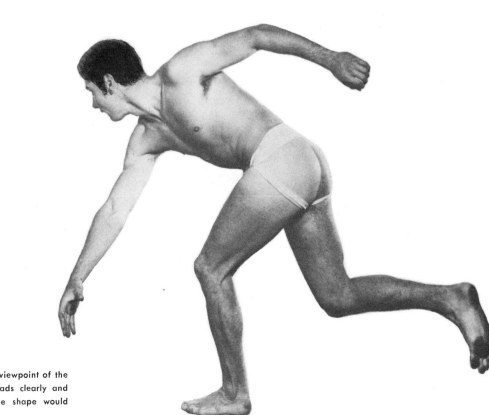

Final choice: Both the action and the viewpoint of the figure are good here. The action reads clearly and even if reduced to a silhouette, the shape would explain itself fully.

Points to remember

The surest way to gain proficiency in drawing the human figure is by repeated practice from the model, from photographs, or from imagination. However, simple repetition is not enough. With each figure you do, keep in mind the approaches presented in this book and apply them carefully until they have become a well established mental habit.

Step 1. Using the same photo of the figure throwing a ball from the previous page, begin by observing the action of the pose and make a number of gesture drawings to interpret it. This will enable you to improve on the action of an inadequate photo while utilizing the factual information in it.

Step 2. When the appropriate gesture sketch has been selected, you can then think about drawing the figure itself. Translate the gesture into a basic figure by keeping in mind a concept of the body as being made up of individual three-dimensional parts. This diagram represents the mental concept only.

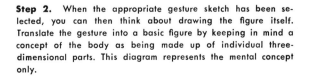

Step 3. This is the basic figure you will actually construct. Because each of the parts is easy to draw, it is a relatively simple matter to assemble them in carrying out the pose of the photo or the action of the gesture. Note here that the figure is properly balanced and that the throwing action causes the upper and lower sections of the torso to twist in opposing directions.

Step 4. With the basic figure as a foundation, you can now modify or "humanize" it by adjusting the contours as they are related to the underlying muscles and bones. Again, it is not necessary to make as complete an analysis of the anatomical parts as in this drawing, but it is important to know them well enough to record their surface effects.

Step 5. As the figure is completed, work out the areas of light and shadow which will be determined by the light source and influenced by the anatomy of the figure.

HENRI MATISSE, The Dance
In this famous painting done in 1910, Matisse used the figures arbitrarily with less regard for their anatomy than for their shapes. This, combined with bright, vibrant colors, created an over-all impression of great joy and festivity.

GUSTAV KLIMT, Danae
The artist used fluid, curving lines in the hair and in the patterned drapery, to complement the curved shapes of the figure in this sensuous painting.

Interpretations of the figure

The purpose of this book in so thoroughly investigating the human figure has been to teach the reader how to draw or paint it successfully. This is a two-way process however, requiring a commensurate amount of practice and review on the part of the reader. Although the human figure in its complexity of form and action is one of the most difficult subjects to draw, we have shown how to reduce the problems to simple successive stages that can be mastered, step by step.

Another important source of instruction and inspiration can be found in studying the work of other artists. In the future, whenever you see a drawing or a painting, try to look at it with a fresh eye. What can you learn from the way the artist rendered the figure? Even more important is to ask yourself why the figure was used in that particular way to express the artist's idea. Be critical. How successfully was it carried out? Could you improve on it?

The figure as presented here has been treated in the traditional manner with classic proportions. WE feel that the knowledge of these proportions is essential for every artist. However, this does not mean that an artist may not vary these proportions for his own purposes.

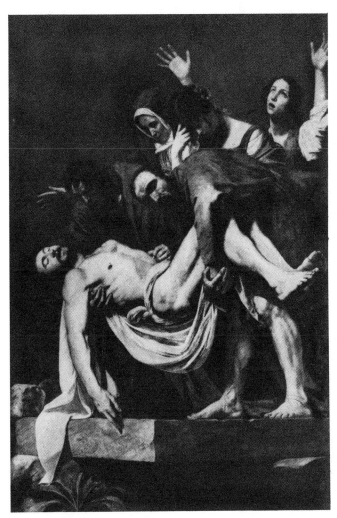

CARAVAGGIO, Descent from the Cross
This carefully painted and composed painting has great power and conviction. It is interesting to see how the use of sagging shapes in the figures to indicate the feeling of great grief has been repeated in the shapes of the drapery.

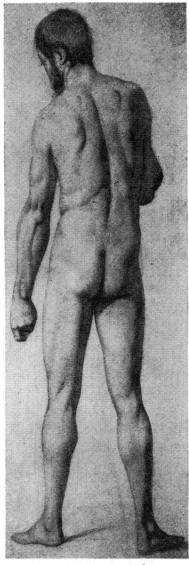

PAUL CEZANNE, Study of male figure
This nude study, made when Cezanne was an art student, clearly demonstrates his ability to draw classically proportioned figures.

Many of the world's masterpieces contain figures far from ideally or academically proportioned. An important distinction to make is that the artist should be in control, able to draw academically or to deviate from it, if desiring to do so, from knowledge rather than ignorance. Picasso, who fractured and reassembled the human figure in every way he could devise, from Cubism to the "Guernica," was also able to draw classically proportioned figures. Michaelangelo took great liberties with the figures in his monumental mural for the Sistine Chapel, while the works of some his contemporaries, if more "perfect," look weak in comparison. This is not intended as a recommendation for either distortion or academic realism.

The human figure continues to provide one of the most provocative and challenging of subjects and the freedom of decision about how to draw or paint it is the prerogative that properly lies with each individual artist.

PAUL CEZANNE, The Bather
A similar view of a male figure; this painting was made by the mature painter. He was obviously not interested in creating a literal replica of his model, but was searching for new means of creating planes and form through the use of color.